THE WORK OF ATGET

BY

JOHN SZARKOWSKI

AND

MARIA MORRIS HAMBOURG

———————

Springs Industries Series on the Art of Photography

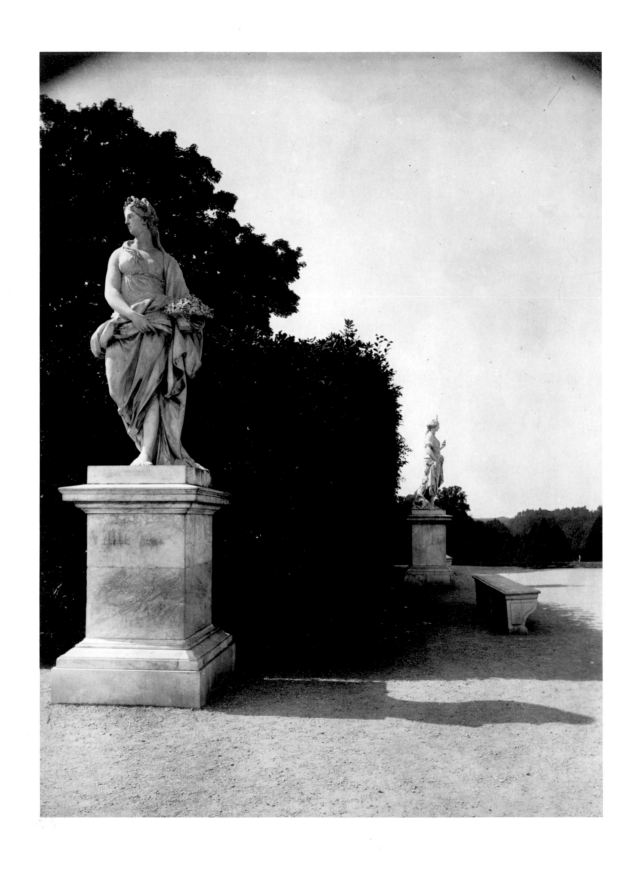

Versailles, parc, Le Printemps par Magnier. (1901)

THE WORK OF
ATGET

———— ✦ ————

VOLUME III
THE ANCIEN REGIME

THE MUSEUM OF MODERN ART NEW YORK

Distributed by New York Graphic Society Books
Little, Brown and Company, Boston

The Museum of Modern Art

11 West 53 Street

New York, N.Y. 10019

Printed in the United States of America

Contents

Acknowledgments

The Work of Atget, although published in four volumes, has been considered by its authors as one book. The many individuals and institutions whose assistance has been acknowledged in the first two volumes have made an essential contribution to the work as a whole; although their names are not repeated here, we do restate our gratitude to all of them.

Maria Morris Hambourg's essay in this volume, as well as the related appendix, is derived in large part from her dissertation, "Eugène Atget, 1857–1927: The Structure of the Work" (Columbia University, 1980). For critical and editorial help on the revised and abridged version printed here, she expresses her deep gratitude to Francis Kloeppel and Marjorie Munsterberg.

For this volume, thanks are due to Françoise Heilbrun and her colleagues at the Musée du Louvre for help in identifying certain works reproduced here, and to Andrew Zaremba, librarian of the Century Association, for his generous permission to reproduce in the Notes to the Plates works from the Association's Platt Library.

Like the earlier episodes of this work, this volume, and the exhibition that it accompanies, has been made possible by the very generous support of Springs Industries. On behalf of The Museum of Modern Art, and the public that it serves, we express the deepest gratitude.

JOHN SZARKOWSKI
MARIA MORRIS HAMBOURG

The Structure of the Work

AFTER half a century of appreciation, Atget's work is still widely perceived as enigmatic. Most puzzling is its unevenness; while there are pictures as potent, satisfying, and elegant as any ever made, there are also many dull ones whose interest is limited to the historic value of their report. The inequalities might have been explained if Atget had made distinctions between the transcendent and the prosaic pictures, but he did not. This commercial photographer treated all his photographs as equally serviceable documents. He indexed them indiscriminately by subject, and charged no more for mastery than for mediocrity. Some say that he did not acknowledge his successful pictures because he could not *see* them, as they owed largely to luck. Others, who concede his artistry, remain suspicious of its origin in practical commercial work.

These perplexities stem from applying to Atget's intentions historically inappropriate concepts of art, especially modern permutations of Art for Art's Sake. Atget understood art to be skill, the capacity to raise work to the highest standards of excellence. It was not an autonomous, self-justifying activity. One plied one's art in the service of a calling. This notion was essential both to his formation as an actor and to his work in a utilitarian branch of photography. Thus it was not a conscious attitude but an ingrained assumption.

Atget's rare statements of opinion reveal his position. In 1912 he wrote to the curator of the Bibliothèque Historique de la Ville de Paris, defending his "immense production made more for love of Old Paris than for profit." In 1920 he wrote to the Minister of Beaux-Arts, saying, "Single-handedly and of my personal initiative, I have made...a collection of artistic documents. . . . This enormous artistic and documentary collection is now complete." Finally, around 1925, in reaction to Man Ray's intended appropriation of his photographs as Surrealist art, he demurred, "These are simply documents I make." These comments,[1] the sum of his known remarks on the subject, are unmistakably clear: Atget did not separate artistic, documentary, and personal motives. Moreover, in the light of self-conscious, reflexive modernist art (such as Man Ray's), Atget's art seemed but the unobtrusive agent of documentary function.

The terms Atget used illuminate his sense of his work and some of its essential qualities. As documents first of all, the photographs maintain a serious, circumspect demeanor; they are useful and factual. As artistic creations, they are poised and lucid, and as the issue of a selfless motive, they evince wonder, concern, and respect. In his comments Atget also alluded obliquely to the fact that for him photography was a commercial enterprise. It was through (not despite) the consideration and accommodation of commercial practice that his intellect, vision, and artistic abilities developed. If we can forgo our habitual perspectives on art and accept these terms instead, we will see that Atget's whole work has a sense. That sense is conveyed through its structure.

The oeuvre, as we know it today, consists of a little

more than eighty-five hundred pictures.[2] Although Atget may have made more photographs, he did not keep them; those he preserved were cataloged and stored on shelves in his darkroom. This growing file of images represented a commercial stock—wares to sell—but it also came to represent a treasured personal collection—a work to be guarded intact. The contradictory demands of salable stock and permanent collection were resolved by keeping the negatives, which are unique, to make prints, which are dispensable. This was the usual practice for independent photographers. Atget not only retained his negatives for most of his life, but he scrupulously limited depletions of his stock so that his base inventory remained complete.[3]

Keeping order was the problem. It is not clear when Atget found it necessary to devise a system to catalog his pictures, but by 1898 at the latest he was numbering his current production to file in categories, and by 1901 we can distinguish a basic separation of his work into aspects of the land, historic civilization, and popular culture of France. Beneath these broad categories Atget gradually produced large and small series of pictures distinguished by subject and locale. The functions of the series were both intellectual and practical: by isolating certain themes Atget could give them greater coherence and cogency, pursue them more directly, and render them more accessible within the collection. Altogether there were thirteen series, five of which, judged either by their span or the many hundreds of pictures they contain, were major undertakings. The remaining eight were more limited in focus and duration; as most were originally subdivisions of major series, we have called these lesser groups "subseries."[4]

The first major series was Landscape-Documents, starting as a slender file of diverse documents dealing primarily with flora and fauna; it was the only series that spanned Atget's entire career. In 1898 Picturesque Paris and Art in Old Paris took shape, and in 1901 a suburban extension was created, Environs, sometimes called Art in the Environs. Picturesque Paris turned out to be a periodic pursuit, but Art in Old Paris and Environs were more regularly produced, eventually

accounting for half of Atget's output. By 1907 Atget was working on his fifth and last major series, Topography of Old Paris, and in 1911 he initiated a related subseries, Tuileries; basically neither survived the war. The other subseries were related to Landscape-Documents: Vieille France, an early subdivision within the series, later became a separate appendage; Interiors, begun as part of the series, was spun off in 1910; Saint-Cloud and Versailles were similarly formed in 1922. They were followed by two autonomous but thematically related subseries, Parisian Parks in 1923 and Sceaux in 1925. Lastly, a small group of documents of costumes and religious art comes to us without affiliation or date. With very few exceptions, Atget filed all his pictures in one of these thirteen series.[5]

Within series the photographs were numbered consecutively in normal counting sequences; of these there were fifteen, one for each series except Picturesque Paris, which had one for each of its three periods. No hierarchic distinctions were made: Atget simply assigned a negative to the appropriate series and engraved its emulsion with the next number in that sequence. Prints from the negatives, which also display the number, were placed in orderly progression in homemade paper "reference" albums. Serial position was permanent, as was the consecutive relation of reference albums within series. Arranged in proper order, the file of reference albums for the thirteen series describes the compound structure of Atget's lifework.

Atget also created a second type of album, conceived thematically and without particular regard for series or chronology. These editorial albums, composed of selected duplicate prints from the reference albums, cut through the oeuvre in various ways, addressing topics of interest to different sorts of clients. Sometimes their major market is clear—for instance, an album of door knockers appealed to metalworkers, and one of fountains to stone carvers—but usually they suggest several uses. In some cases the intended clientele remains a mystery, for Atget's purposes were large and elastic and comprehended inherently personal motives, too. The editorial albums were the flexible process that accommodated all intentions; as his ideas

and commercial strategies changed, he made new albums and shifted his photographs among them without disturbing the underlying order of the catalog.

The system Atget devised, with its multiple categories and unlimited capacity, was particularly well-suited to an ongoing work unbounded in the scope and valence of its exact description. It performed its clerical functions well: by dividing the work into rational units with an internal order it favored efficient storage and retrieval; it also easily accommodated changing commercial functions since the shelf order implied no absolute intellectual context. And, since it so expedited and facilitated consultation, reprinting, and the making of new albums, its long-term use involved the perpetual review of earlier efforts. Thus it subtly enriched Atget's artistic self-education and encouraged the temporal and thematic correspondences so characteristic of his work.

* * *

Although it is not known how Atget came to photography, his decision to take up documentation for artists seems to have turned on an interest in art deep enough to tempt him to paint for his living, a lack of painterly facility marked enough to urge a different tangent, and economic necessity real enough to require a practical calling. While documentation for artists was an apt answer to those conditions, it was not an easy solution. This line of work required a stock of photographs representing a great variety of things artists might need as models, described in ways that were appealing, legible, and easy to use. These considerations and the fact that artistic tastes and needs were naturally fluid, posed many problems, especially for a man trained as an actor, not as a photographer.[6]

By the time Atget opened shop, which could not have been later than the winter of 1891, he already had an inventory, or at least the beginnings of an inventory, in "landscapes, animals, flowers, monuments, documents, and foregrounds for painters."[7] None of the early pictures in the Abbott-Levy Collection can be dated precisely, but the oldest parts of the Landscape-Documents series are filled with pictures of that description and probably represent what remains of the original stock. The photographs are arranged in six groups according to subject and function. The first group served landscape painters; it contains rural scenes and pictures of trees, boats, haystacks, harvesters, and other characteristic landscape elements. Two more groups contained animals: domesticated fowl and livestock in one, and sheep dogs, oxen, donkeys, and other work animals in the other. Foregrounds for painters, which are mostly pictures of plants, trees, and flowers, were filed in the fourth group, while the fifth virtually repeats the subjects of the first, for reasons still obscure. The sixth contains "monuments," that is, photographs of architecture and decoration that provided exact local settings for genre and historical paintings. This group, which later became the subseries Vieille France, included the choir stalls and portals of Amiens cathedral, the courtyard of the town hall in La Rochelle, and various other provincial buildings. At some point the stock also contained photographs of models posing, of soldiers, and of famous people (reproduced from portrait drawings).[8] In his dealings with artists, Atget would also reproduce their paintings for them and travel to make photographs upon their request. He seems to have welcomed all contacts with the artistic community that might generate business.

As a novice both in photography and in this particular specialization, Atget not surprisingly produced highly uneven work. He not only had difficulties with basic technique but also had trouble learning to turn the camera's peculiar vision to his purposes. His initial instinct was to place the object to be documented in the middle of the picture plane surrounded by a buffer of empty space. This avoided the awkwardness of severing objects at the edges of the visual field, and it addressed each object as an exemplar of its kind: for all their individuality, the fruit trees in Atget's early work disclose a generic posture and shape as clearly as drawings in a botanical dictionary. If an object could not

be adequately understood in profile, Atget framed it obliquely to give its three-dimensional structure better definition.[9]

If it was impractical to approach his subject in this simple expository manner, Atget devised other strategies. When he found it impossible to use the sky, a wall, or some other neutral area as an isolating zone, he improvised a backdrop from a white sheet hoisted on whatever stakes or shovels he could find at hand. When the dimensions or location of the object ruled out the sheet, Atget might throw the background out of focus. Sometimes, however, the problem was not the clear description of a thing, but the representation of one of its functions, actions, or aspects. To show how the rotation device in a windmill worked, or the way a bridle fitted a horse's head, he would bluntly frame just those details, abruptly cropping out whatever was irrelevant, and he did this without apology as it were, without trying to palliate the often curious pictorial results of his descriptive expedience.[10]

Atget could also make pictures much more in line with accepted norms of representation. His landscapes, especially, look like their counterparts in painting, to some degree because the very idea of landscape had pictorial parameters, but also because the photographs were intended to appeal to painterly taste in landscape models. Generally Atget sought out bucolic scenes of the sort that Charles Daubigny, Jules Dupré, Camille Pissarro, and other Barbizon and Impressionist painters had popularized in the Ile-de-France. These he framed appropriately—thatched-roof cottages are seen at the end of country lanes, and cows graze beneath blossoming apple trees—unless the camera sabotaged the conventional rendering with odd spatial effects or indiscriminate chiaroscuro.[11] In these cases too Atget tolerated the distortions.

Because of the diverse nature of the concerns, the variable capacities of photography in handling them, the lack of dates, and the large lacunae in the files, it is impossible to discern any consistent development in Atget's style or vision during this period. The extant photographs do not even narrate his mastery of technique (doubtless a gradual process); they simply demonstrate it. A comparison of what seem the poles of

his abilities is inconclusive: consider, for example, his photographs of animals, all probably taken between 1888 and 1891. They are technically flawed, as well as coloristically and formally dull, but whether their listlessness is due only to inability or also to lack of interest, or to dreary precedents in animal documentation that Atget knew, we cannot say.[12] By the same token, the success of *La Rochelle*, made around 1896, might be attributed to the intervening years of practice.[13] We sense an assurance and a real understanding of camera position in the way the dark boats are pitched like musical notes across the smooth tidal sands of the harbor. However, we might also ascribe this confidence to Atget's prior experience and greater knowledge of sailboats (than of barnyard fowl) and to the more salutary influence of seascape traditions. In this and indeed in most cases, success is so random, quirky, and mysterious that it does not seem to rely on the calculations of a trained eye, but on intuitive acts of recognition.

Since coherent development seems not to have been the nature of his early experience, we might more profitably ask what making documents for artists taught Atget. Perhaps most important for his subsequent career was the inculcation of a generous flexibility of approach. Unlike the portraitist with his array of props and stock poses, or the industrial photographer with his standard illuminations, Atget treated subjects so varied that he had little chance to develop all-purpose formulas. He was of necessity engaged in problem-solving cued to the specific nature of each object or scene and to its intended pictorial function.

The practice also trained Atget to treat a flower, a well, or a garden gate as a separate, individual motif, not as a detail subsidiary to a larger whole, as was usually the case in painting. Since the camera could not "vignette" or withdraw these things from their surroundings, Atget learned to do without a broad clarifying context and to concentrate wholly on the immediate issue.[14] While these conditions did not always produce unusual solutions, they often did. Thus he grew attuned to the apperception of nominally inconsequential motifs as the basis for whole, integral, sometimes unconventional pictures.

Through the making of documents for artists, Atget became peripherally acquainted with the traditions, training, practice, and current trends in painting—his attention here was broadly inclusive rather than closely focused. Even after architectural photography became his foremost activity, Atget persisted not only in selling to artists, but intermittently in making them new documents that display the same supple ingenuity as the early examples. He also continued to paint and draw, frequented his friends among the painters, accepted an occasional commission from an artist, and reproduced works of painters from Giotto to Gavarni for his collection of documents.[15] Thus the primary concerns of the early career threaded through his life in various guises, connecting him to painterly problems, solutions, and traditions at several points. His maintenance of this strain of his practice and the manifest continuity of his interests suggest that Atget's visual talents, far from being innocent of the artistic ends they served, referred to them all along the way.

* * *

Although he had lived in Paris and had taken photographs there on request, Atget did not create a category of urban views until the early spring of 1898. At that time he set up a numerical series to file the results of some recent forays—eclectic gleanings of street scenes, picturesque spots, and famous monuments—a little something for every taste. Presumably the pictures answered needs among Atget's usual artistic clientele, and they also interested the Musée Carnavalet (the museum of the art and history of Paris), his first institutional client.

Successful from the outset, the Parisian series grew quickly, and within two or three months Atget had to revise his file both to accommodate a basic dichotomy in the work and facilitate its diverse functions. In the existing file, which came to be called Picturesque Paris, he cataloged pictures about people and urban life; he also set up another, separate numerical series to file photographs of streets, art, architecture, and other structures of the urban setting. After this division, the distinctions between pictorial genres gradually sharpened; prominent buildings were reduced to the role of backdrops in scenes of Parisian life, and conversely, the animating presence of the populace was deemphasized in views of architecture. Since it was easier to deal with the issues singly, this division was primarily a practical measure, but it was also an expression, the first we can reconstruct, of the photographer's efforts to distinguish among and organize the multiple facets of his understanding of his subject.

At the start of the Picturesque Paris series, Atget tried his hand at candid reportage, photographing people as they bought and sold provisions, browsed in secondhand stalls, read on park benches. Their casual postures, the inclusion of curious bystanders, and the relatively loose compositions convey an immediacy and an animation unique in the oeuvre. These characteristics tapered off and disappeared during 1899, when Atget increasingly focused on vendors, knife grinders, street singers, and others in the "Petits Métiers," or "small trades." Rather than catch them unaware, Atget had them pose, exhibiting their goods or their traditional attributes with familiar gestures. Some of the early examples retain the residue if not the gesture of spontaneity in their cropping and formal juxtapositions, but later examples are wholly deliberate. The vendors stand rooted to the pavement before an indistinct cityscape, with all contextual detail, untoward incident, and movement either minimized or eliminated. Many of the last "Petits Métiers" in the series achieve the static, emblematic presence of the well-known "Cris de Paris" print cycles.[16] Whether or not Atget drew directly on them, in a span of three years he had transformed a reportage of contemporary street life into a catalog of ancient ambulatory trades depicted in a manner consistent with their pictorial tradition. For its intimations of gradual acculturation alone this visual evolution would be interesting; it is therefore all the more telling that in the process a need for physical and cultural permanence and total picto-

rial control came to dominate the undisciplined complexity and instantaneity of modern urban experience.

When, in 1900, Atget had collected all the small trades still practiced, he stopped photographing people. He might have used his simplified, distilled approach on other groups of Parisians—uniformed officers for example, or the ladies that fascinated the young Jacques-Henri Lartigue, or the gypsies and prostitutes that Atget years later did portray. That he chose not to pursue this line of documentation further and instead turned his full attention to more architectonic aspects of Paris suggests the unsuitability of dynamic subjects for his increasingly deliberate method.[17] It also hints at unequal markets: while we do not know how large a demand existed at that moment for the scenes of Parisian street life, it probably paled before the very positive reception given the documents of architecture. In any case, Picturesque Paris became a dormant file after 1900, while architecture became the established priority.

Atget called the file of architectural views "Vieux Paris," a phrase that identified both its content and its intended audience. The term evoked respect for the cultural past and was freighted with innumerable, even contradictory associations; but reduced to its practical sense, it simply meant those aspects of Paris—its buildings, streets, and artifacts—dating from periods prior to the Revolution. By calling the series Vieux Paris, Atget not only set the historical parameters of its contents, but he also signaled his consciousness of the enormous interest Old Paris held for many of its citizens at the end of the nineteenth century. Banding together in historical societies, they agitated against the urban modernization that had begun in mid-century under Haussmann, and they fought for the protection of what remained of their ancient neighborhoods. Their cause became official policy when the Municipal Commission on Old Paris began to orchestrate research, documentation, and preservation activities in 1898.[18] It was at this juncture that Atget decided to include Parisian views in his stock of photographs.

Atget's early documentation of Old Paris was expansive and amateurish: he tried out the field. In the 1898–1900 period he concentrated on buildings of his-

toric consequence or pedigree: churches, convents, hospitals, palaces, the town houses of the aristocracy. He also collected rapidly vanishing ornamental motifs, such as those decorating shop signs and public fountains, and he made views of picturesque streets, courtyards, bridges, and quais. Most of these sites lay in the heart of Paris, in the dense central wards formerly bounded by the city walls, but a few of the picturesque sort were located in the outlying districts of Montmartre, Passy, and around the Gobelins Manufactory. Atget covered the territory in an energetic but errant manner, skipping from one sort of motif to another, learning as he went, following his instincts and the popular lexicons of the subject.[19] As a novice in the field he rehearsed the discoveries of other "amateurs de Vieux Paris" and also naturally duplicated many of the motions of the newly established Commission.

Documenting Old Paris proved to be not only an education in French history, local topography, and architectural style, but also an education in photography. The lessons of the first three years provided Atget with a battery of tools for his trade; although he would grow more skilled and venturous in its application, this equipment served him to the end of his days. Whereas previously he had wielded his camera to capture specimens, somewhat in the manner of a naturalist with a net, the Parisian setting overwhelmed that elementary approach with complex visual structures that invoked the talents of an architect. As a picture maker regularly confronted with scenes, not isolated things, Atget gradually discovered that space was not merely the natural habitat of the motif, but the crux of his pictorial problem. Working like a stage designer, but with only two dimensions, Atget learned to limit, direct, and modulate space with planar architectural elements and light. With a little practice he was soon positioning his camera so that walls served as theatrical flats or *repoussoirs*, and cast shadows and highlights worked for, not against, the organization and articulation of the picture.[20] An habitué of the stage and a sometime painter, Atget had a natural facility for this constructive sort of art, but sometimes he included large empty foregrounds that leached the power from his compositions. It was presumably to correct this

that he would rephotograph a site two or even three times, moving closer at each try before finally sacrificing the idea of framing integral objects (a whole building or facade) to his pictorial and descriptive needs. Fully three years passed before he consistently adopted closer, partial views as desirable alternatives to spatial dilution.[21]

When he had thoroughly, if unsystematically, surveyed Old Paris and recorded hundreds of streets, monuments, houses, and shops, Atget began to photograph the statues, signs, and ornaments that embellished them. Concomitantly he stopped working in locales where the architecture was vernacular in style and lacked such decoration. The dual shift—away from the broadly inclusive, colorful, layman's view of Old Paris and toward a more pointed and professional study of architecture and decoration—was reflected in a new title for the work; the Old Paris series became Art in Old Paris.

In the summer of 1901, when Atget took his first full-frame photographs of door knockers and began to find the word "detail" necessary for his captions, the tactical transition was under way. Moving from the broad and general to the ever more specific, his eye became increasingly attuned to subtle distinctions and smaller decorative parts, to individual details of style, structure, and craftsmanship. However it was accomplished—in a single session or over a period of years—his documentation of a thing generally progressed from far to near, from whole to part, and from exterior to interior. This progress followed the logical unfolding of visual experience and traced the photographer's path of discovery; it was not a standardized procedure. Atget's method of gathering his motifs was indeed so personal and irregular that it might best be described as discontinuously accumulative. As his knowledge of his subject deepened and the needs of his clientele evolved, he revisited sites, probing for motifs he had previously overlooked or framed otherwise. Like a miner who necessarily starts in a slightly different place each day but retraces his path to get there, Atget delved into Old Paris, seeking out rich veins, exploring and excavating whatever seemed promising along the way.

While his accumulative method greatly complicates the basic morphologic features of his work, some broad contours within the Art in Old Paris series can be discerned. In 1901–02 Atget mostly photographed decoration on facades—of town houses (balconies, doors, door knockers), cabarets (grills), and shops (signs). In the next years he gradually penetrated further, photographing many courtyards and staircases as well as the exterior and interior ornament in churches. By 1905–06 he was concentrating on stairs, mantels, moldings, woodwork, and other interior details in the most elaborate town houses. Thus by the end of 1906 he had a good inventory of all types of architectural decoration, and during the next five years he added to this stock at only half his prior rate. His subsequent contributions treated all types of decoration, as well as figural sculpture and bas-reliefs.

Atget concentrated on art and architecture for more than a decade; the specialization evidently suited his proclivities, and his market was secure. A very real need for documents of decoration existed, for the campaign to preserve Old Paris had reinforced interest in styles of historic ornament, both in their own right and as models for contemporary pastiches which, along with Art Nouveau, were then the prevailing fashion. Because the past served this exemplary function, designers, craftsmen, and schools of applied art collected pictures of period furnishings, decorative schemes, and ornamental details, although illustrations of the last were in short supply. In recognition of this lack, the Commission on Old Paris proposed that a portfolio of photographs of "The Decorative Arts as applied to Construction in Old Paris" be created.[22] Commissioner Georges Cain, Chief Curator of the Musée Carnavalet, agreed to oversee the production and to house the collection in his museum.

By 1905 Cain had bought six hundred of Atget's photographs of decorative art in Old Paris.[23] While the agreement underlying these acquisitions most probably was informal, bills of sale and receipts of photographs testify to the frequent exchanges between Cain and Atget beginning in June 1901.[24] Since this was the moment when decoration became prominent in Atget's work and the name of the Old Paris series was

changed, Cain was probably involved. Whether he actually suggested the decorative slant or simply recognized its value for the municipal collections, he encouraged Atget's new direction by regularly purchasing the pictures.

While the Art in Old Paris series answered needs recognized by the Commission and (through Cain) received its unofficial support, Atget never worked directly for the agency.[25] Independent of supervision, he proceeded in what was becoming a rather idiosyncratic manner that strayed from the resolutely purposeful and economical procedures expected by the Commission. Their explicit instructions kept from their photographers just those problems whose variable solution constituted any interest the exercise had beyond its commercial value. Atget probably would have found the least restrictive of the Commission's prescriptions problematic, even an order so simple as a photograph of a doorway "with door closed."[26] His receptiveness to the possibilities of the moment—to conditions of light, the approach of a pedestrian, the trace of a streetcleaner—and his sensitivity to shapes, textures, and gestures resisted regulation. Thus for any reason or combination of reasons he might open a closed door, and, provided his picture transmitted the necessary information, he even accepted the blurry "ghosts" of people passing, partially transparent objects, two-headed horses, and other anomalies that most professionals rigorously avoided. In effect, the flexibility and individuality of Atget's response prevented him from being entirely reliable in the production of strictly proper architectural documents.

This unruly character was not born of heedlessness or disrespect of standards, but of a greater concern for content than for etiquette. Atget's method was relatively inefficient because it was tied to the progress of a persistent vision that welcomed opportunities to learn more and see differently. It was uneven and unrepresentative because he did not bother with lights, scaffolding, and most of the official permissions and assistance often needed for complete professional coverage. Atget brushed aside such issues because the potential of what was available to his eyes was so generous that pursuit of obscure, restricted, or inaccessible aspects was not necessary.

Indeed, much that concerned other photographers scarcely occupied Atget. For most architectural photographers, it was paramount to achieve the regularity and frontality of elevation drawings, and to that end they sought camera positions that were elevated and parallel to the motif. Atget habitually shot from the pavement and frequently from an angle. This was easier and from a pedestrian's point of view more natural, but it produced pictures that were open and familiar, not schematically correct or polished.

When he had located something of interest, Atget fixed his frame to focus attention on the motif without removing it from the context of lived experience. Through the asymmetry of his compositions and their frequent lack of closure, he distinctly implied the continuation of the picture space beyond the frame. Many of the phenomena he included within the frame performed similarly—glimpses down side streets and into courtyards, shadowy places at the top of stairs, and reflections in shop windows. Furthermore, the apron of ground he left at the base of many pictures provides imaginative access and conveys the sense that the picture space is easily inhabitable, even contiguous with our own. So closely does Atget's upright, *rez-de-chaussée* stance duplicate our own that we have difficulty imagining it to be conscious strategy. The lack of artifice and the human posture seem rather to suggest that it derived from the photographer's authentic, sentient response to the world in which he was at home.

* * *

From 1901 to 1921 Art in Old Paris was the primary vehicle of Atget's professional renown, and like any long-term project that fosters a career identity, it tends to overshadow other activities. When we speak of Atget as a specialist in views of Old Paris, we are in fact referring to three major series within the oeuvre, the

one we have been discussing and two related ones, Environs and Topography. Environs was initiated in 1901 after Picturesque Paris had been laid aside, Topography in 1906 when a decline in collecting momentum in the Environs series grew marked. This pattern was characteristic: Atget branched out in pursuit of new themes every few years, not coincidentally just when quiescence in one or more series threatened to leave him without the freedom of choice apparently essential to his well-being and his art. Thus, in 1901, with Picturesque Paris dormant, Landscape-Documents more or less becalmed, and Art in Old Paris looming as his sole occupation, Atget struck out for the environs and made a different sort of document that required a new category in his file. Except for pictures with purely botanical or pastoral subjects (the domain of Landscape-Documents), he filed all photographs taken in the suburbs between 1901 and the war in the Environs series. With some change of content, Atget maintained the series until his last years, by which time he had produced eleven hundred pictures in this category.

A study of the Parisian region was a natural complement to one of Old Paris. Cradling Church and Crown, this area had also nurtured the capital, whose rapid growth urged many Parisians (and their princes) back to the countryside in retreat. Many of the most venerated monuments of French civilization—the palaces of Versailles and Fontainebleau, the cathedrals of Chartres and Saint-Denis—are not located in Paris but in its vicinity. So intimately involved is the capital with its environs, and so essential is their nourishment to the idea and existence of the city, that any serious interest in Old Paris leads beyond its boundaries to the heritage of the Ile-de-France.

As was so frequently the case for Atget, his first years of work on the series were far and away the most prolific. In 1901 and 1902 he took nearly four hundred photographs in at least thirty-two different locales in the immediate surroundings, the "Petits Environs." Fanning out both to the north and south, he visited Montmorency, Pontoise, Bourg-la-Reine, Choisy-le-Roi, Versailles, and other communities, doc-

umenting fine architecture, decoration, formal gardens, and such popular curiosities as the café in the tree at Robinson and the tree of Saint Vincent de Paul at Clichy. After 1902 he expanded into the "Grands Environs," to Beauvais, Compiègne, Etampes, Mantes, Senlis, and other towns at a farther remove from Paris. He did not treat just the wider concentric ring of suburbs however, but often reverted to the "Petits Environs," especially his favorites to the south. He revisited some sites, notably Versailles, every year.[27]

Atget's choice of subject was informed by several functions and traditions. First, the Environs series was an extension of Art in Old Paris and answered the needs of the same collectors, craftsmen, and institutions to which that series was addressed. In point of fact, many albums of his photographs of sculpture from parish churches and provincial museums, and of ornamental ironwork and interior decor from country estates, were not titled Environs but Art in the Environs. Broader views of château facades, gardens, and other relics of the Ancien Régime were closely associated with these documents and served some of the same purposes. However, as these views were heir to the long tradition of illustrating preeminent sights of the Parisian region, in principle they could have competed also for the attention of tourists and bourgeois collectors. But the competition was unequal. No longer in the hands of artists working alone,[28] the production of such views had been taken over by a veritable publishing industry led by large photographic firms like Neurdein Frères. While Atget's views were roughly comparable to theirs, he could not distribute his so widely; if we judge from the extant examples, these photographs reached only a limited clientele, chiefly among archivists and architects.[29]

Besides documents of art and architecture, which accounted for about half its contents, the Environs series had large concentrations of two other kinds of subject— motifs specific to localities and motifs generically picturesque. The first group covered whatever sites the town fathers, preservationists, and local antiquarians prized in their community—an ancient chapel, a manor house, a ruined castle or abbey, the tombs

and birthplaces of illustrious citizens.[30] Mingling with these was the other sort of motif, long familiar from Romantic prints and Barbizon and Impressionist paintings. These subjects, which for lack of a better term we call picturesque (following Atget's example), included the entrance to the village, the town square, the farmhouse, well, and barnyard, and other structures whose simple adornments and vernacular style are richly redolent of human life.[31]

Working in the environs challenged Atget in many of the ways that working in Paris did, and, through repetition and diversity of example, reinforced what he was learning there about scenic organization and lighting. He found suburban photography particularly stimulating when it comprehended Versailles and Saint-Cloud. Versailles came first and was the more potent revelation. Having little by little cultivated photographic skills that would resolve the cacophony of the world into harmonious visual phrases, Atget walked into the gardens of Versailles in the summer of 1901 and saw the orderly ideal he carried within him splendidly laid out in three-dimensional material reality. The careful design and judicious embellishment of the gardens immediately elevated the initial terms of his task to a more exalted and exacting plane.

Of the many lessons Versailles proposed, three stand out. First, Atget learned to simplify his compositions by giving parts of the picture over to wholly unified tones, either very dark, as in the slightly underexposed hedges and trees, or very light, as in brilliant skies and water surfaces. Much of the tonal massing was accomplished with hedges, against which white marble statuary stood beautifully revealed. By providing numerous opportunities for juxtaposing plants and statues in photographs, Versailles also encouraged their comparison, and, in accord with the Rococo painterly convention, their formal correspondence. Finally, the immense scale and planned perspectives of Versailles induced the precise visual joining of near and far. Although the phenomenon took place on the ground glass of the camera, the act of attention was not unlike sighting a weapon: Atget centered distant forms, tiny like a gun's bead, in the cup or aperture of the larger, nearer objects in the picture. All three pictorial strategies—tonal massing, formal mimicry, and surface congruence of near and far—were tools Atget carried thereafter to help clarify the position and scale of objects, underscore their expression, and invest them with his sense of their meaning.[32]

The success of Atget's work at Versailles and his prodigious production, especially in the first two years, suggest the headiness of the experience. On first acquaintance he rapidly recapitulated the development he had already traced in Old Paris in its early stages. He began with a quick survey of the expected sites—the approach to the Château, the Cour d'Honneur, the grand parterres, prominent statues and fountains. Then he concentrated on decoration in more concerted surveys of specific areas of the park and the Trianons. As in Paris, these studies progressed from broad or distant views to ever closer examinations of sculptural motifs.

Working in the environs also brought Atget an insight into the basic premises of his larger subject. From 1904 to 1907 he visited Saint-Cloud, a formal garden of the same vintage as Versailles, but bereft of its château and partially denuded of its statuary. With the exception of the Grande Cascade, a richly ornamented fountain situated apart, the elements to be documented were reduced to the flights of steps (of which there were many), balustraded terraces, alleys, and pools that had been carved into the uneven wooded hillside to make a more rational domain. Since the terrain was irregular and certain sections of the park remained in a rough, nearly natural state,[33] Atget's attention was drawn not to the decoration, but to the subliminal drama gradually played out between the power of nature and the designs of men. While this sense was already beginning to take form for him at other sites, it expressed itself openly at Saint-Cloud in the autumn of 1906, when fallen leaves drifting on stone steps dramatized the changing of seasons in a static man-made decor. This perception reached the quick of Atget's art and immediately drew forth a new vision of Versailles as well.[34] Interestingly, it was accompanied by the technical innovation of shooting

directly into the light. Like the potential meaning, this technique had been available to Atget and even gingerly approached, but never before fully exploited. The flaring radiance so aptly suggested the presence of immaterial forces that the luminous effect became associatively linked with Nature's mysteries; lodging together at the heart of Atget's sensibility, they generated some of his best pictures.[35]

A marked drop in the rate of production of Environs pictures occurred after 1902. Once the dazzle of first discovery had faded, for instance at Versailles, it required proportionately more time, reflection, and ingenuity to glean additional pictures from the site: as Atget grew better acquainted with the themes of the environs, he was not as quickly satisfied with the immediate solutions. Furthermore, longer trips to reach sites in the "Grands Environs" slowed his output year by year. In 1907 he took only forty-three pictures, and thereafter he ceased working on the series on any regular basis until after the war.

As his work for Environs dwindled, the void was filled by a category of urban documents called the Topography of Old Paris. This, the fifth and last of the major series Atget undertook, was initiated in 1906 but not definitively organized or focused until 1907. Characteristically, it absorbed most of Atget's energy at the outset and quickly assumed a place of importance in the oeuvre—so much so that had the war not halted everything, Topography might have rivaled Art in Old Paris as the primary file in the oeuvre.[36] Despite the abbreviation, the series nonetheless grew to sixteen hundred photographs and was the second largest Atget compiled.

For the first five years of its existence, the Topography series was a detailed and accurate description of the central wards of Old Paris. It followed the ancient uneven warp of streets that underlay the city's fabric and established its pattern of neighborhoods. Street by street and district by district, Atget systematically recorded the physiognomy of the city and then captioned the photographs with relevant topographic data and detailed historical information. The methodical implementation and the conscientious providing of historic

context, like the relatively impartial point of view Atget adopted, signal an attempt to conform to the needs of a client. He was Marcel Poëte, pioneer urban historian and chief librarian at the Bibliothèque Historique de la Ville de Paris.

The topographic survey had its origins in "a unique collection of photographs of Parisian scenes dating back to the middle of the nineteenth century."[37] Most of the photographs were by Charles Marville, who had produced them for the Travaux Historiques, a municipal historical agency created and directed by Baron Georges Haussmann.[38] The more than four hundred large glass plate negatives from that campaign were stored at the Bibliothèque Historique de la Ville de Paris, and in 1899 the photographer Paul Emonts was hired to clean and print them—a task finished in 1905.[39] The following year, when Poëte resuscitated the functions of the Travaux Historiques and proposed to acquire new photographs of Old Paris that would "attach this present to the past," his notions of that past and of the value of such documents were directly indebted to Marville's campaign.

Poëte chose Atget, not Emonts, to make the new documents relating to Marville's. Although Emonts had intimate knowledge of Marville's work and forty years of personal experience photographing architecture, in 1906 his career was at its end.[40] Atget, on the other hand, was in his prime at forty-nine, a specialist in views of Old Paris, a reputable and regular supplier to the library (which already owned 2,516 of his photographs), and the conspicuous man for the job. From 1907, when his preliminary sketch at an "Ancienne Topographie" took definitive form as the "Topographie du Vieux Paris," until 1912, when a contretemps undid the arrangement, Atget sold his Topography series exclusively to the Bibliothèque Historique de la Ville de Paris.[41]

If the project was inspired by Marville's documents, the content of Atget's series was, of course, the product of another age and sensibility, and differed from the earlier example in many ways. Marville had practiced the expensive and exceedingly painstaking wet collodion process. The lengthy deliberations it imposed

not only limited the number of pictures he could take, but also reinforced their formal character, which was as weighty and resolute as the Beaux-Arts architecture and political machinery of the Second Empire. Never offhand or incidental, Marville's photographs have static balance (usually symmetrical), stagelike spatial construction, and a respect for the "correct" drawing of architecture and clear rendition of detail. Atget was equipped with smaller and less expensive negatives, easier to carry and process; he therefore enjoyed much more latitude in covering his terrain and had taken thirteen hundred photographs by 1912. Furthermore, his wide-angle lens and his personal proclivities tended toward oblique, angular, and funneled spatial arrangements that have none of the classic, massive rectilinearity of Marville's work. The perspectival rush and attendant radical diminution of scale, as well as the contrast of dark foregrounds and atmospheric distances, invest the best of Atget's topographic pictures with a real dynamism. However, in the less successful work (of which there is much), the same characteristics leave the pictures uncentered and unresolved. While Marville's pictures were among the best of his career, Atget's Topography series had the highest concentration of prosaic pictures in his oeuvre.

The nature of the survey and the library's role in it clearly affected Atget's results. Just as Art in Old Paris elicited some rather standard piecework, at times downright routine, so Topography required an approach, resembling cartographic cataloging, that also worked against inspiration. Atget's topographic strategy usually involved orientation views up and down a street and a progressive canvassing of each side of the street for buildings worthy of record for the city archives. The quarters covered, designated by the librarians, were generally those overlooked by tourists and unphotographed by all but the occasional serious amateur; they were old residential districts lacking famous monuments and markedly picturesque qualities.[42]

If workmanlike documentation of these rather anonymous areas was the job, the problem for Atget was the visual and procedural monotony this entailed. As he covered the requisite areas and streets, he gradually allowed instinct, curiosity, chance, and unprogrammable apperceptions more rein, so that, while the pictures were preordained in topographic location, they were less and less preconceived in their focus and their frame. Instead of making a single comprehensive view of an old residence at a certain address, Atget might take three partial views that provided some interest for him and an adequate description of the site as well. By 1909, signs of domesticity, decorative motifs, and various formal devices incidental or even irrelevant to the project had begun to creep in. Atget had not avoided the problem but engaged it, progressively enriching the Topography series with human meanings and visual inventions characteristic of work in which he was genuinely present.

* * *

If the first decade of this century was the period of Atget's highest productivity and professional consolidation, the decade that followed was a period of gradual fragmentation and redefinition. During this period Atget asserted his control over his work, redressed imbalances in his collection, and slowed his pace to accommodate a more personal approach. This last was manifested in a spate of bound albums, a growing incidence of picturesque motifs, and the development of a vision less conceptually codified, more abstract and perceptually ordained. The gradual withdrawal from a broad and public orientation and the increasing investment in private concerns were interrupted by the war.

In 1908–09, when Atget was solely engaged in rather routine record-making for the Topography and the Art in Old Paris series, he responded to an urge to create something more coherent and permanent than his current activities allowed. He had made thousands of photographs, each one carrying its singular bit of information; these were accumulating in his serial files and were scattered through the folios of public collections and the folders of artists and craftsmen. It was partly in response to this situation that Atget decided

to publish selected highlights from the Art in Old Paris series. Using his "Motifs Décoratifs" editorial albums as his models, he had two maquettes of the first volume made, with original photographs, leather bindings, printed captions, and a handsome title page that read "L'Art dans le Vieux Paris."[43] In this tentative form his documentation of Old Paris attained a nobler, more ambitious profile, but the project never matured beyond this stage.

Instead of editing old documents of art into new packages, Atget revised his aim and hit upon the more felicitous idea of making albums on such themes as he had addressed in the Picturesque Paris series a decade earlier. He was apparently prompted to this solution by that precedent and by the production of another album that did meet with success—not as a document of historic decoration, but as a document of contemporary French manners. In 1909–10 he made sixty photographs of interiors that were acquired by the Bibliothèque Nationale as a bound album. Like the street scenes and *Petits Métiers* he had sold to the same institution in 1900, this collection of interiors was cataloged intact, with proper credit to the author, in "Customs, France," not in "Topography, Paris," where the rest of his photographs were more or less anonymously dispersed. Atget followed this success with five additional albums, four of which were similar in concept, and all of which were cataloged in the same fashion at the library.[44]

The difference between the bound albums at the Bibliothèque Nationale and the paperbound editorial albums that Atget showed and sold to clients is on one level simply the binding, for the same albums in homemade wrappers (and occasionally with printed title pages) exist in other collections.[45] On another level, with or without bindings, they are quite distinct, because they are composed mostly of new pictures taken expressly for the purpose. Unlike the editorial albums and the aborted Art in Old Paris books, they are not simply anthologies of preexisting work. Their purposeful production, fixed order of imagery, and self-sufficiency all represent an unprecedented degree of personal deliberation, control, and authority for Atget.

It seems therefore especially telling that the albums began in an act of self-perception. Atget photographed his apartment first. Depending upon which aspects he framed, he could represent his place as the home of a dramatic artist, a photographer, or a petit-bourgeois citizen. However, in a single picture he could not convey the larger truth (which combined all three identities), because the evidence of his avocation, job, and life-style happened to be segregated in his rooms.[46] Given this personal demonstration of the partial relation of biographical fact to pictorial truth, it followed that by carefully tailoring his photographs of other interiors, Atget could stitch together the stuff of invisible lives into a fabric of his own design. Thus, in a dozen apartments including his own, he shifted furniture and artifacts, skewed the facts, and invented such characters as Mr. R., Actor (Atget himself); Mr. F., Businessman; Mr. B., Collector; A Worker (also Atget); and Mrs. C., Milliner, to be the cast for the group of domestic scenarios he christened *Artistic, Picturesque, and Bourgeois Parisian Interiors at the Beginning of the Twentieth Century*.[47]

Neither a study of decorative styles nor, in any scientific sense, of sociological conditions, *Parisian Interiors* was an odd book of picture figments whose range and understanding reflect nothing so objectively as the scope of Atget's own imagination, morality, and experience. It describes the broad center of Parisian society, and reveals the common, unwritten codes of respectability, material comfort, visual discrimination, and privacy that regulated Atget's life and those of his acquaintances—whether artists, well-to-do clients, or poor relations. Remarkably intimate without indiscretion, the album is a further step in the development of a veiled but distinctly personal expression in Atget's art.

The themes of the other albums continued these trends. Taking his cues from the street scenes and *Petits Métiers* of 1898–1900 (and even reusing some pictures), Atget opened a new section in the Picturesque Paris catalog to file the photographs he was making for the albums.[48] They depicted modes of transport, boutiques, ragpickers, quais, and the fortified zone at the edge of the city. The emphasis on work and the working class, and on marginal characters and districts,

placed this series at a far remove from the rarefied reflections of higher-class life visible in the stylish mirror of Art in Old Paris. In Picturesque Paris, lack of luxury made life the primary concern, and art its poignant, vernacular expression.

The first album to reach completion after *Parisian Interiors* was *Vehicles in Paris in 1910*, a survey of the array of conveyances visible in the streets at a moment when the incipient but clearly inevitable mechanization of transport promised to make horse-drawn vehicles relics of an older age. Atget followed this in 1912 with a study called *Trades, Shops, and Displays of Paris*. Extending his interest in the *Petits Métiers*, he grouped together shops for sales and shops for crafts, in order to depict Parisian modes of organizing and displaying wares. These varied according to the imagination and taste of merchant or artist, the nature of the products offered, and the paraphernalia of the occupation—and found such disparate embodiments as kiosks, grocers' carts, sidewalk displays of secondhand clothes, a printer's press, a Morris column, and the facades of cabarets. Collecting many of his pictures of shop signs and bistro facades, Atget then produced *Signs and Old Shops of Old Paris*. In the next album, *Zoniers* (1913), he dealt with the gypsies and ragpickers who occupied the so called "zone," the no-man's-land of tracks, shacks, fortifications, and embankments at the edge of town. That landscape, soon to be reclaimed, was the subject of the last album, *Fortifications* (1915).[49] Because of the war, Atget never bound his extensive survey of the quais (1911–15), nor did he have time to make more than a few pictures of street circuses—a theme that had fascinated him in the early phase of the series, and which he would pick up again after the war.

The themes of the second phase of Picturesque Paris, and indeed of the series as a whole, owed much to the tradition of the "Tableau de Paris," a literary genre popular since the Revolution.[50] Often a collective illustrated work, it described whatever was typical and topical in Paris of that day. The ephemeral, contingent flux of the city—its crowds, fetes, and foibles—were savored as indicators of the moral and political ethos of contemporary society, as were itinerant characters and their marginal lives. The awareness of a constantly evolving and thus distinctly modern code of manners, fashions, and values was linked from the outset to the concept of Vieux Paris, for they arose simultaneously when the present could be clearly defined by the rapidity with which it became the past. These concepts were natural complements; without her "picturesque" mores and peculiar fauna, Old Paris was but an elaborate and empty stage, and without Old Paris, the properties and characters of the present had no measure of their modernity, no traditional frame. In reaffirming his interest in Picturesque Paris, Atget redressed within his collection a balance lost since 1901, when he had steered his course toward architecture, decoration, and later, topography.

Whatever we wish to call the pressure that led to the making of the albums, it was related to other disruptive symptoms in Atget's practice in this period. Beginning around 1910 there was a marked rise in picturesque subjects in Art in Old Paris and Topography. The quintessential motif of this sort was the old courtyard, embellished with a well perhaps, some potted plants, a concierge's box—a sensibly inhabited, private space. Such motifs, neither fine architecture nor primary urban structure, were inappropriate to both series; however, Atget cherished them more than the consistency of his catalog rubrics. He filed the pictures as he could and later grouped them in an album.[51]

While the pursuit of such favored motifs was hardly revolutionary, the motivation that underlay this tendency was a powerful force; when regularly thwarted, it eventually brought Atget's predicament to a head. Throughout the first decade of the century—and increasingly toward its end—the projects he had found commercially viable had demanded submission to values narrower than his own. His freedom to maneuver was restricted still further, in 1911, when he accepted from Marcel Poëte a commission to document the Tuileries Garden for the Bibliothèque Historique de la Ville de Paris. This project turned out to be less inspiring than any yet encountered. Part of the problem was that the park, originally a royal garden designed

by André Le Nôtre, had lost its elegant bowers and degenerated into a somewhat dreary arena of statues and vases, many of them nineteenth-century contributions of dubious merit.[52] With these Atget's patience and imagination wore thin; constrained to record every sculpture, he framed and exposed his plates carelessly. When Poëte expressed dissatisfaction and refused some of these photographs, Atget's frustration became explicit. He tried to excuse himself by citing difficulties he was having with an assistant librarian, whose attitude and intervention rankled him. But this was only the surface symptom of the real problem, which was that adopting other people's values in place of his own was finally impossible. The incident reinforced him in the opinion that "people did not know what to photograph."[53] He wrapped up the Tuileries survey and, more important, broke off his exclusive arrangement with the library for the Topography series. After this rupture in June 1912, he sold the Topography series to anyone interested[54] and moved its production away from the careful mapping of the central wards favored by the library, to looser surveys of eccentric districts and charming locales of the sort he liked to haunt (e.g., Bercy, Passy, the Cour de Rohan). He did not work under supervision again.

The gradual shift in attitude that induced the albums, the choice of picturesque subjects, and the repudiation of official patronage was paralleled by an increasing disposition toward new pictorial strategies. In this period Atget began to disregard what was agreed to be photographically correct, relevant, and useful and to welcome the results of his visual explorations instead. His willingness to forget what he knew in the face of what he saw was signaled most clearly in a tendency to geometric abstraction and a greater attention to ephemeral effects of light.

Atget had been enhancing the geometric structures of his motifs through lighting and framing since 1900, and he would continue to do so until his death; however, in the years around the war, the geometric configurations sometimes became so emphatic that, were the subjects unintelligible, the photographs could stand solely on the strength of their structures. Unlike some

strains of truly nonobjective art, this abstracting vision was not a flight from reality, but an acute investigation of the concrete world. The pictures differed from the rest of Atget's work only in the insistency with which their stark structures compel our attention, integrate their components, and exclude local color.[55]

When enhanced by tonal simplicity and the radical cutting of forms by the frame, Atget's abstracting vision has a Cubist look, and, since his competency in this idiom evolved contemporaneously with and close to the sources of Cubism, it may be that the flat and fractured visions of the painters helped recommend the imagery he discovered on his ground glass. But since other photographers (notably Henri Le Secq and Timothy O'Sullivan) had developed somewhat similar graphic styles without the corroboration of Cubism, it seems more likely that the phenomenon arose from habits of critical acuity sharpened by years of attention, the ability to previsualize photographic values, a heightened awareness of the frame, and an urge to make pictures as integral and discrete as any well-crafted object. That Atget manifested these penchants in the third decade of his career denotes not only an internal and external liberty, but also a greater sensitivity to the camera's own modes of apprehending reality.

Just as he felt free to avail himself of such formal devices that did not so much clarify conventional subjects as propose alternatives to them, so Atget allowed atmospheric effects a larger role in his work. While technical manuals advised soft, even light and transparent shadow for good definition, Atget encountered things in harsh or feeble light that interested him, not despite the adverse conditions, but because of them. During this period he began to investigate and accept these new effects. He studied the configurations of sun and shadow on tree trunks at Villeneuve-l'Etang, Versailles, and other locales and captured gossamer tissues of light floating in the branches of the Park Delessert.[56] If there was an external impetus to this renewed interest in botanical motifs, it has not yet surfaced; what is certain is that Atget's pursuit of these exceptionally plastic subjects was predicated upon, and further en-

couraged, a sporadic visual adventurousness reminiscent of the spirit of the decade when he made documents for artists.

After war broke out in August 1914, Atget was able to continue working, though at a much reduced rate, for two years. He was active both in Paris and in rural regions, producing some of the most vigorously geometric, formally inventive pictures of his career. He also sought out motifs of quiet, sleepy charm far in spirit, if not in fact, from current hostilities.[57] The privately motivated, questing nature of his trips and the scarcity of funds and supplies narrowed his production to a trickle, and in 1917 and 1918 he did not photograph at all. Although this postponed for a period his instinctive movement toward unordained visions of the world, the direction was irreversible. Inasmuch as it was the expression of a more open sensibility, it could not be unlearned.

*　　*　　*

In his last years Atget attempted almost nothing that he did not in some sense already know, yet his work underwent tremendous transformation. Continuing with the themes of the prewar period, Atget saw his material differently—atmospheric, resonant, and mysterious—ephemeral of aspect but timeless in importance. The work was the expression of an older man's vision, bold and synthetic in indication, complex and subtle in suggestion, and palpably sensuous. It did not analyze fact or trace history, but mused on life. Before achieving this final state, Atget's photography entered a three-year period (1919–22) of extraordinary formal fecundity, the efflorescence of the experimentation begun in the previous decade.

After the two-year hiatus enforced by the war, Atget began photographing again in 1919. Adding a few pictures to the Topography series in July, he then gave up that file permanently and turned to his original mainstay, Art in Old Paris. In that series as well as in Environs, he again took up his decorative specialization, returning to many familiar sites to rephotograph motifs, now in extreme close-up. His results were highly sculptural, expressive, and often entirely divorced from their contexts.[58] Similar qualities also characterized the pictures Atget made in the 1919–21 period for Landscape-Documents. So closely did he crop his studies of trees, lily ponds, gardens, and other botanical subjects that their large intricate forms fill the frame and cover the picture surface with uneven flickering textures. These motifs were not available to the casual eye; they were the compact, irreducible visions that remain after the inessential has been excluded, kept beyond the picture's frame.[59]

The more absorbed Atget became in the process of editing new visions of the world into photographs, the less interested he was in handling pictures he had made long before. Thus he sold a large collection of negatives concerning art and architecture to the Monuments Historiques in December 1920.[60] Disburdened of the responsibility of that work and of a great weight of attendant commercial procedures and functions he had performed for two decades, Atget became emphatically bolder in seeking out and appropriating the new regions of his freedom. No longer forced to relegate picturesque nooks and corners to the margins of his practice, he was soon luxuriating in them, gathering the motifs from the back lanes and old courtyards he so favored. He also recognized the wonder of his instrument, and gloried in its peculiar attributes. His attitude and procedure shifted: before he had used the camera to capture the world of his acquaintance; now he looked into it to see what he could see.

What appeared on the ground glass was perhaps as surprising to Atget as it remains for us. Everywhere unpredicted optical conjunctions replaced expected formulations. Light dissolved, reflections enlarged, and shadows obscured nominal subjects, momentarily removing them from familiar frames of reference. Under the black cloth space was fluid; it warped, fused, and expanded as Atget adjusted and rotated the camera —things normally separate converged, those conjoined became polarized.[61] Such exuberant perceptual explo-

ration could not long continue in so open and extravagant a form, and after two wonderfully robust years (1921–22), the vigor receded to a calmer resourcefulness. Atget had fully extended his visual reach.

In the 1922 season Atget initiated a new sort of campaign, which his trip to Montmartre that March may symbolize. For the first time since his initial exploration of Paris, he went back to photograph the old streets around the Place du Tertre. In April he made copy photographs of his early views of the same sites, in May he returned to the area, and in June repeated the trip again.[62] What so attracted him to Montmartre also took him that summer to villages in the southern suburbs—to Verrières, Sceaux, and Châtillon—where he photographed old houses, streets, and courtyards.[63] The shift, first in Paris and then in the environs, from the close-up details of art and architecture of 1919–21 to scenic views in 1922, was so clear-cut and conscious that it induced a titular change as well: Art in Old Paris became Old Paris, and Art in the Environs was likewise simplified in name and broadened in scope.[64]

That Atget reassigned his original title to the series was not fortuitous; he had indeed reverted to the kinds of concerns that often had occupied him in the 1898–1900 period. In his early career, he had gone to places considered picturesque and made "picture-perfect" views of them. He had included the urchins of Montmartre and the blacksmith of the Butte-aux-Cailles as requisite notes of local color in scenes so clearly and rationally constructed that they resemble stage sets.[65] In the twenties Atget was attracted to the same sorts of sites, but he photographed them differently. Rather than make pictures that judiciously disposed certain identifiable picturesque elements in a delimited space, Atget took complex visual fields perceived whole, integrated through the dynamics of atmosphere and light. Equipped now with a sensibility more attuned to perceptual and optical phenomena, he proceeded with remarkable liberty to revise time-honored conventions. Having traversed the frequently clichéd territory of the picturesque, Atget coined a new sort of scenic art that was broader and less concretely tied to

historic sites and quaint motifs. Shaped from the coloristic properties of light, mood, and atmosphere and private estimations of cultural value, the late views often contain very little that is not ineffable.[66]

Atget's fascination with view-making necessitated other structural changes in 1922. Since the end of the war he had made more photographs for the Landscape-Documents series than he had since 1900.[67] These were not only documents of trees, plants, and natural landscapes, but also views of gardens and parks of great châteaux. Perhaps because they supplemented botanical documentation of the same sites, the views were filed in Landscape-Documents, but in truth they concerned subjects more appropriate to the Environs series. As the views of Versailles and Saint-Cloud accumulated in 1921–22, the Landscape-Documents series had changed from a file for occasional photographs of plants into a major but ungainly series with two bulking nuclei. Consequently, when Atget refocused the Environs series, he also cleaned house in Landscape-Documents, returning it to its original function by setting up parallel subseries for Versailles and Saint-Cloud.[68] Both themes remained important preoccupations until at least 1926. Similar considerations and interests subsequently prompted Atget to initiate two more subseries: Parisian Parks in 1923 and Sceaux in 1925.

The summer of 1922 saw Atget make one other structural accommodation to his file. In 1921 he had photographed prostitutes and brothels for André Dignimont, the illustrator and photographic collector.[69] The next year, in his trips in the environs, Atget photographed a farming couple in Verrières and a peasant in Châtillon.[70] Instead of tucking these pictures into the prewar file of Picturesque Paris, Atget attached them to the sequence of prostitute pictures and thus reopened the Picturesque Paris series in its third and final phase.[71]

In accordance with its own precedents, the third part of the series was concerned with the Parisians, but it moved quickly from direct confrontation of people in certain métiers to more oblique use of their cultural artifacts. Returning to the same themes he had treated

before the war—to boutiques, displays, and amusements—Atget found not the simple evidence of a folk culture, but ellipitical quips, skits, and sketches from life. Droll, whimsical, ultimately ironic, these pictures possess the knowing deadpan humor of perspicacious social observation. Through the simpering expressions of mannequins and the sad elegance of sideshow decor, displays of housewares, old clothes, and surgical trusses, bookstalls and nightclub facades, the aspirations, needs, and fantasies of the Parisians emerged in telling and poignant disguise. From candid shots of street spectacles (Part I) and catalogs of the materials of vernacular culture (Part II), the Picturesque Paris series had become a mirror of modern man's moral physiognomy.

The evolution from visual report to metaphorical discourse took place throughout the work. During the last five years of his life, Atget saw his subjects as part of an overarching system of related meanings. His ideas about civilization and nature approached and mingled. He saw the city couched in the natural—Notre Dame appeared through the trees, Sacré Coeur disappeared in fog, the Luxembourg Palace was overrun with flowers—and in the country, where nature was normally sovereign, cultural relics and the photographer's memory imbued every landscape with history. The relatedness of life, art, and nature became manifest on all sides—in rain-glazed pavements, moldering stones, gleaming statues, window reflections, the enveloping fog and mist—indeed in every characteristic of Atget's late vision. Although structurally intact, the meaningful division of the collection into aspects of the land, historic civilization, and popular culture was dissolving from within.

As Atget drew closer connections between things in his last years, he softened the abrupt, edgy contrasts and unmitigated optical experimentation that had occurred in the immediate postwar period, with a scale of consonant middle tones expressing broad unities.[72] Similarly, his earlier vision of a world that stretched into deep space past separate, proximate, tangible objects now collapsed into a fused and flattened space where scarcely anything was clearly bounded or discrete. Atget bonded space to the surface of his pictures by catching it in filigreed branches and by condensing it on planes of glass and water. He muted distance in haze, mist, and light, blunted perspectives with broad compositional units of equal tonal weight, and blocked recession with large monolithic forms. He related things to their reflections, replaced parts of distant objects with analogously shaped parts of closer ones, and discovered everywhere affinities of form and attitude that telescoped, minimized, and parried spatial separation.[73]

Contrasted with the routine piecework of the middle career, the late work with its larger focus on whole perceptual fields makes us more conscious of Atget's original vision. This is as it should be—not because photographs of door knockers have less room for idiosyncrasies (they are there, but their expressive scale is narrower), but because more of Atget was in fact available and present in the late period. He was not only a man of broader experience and culture, but his work was also less inflected by the concerns of his clientele. Furthermore, at some level in his being the separation between life and photography had become permeable: photographic priorities helped rule daily habits and the pictures acquired an existential tenor. This development is so unlike practical workaday service that we are ill-equipped to deal with it. We can point to Atget's new formal strategies as adjustments to an imperative emotional need, and to his habits of rising before dawn and working in late winter as the dictates of his photographic program. But this does not explain the poetry—the allusive, meditative quality, and the absorption of discrete things into a broader continuum defined by and sensibly including the maker. We can account for the transmutation of facts into ether only by understanding the man's progressive assumption of the creator's role.

This extraordinary development did not accompany the adoption of a wholly new attitude or technique, but a gradual defection from what had been understood as photography's informational function. Having served those ends, albeit in unorthodox fashion, for thirty years, Atget had ingested the tradition too completely ever to reject it. He therefore continued to make documents in his preestablished areas of spe-

cialization, and if nothing distracted him, he could satisfy the normal requirements as well as he ever could.[74] However, he was very often pursuing other interests that compromised or enlarged documentary standards. Instead of legibly rendering a statue's expression, gesture, and volumes, as he might have done before the war, he often dispensed with these standards of order and clarity for a nebulous, obscure expression rich in mystery and inference.[75] He also recorded inflections too subtle and elusive to have any documentary value of a normative sort. His tenuous, elegant impressions of dawn light in the streets of Paris and across the ponds at Saint-Cloud are, even by Atget's lenient codes of documentary usefulness, ephemeral and superfluous.[76]

As documentary etiquette was clearly inadequate for Atget's late practice, what help, beyond the sustaining resources of his own method, could he enlist? While affinities between his photographs and Symbolist painting might suggest the support of that movement, this hypothesis is as unlikely as unnecessary, for the private pressures of Atget's own psychology were seeking a more expressive vehicle than traditional documentary language could provide. This put him in a position similar to that of fin-de-siècle artists trying to resurrect meaning from the residue of half a century of realism.[77] That he, like some of them, emptied much detail and incident out of his pictures and filled them with resonant atmosphere and silence instead does not imply the borrowing of a device but the independent winning of a comparable solution.

For the repeated treatment of his motifs Atget had the inescapable model of Claude Monet, who had been producing his highly acclaimed serial paintings since the photographer's career was young. The evident formal correspondences between certain of the paintings and some of Atget's photographs, as well as Atget's special interest in river scenes and water lilies and his fascination with the precise indication of time of day and season, all suggest a debt to Monet.[78] Similarly Atget's attention to Camille Corot's ponds and their soft, shimmery light could not have been uninformed by that painter's example.[79] Although Monet and Corot provided important referents, the extent of their effect is obscure; it is unlikely that Atget consciously emulated them, but their precedents may have served as inspiration, and almost certainly as confirmation of such artistic pursuits.

Beyond a degree of moral encouragement, however, and some suggestion of a terrain, Atget probably drew little from the example of painters. Unlike Pictorialist photographers who took over painterly themes and handling virtually wholesale,[80] Atget had no use for handling, and his themes were already established. His problem was not the acquisition of a style, but the ability to make intuitive perceptual acts that subsumed everything—personal experience, the specificity of the moment, and deep cultural knowledge—into pictures. For such intricate operations there were no guides, only fellow photographers, each of whom instinctively established his own bearings. Of his contemporaries perhaps only Alfred Stieglitz understood the photographer's problem in similar terms. Had his work been accessible, could Atget have seen in the American's intensely self-conscious artistry an illumination of *his* subject, delimited by the high walls of French heritage and the shape of French sensibility—and only reticently modulated by self-expression? Perhaps a territory so transparently objective yet sensibly subjective could only be charted intuitively and alone.

Indeed, much has been made of the solitary nature of Atget's existence. Certainly he spent most waking hours immersed in seeing and in reproducing his understanding of what he saw. However, the gravity of his undertaking has been misread as nostalgia, and the bittersweet melancholy of certain pictures, like the transcendent lyricism of others, has been presumed the equivalent of his mood. Yet the content of the art is not the emanation of pure feeling, but of infinitely complex associations of sentiments, ideas, and objective properties. Atget's private response, especially the keen transfiguring pleasure of the creative act, has disappeared into the photographs, retrievable only to the imagination that can construe the triumph from the difficulty of what was done.

M.M.H.

In addition to bibliographic references, the reader will find here notations of the plates and figures in the first three volumes of *The Work of Atget* that illustrate the issues discussed in the text. The abbreviation "diss." (followed by page numbers) is used in instances where the information or the line of argument is drawn from the author's dissertation: Maria Morris Hambourg, "Eugène Atget, 1857–1927: The Structure of the Work" (Columbia University, 1980).

1. "...étant donné l'immense production, faite par moi, par amour du Vieux Paris, plutôt que pour le bénéfice que cela me rapporte." Letter to Marcel Poëte, June 14, 1912. Diss., p. 482.

 "J'ai recueilli, pendant plus de 20 ans, par mon travail et mon initiative individuelle, dans toutes les vieilles rues du Vieux Paris, des clichés photographiques, format 18×24, documents artistiques sur la belle architecture. ... Cette énorme collection, artistique et documentaire est aujourd'hui terminée." Jean Leroy, *Atget, magicien du Vieux Paris* (Joinville-le-Pont: Pierre-Jean Balbo, 1975), n.p. Reprinted in "Eugène Atget, Portals, Passages, and Portraits," *Camera*, 57, no. 3 (Mar. 1978), p. 4.

 "These are simply documents I make." Reported by Man Ray in Paul Hill and Tom Cooper, "Interview: Man Ray," *Camera*, 54, no. 2 (Feb. 1975), p. 40.

2. Estimate based on number of known prints and evidence from numerical sequences of all series.

3. "Levy remembers that Atget would sell only duplicates or what he could easily replace in his albums, often not more than five or ten a day." David Travis, *Photographs from the Julien Levy Collection Starting with Atget* (Chicago: The Art Institute, 1976), p. 13. See also "Interview: Man Ray," p. 39, and diss., pp. 429–32.

4. Atget's use of the word "série" was extremely flexible. Sometimes he made a "nouvelle série" each year; for example, the Versailles pictures are stored in albums labeled "1ere série 1901," "2eme série 1902," etc. He also used the word to designate large sections of his collection of views of Paris (letter to City Council, 1902; diss., pp. 426–27). By about 1910 the growth of the work had made the variable usages of "série" so complex that Atget dropped the word and just numbered the albums in the series, for example, "Album no 12, Environs de Paris," or "Album no 3, Saint-Cloud." He never clarified the major and minor groupings, but the differences are pronounced and evident in the albums of the Abbott-Levy Collection, which have provided the names and evidence for the basic structure described below.

5. Occasionally, but very rarely, unnumbered photographs do turn up. We also note the briefest of Atget's series, begun in July 1915 and abandoned in August 1915: three photographs of the homes of illustrious Parisians, numbered 10, 11, and 12.

6. This essay is conceived as the complement to the biography of Atget that appears in Volume II of this book. When biographical facts appear here without source references, the reader may assume that he will find a fuller account in the biographical essay.

7. See Vol. II, Appendix B.

8. This account of the early organization is much simplified. The initial numbers of the six groups were probably 10, 200, 400, 600, 800, and 1100 (see chart for Landscape-Documents on p. 182). The miscellaneous pictures of models, soldiers, and portraits are numbered 1955, 2000, 2061, 2106, and 2109, and would seem to represent remnants of other groups in the original stock (Atget Archives, MoMA).

9. For the trees, see Vol. I, pls. 1, 8, 9 and fig. 1; for the three-quarter view, see Vol. I, pl. 2.

10. For the use of the sheet, see Vol. I, fig. 28; for backgrounds out of focus, see Vol. I, pls. 44 and 49; for the results of descriptive expedience, see Vol. I, pls. 5 and 7.

11. For conventional rendering, see Vol. I, pl. 14, figs. 8, 10, and 11; for unconventional rendering, see Vol. I, pl. 12.

12. Cf. Charles Bodmer, who worked in Barbizon in the 1870s and 1880s. Atget copied some of Bodmer's barnyard photographs, specifically his pictures numbered 182, 184, and 191, and incorporated them into his own catalog (Study Collection, Atget Archives, MoMA).

13. See Vol. I, pl. 103.

14. See Vol. I, pls. 20, 24, 35 and figs. 2, 5, and 6.

15. The reproductions are part of the Costumes–Religious Art series, which, although undated, appears to be the work of the postwar period. The photographs are in the Study Collection, Atget Archives, MoMA. For fur-

ther discussion of Atget's connections with the artistic community, see Vol. II, Biography, *passim*.

16. Traditional representations of the street trades of Paris in etching, aquatint, and lithography were the common heritage of visually educated Parisians, and Atget probably knew reproductions of the printed series of François Boucher, Carle Vernet, and others.

17. My understanding of these formal tendencies draws on Szarkowski (see Vol. I, p. 14).

18. For a more detailed discussion of Vieux Paris and Atget's place in it, see Vol. II, pp. 16–19 and 164–67.

19. The work of this period is illustrated in Vol. II, pls. 3, 18, 26, 42, 48, 61, 63, 64, 84, 87, 94, 95 and figs. 2, 18, 33, 38, 45, 48, 63–66, 75. We do not yet know which guidebooks Atget consulted during this early period, but he used the Marquis de Rochegude's pocket guide, *A Travers le Vieux Paris*, after its publication in 1903.

20. See Vol. II, pl. 45 and figs. 33, 48, 64; also diss., p. 322.

21. See Vol. II, figs. 18 and 38.

22. *Procès-verbal de la Commission du Vieux Paris* (June 2, 1898), p. 37; (Oct. 6, 1898), pp. 26–29.

23. While Cain definitely concentrated on Atget's photographs of decorative art, he did not limit his purchases exclusively to them.

24. Prior to this, Atget's sales to the museum were handled by the print dealer Danlos, for reasons still not entirely clear. *Registre d'Entrée*, vol. 1 (1881–99) and vol. 2 (1899–1916), Print Room, Carnavalet, Paris. Secondary confirmation of Cain's firsthand acquaintance with Atget's work is provided by Atget in his letter of November 19, 1902, to the Victoria and Albert Museum (Atget Archives, MoMA). In the interest of soliciting business, Atget cited Cain as a reference who would vouch for the quality of his photographs.

25. Atget is not among the photographers cited in the register of negatives made for the Commission. Furthermore, in the minutes of their monthly meetings, his name appears only three times, twice because he had photographed buildings, since destroyed, of which the Commission owned no pictures. In 1908 he gave a photograph to the Commission to illustrate the Commission's report, and in 1916 he sold a second one for the same purpose. The other mention was incidental: in 1902 Atget had petitioned the City Council for support of his photography of Old Paris; the Council referred his request to the Commission, where it was naturally tabled, the Carnavalet already owning the work in question. For full documentation see diss., pp. 199–200.

26. For example: "La réproduction devrait comprendre, autant que possible, le portail de pierre, et il serait indispensable d'obtenir l'authorisation de laisser la porte fermée." *Procès-verbal* (Dec. 7, 1899), p. 355.

27. Atget used the terms "Petits Environs" and "Grands Environs" in his letter of November 19, 1902, to the Victoria and Albert Museum (Atget Archives, MoMA). For his special fondness for the suburbs to the south, see Vol. I, p. 153.

28. Of the early examples dating from the end of the Ancien Régime, the preeminent one was Dezallier d'Argenville's *Voyage pittoresque des environs de Paris; ou description des maisons royales, châteaux . . .* , which enjoyed many editions between 1755 and 1779. The tradition was continued in the nineteenth century by numerous albums of lithographs—to name but one example, *Paris et ses environs, grand album*, published by Martinet in Paris in 1861 with plates by Jacottet, Benoist, and others. There were also albums of original photographs, although not many; of these the noteworthy example is Louis Robert's *Souvenirs de Versailles*, published by Blanquart-Evrard in 1853. By the 1890s the publication of hundreds of guides for hikers and bicyclists (and later for automobilists) encouraged the growth of the photographic firms, exemplified by Etienne and Antonin Neurdein.

29. Atget in fact complained of the restricted market for the Environs photographs in a letter dated March 28, 1903, to the Victoria and Albert Museum (Atget Archives, MoMA). He did manage to sell the pictures to the Bibliothèque Historique and the Carnavalet, as well as to the architect Destailleur (see Vol. II, p. 37, note 48).

30. See Vol. I, pls. 10, 74, 79, 84, 93 and fig. 52.

31. See Vol. I, pls. 4, 11, 26, 55, 63, 67, 75, 83, 87, 88, 94, 102, 106 and fig. 50.

32. For tonal massing, see frontispiece; for formal mimicry, see pls. 22, 81, 105; for surface congruence of near and far, see pls. 2, 4, 9, fig. 9, and Vol. II, pl. 111.

33. See Vol. I, pls. 109, 114, 115, 119 and figs. 77 and 78.

34. See pl. 59 and Vol. II, fig. 21; and for Versailles, pl. 31.

35. See Vol. I, pls. 57, 61, 95, and 97; Vol. II, pl. 44; and this volume, pls. 25, 82, 91, 117.

36. Although initially quite different in scope, Topography and Art in Old Paris grew closer toward the war as Atget increasingly disregarded their narrow premises for his own broader, scenic art. When the war was over, Atget began filing in Topography; but soon deciding better, he closed that file and put all new work in Art in Old Paris. See below, p. 24.

37. From a flier titled "Avertissement" pasted on the cover of *Paris au temps des romantiques* (Paris: La Bibliothèque et les Travaux Historiques de la Ville de Paris, 1908), in the copy in that library.

38. Until Marie de Thézy's definitive work on Marville appears, see her essay in *Charles Marville, photographe de Paris de 1851 à 1879* (Paris: Bibliothèque Historique de la Ville de Paris, 1980) and my essay in [Jacqueline Chambord], *Charles Marville, Photographs of Paris 1852–1878* (New York: French Institute/Alliance Française, 1981).

39. Diss., p. 287.

40. Emonts was already photographing in 1865 and had worked for the city since 1869 (de Thézy, pp. 52–53). He was not listed in the *Annuaire-Almanach du Commerce* (Didot-Bottin) after 1905.

41. In its first year (1906) the series was not clearly defined as being the special prerogative of the library. With a few exceptional sales to the Bibliothèque Nationale, the series was made for and sold only to the Bibliothèque Historique de la Ville de Paris between 1907 and 1912. See diss., pp. 237–39 and 269–70.

42. For example, the district between Saint-Nicolas-du-Chardonnet and the Jardin des Plantes, the area around and including the Hôpital de la Pitié, and the area between the Institut and the Boulevard Saint-Germain. All photographs were taken in the first through seventh *arrondissements*.

43. In the Abbott-Levy Collection there are five "Motifs Décoratifs" albums and one copy of the maquette, rebound by Berenice Abbott. The other copy, bought from Atget by an architect and now in a private collection in Paris, retains its original binding and is stamped with the Roman numeral I on the spine, suggesting the first of several volumes. The projected second album may well be the one whose pages are now dispersed in the topography boxes at the Musée Carnavalet, titled *Vues de Vieux Paris* (acquisition no. 7468, June 11, 1910).

44. The street scenes and *Petits Métiers*, part of the first lot of Atget's pictures bought by the Bibliothèque Nationale in 1900 (acquisition no. 6100), were arranged in an album called *La Vie à Paris*. Of the albums subsequently acquired, all but one followed the topical organization of the interiors album; the exception was *Signs and Old Shops of Old Paris*, which was composed of pictures culled from the Art in Old Paris series (acquisition no. 7915, May 1913).

45. The Abbott-Levy Collection contains this material, and much of it was also bought by the Musée Carnavalet. The Bibliothèque Historique de la Ville de Paris owns most of the photographs, not in albums, however, but mounted on cards.

46. See Vol. II, text and illustrations, pp. 19–25.

47. In 1982 the Musée Carnavalet published a facsimile of this album; in the accompanying essays and notes Margaret Nesbit and Françoise Raynaud dissect in detail the contents and significance of the album.

48. In putting together photographic essays, it is common practice for a photographer to raid his own stores for relevant pictures to begin the new undertaking. Atget was thorough in this practice and even changed the negative numbers of his older photographs to correspond with the new sequence. For examples, see Appendix, list of exceptions for Picturesque Paris, Part II, p. 184.

49. For an exhaustive study of the albums, see Margaret Nesbit's dissertation "Atget's Seven Albums in Practice" (Yale University, 1983).

50. I would like to thank Professor Richard Brilliant for directing my attention to Karlheinz Stierle's article "Baudelaire and the Tradition of the Tableau de Paris," *New Literary History*, XI, no. 2 (1980), pp. 345–61.

51. Atget retained the negatives of the courtyards when he sold the bulk of his Art in Old Paris in 1920. He arranged the prints into an album, copies of which he sold to the Carnavalet in January 1922 (acquisition no. 10916), and to the Bibliothèque Nationale, also in 1922 (acquisition no. 8805). These were not bound albums, but simple, homemade albums in paper wrappers.

52. Interestingly, Poëte was of this opinion too, but whether he formed it from Atget's experience and pictures or commissioned the pictures to prove his opinion, we do not know. He said of the Tuileries, "Le jardin n'est plus qu'un corps mort, allongé sur une terre pleine

d'histoire." *Au Jardin des Tuileries*, in the series "Paris: La Vie et son cadre" (Paris: A. Picard, 1924), p. 353.

53. "In reply to my question Atget answered that he never took pictures on assignment because 'people did not know what to photograph.'" Berenice Abbott, *The World of Atget* (New York: Horizon Press, 1964), p. ix.

54. For example, beginning in July of the following summer, he made selections from the series and sold them to the Musée Carnavalet under the title "Vieux Paris, coins pittoresques et disparus."

55. See Vol. I, pl. 89 with accompanying note and figures, and pl. 92, as well as Vol. II, pls. 74–77, and note to pls. 76 and 77.

56. See Vol. I, pls. 40, 41, and accompanying notes and figures, and this volume, pl. 53 and fig. 27.

57. In addition to Vol. I, pls. 89, 92 and fig. 63, see Vol. II, pl. 83, and this volume, pl. 40.

58. See Vol. II, pls. 4, 11, 27, 82 and figs. 26 and 78, and this volume, fig. 25.

59. See Vol. I, pls. 50, 69, 96, 98, 100, 111, and this volume, pls. 50, 70, 72, and fig. 22.

60. See Vol. II, p. 29. All of the 2,621 negatives Atget sold concerned Old Paris. Most were from the Art in Old Paris series, plus a few (bridges and fortifications) from Part II of Picturesque Paris, and several from Topography and Tuileries. He retained the negatives concerning themes on which he would continue to work; these principally belonged to Landscape-Documents, Environs, and Picturesque Paris.

61. For surprising light and shadow effects, see Vol. I, pls. 52, 116, 120, and this volume, pls. 44, 73, 74, 90, 91, and 94. For a good example of unexpected dissociation of elements usually related, in this case a garden vase and alley, compare pl. 95 and fig. 44.

62. See Vol. II, pls. 93, 98 and figs. 72 and 75. The two copy prints appear on the list of exceptions as AP:6428 and 6429, Rue des Saules and Rue Saint-Vincent, respectively. The negatives for these pictures had been sold to the Monuments Historiques in 1920.

63. See Vol. I, pls. 19, 32, 36, 46, 58, 97 and figs. 29 and 53.

64. The change was not a renouncement but a shift of emphasis; Atget did not give up decorative motifs altogether, but did not pursue them as his first order of business. See Vol. II, frontispiece, note to pl. 4, and fig. 39, and this volume, pls. 16, 65, 96 and figs. 35 and 47.

65. For examples of early picturesque views, see Vol. II, pls. 84, 95 and figs. 33, 34, 48, 63–66, and 75.

66. The latter-day picturesque is copiously represented here; among the many examples we note Vol. I, pls. 57, 91, 97, and 101, and Vol. II, pls. 8, 9, 50–55, and 97–101. To see clearly the difference between Atget's early and late picturesque visions of the same place, compare Vol. II, pl. 67 and fig. 48, or pls. 70 and 87.

67. In the fourteen years between 1900 and 1914, Atget made about one hundred photographs for the series (LD:647–755), whereas in the seven years between 1915 and 1922 he made over two hundred (LD:756–800, 900–1076).

68. Atget's interesting solution to his catalog problem ultimately proved impractical. When he set up the subseries, he had reached 1147 or 1148 in the Landscape-Documents sequence. He numbered the first picture in both the Versailles and Saint-Cloud subseries 1148, and as a result their sequences proceeded parallel with that of Landscape-Documents. The triplication of numbers evidently proved so confusing that Atget gave his last two subseries (Sceaux and Parisian Parks) independent sequences starting with 10.

69. For a more complete account, see Beaumont Newhall's notes for an interview with Dignimont (Atget Archives, MoMA) and Vol. IV.

70. See Vol. I, pls. 17 and 33.

71. This will be illustrated, together with the first two parts of the series, in Vol. IV.

72. Compare Vol. I, pls. 116 and 117, and this volume, pls. 76 and 77. See also Vol. II, note to pl. 92. While the late work frequently dwelled in the broad middle area of the tonal range, strong contrasts of extremely light and dark tones occurred when Atget shot into the light (e.g., Vol. I, pls. 80, 95, 101; Vol. II, figs. 19, 20; and this volume, pls. 24, 61, 82).

73. These characteristics are so prevalent it suffices to page through the plates of this volume for illustrations of them.

74. Most of the photographs Atget made of the Grande Cascade at Saint-Cloud in 1923 are good examples of straight, workmanlike documentation.

75. Compare pls. 24, 117, and 118 to frontispiece, or to Vol. II, pl. 13.

76. See Vol. II, pls. 44, 52–55, 90, 100, 101, and this volume, pls. 84–91.

77. Among the painters whose works sometimes approached Atget's views are Charles Cottet (1863–1924), William Degouve de Nuncques (1867–1935), Charles-Marie Dulac (1865–1898?), Fernand Khnopff (1858–1921), and Charles Lacoste (1870–1959). In the case of each artist it is not the entire oeuvre that resembles Atget's, but particular paintings or groups of paintings (especially landscapes and cityscapes such as Khnopff's scenes of Bruges) that share a style or mood similar to that of certain late photographs of Atget.

78. Perhaps the closest parallels between the paintings and the photographs are between the series of "Mornings on the Seine" that Monet painted just before the turn of the century and Atget's river and pond reflections; specifically, compare *Morning on the Seine, near Giverny*, 1897, in the Metropolitan Museum of Art, New York, and pl. 91 in this volume or pl. 101 in Vol. I.

79. See Vol. I, pls. 104–07 and accompanying note.

80. A good compendium of French and European pictorialism is Robert de la Sizeranne's *La Photographie est-elle un art?* (Paris: Hachette, 1899).

Plates

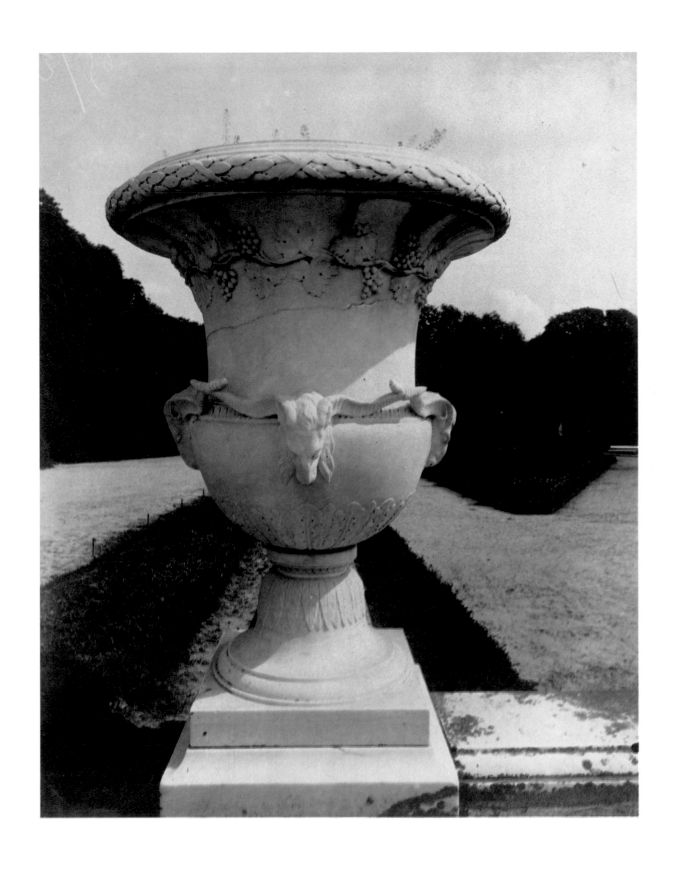

Pl. 1. Versailles, vase. (1905)

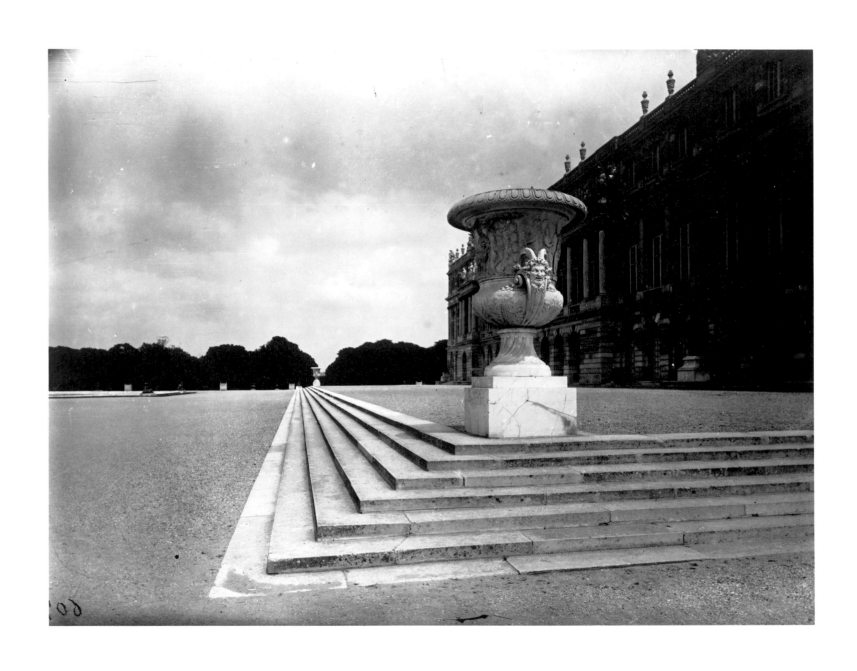

Pl. 2. Versailles, parc. (1901)

Pl. 3. [*Petit*] *Trianon.* (*1902*)

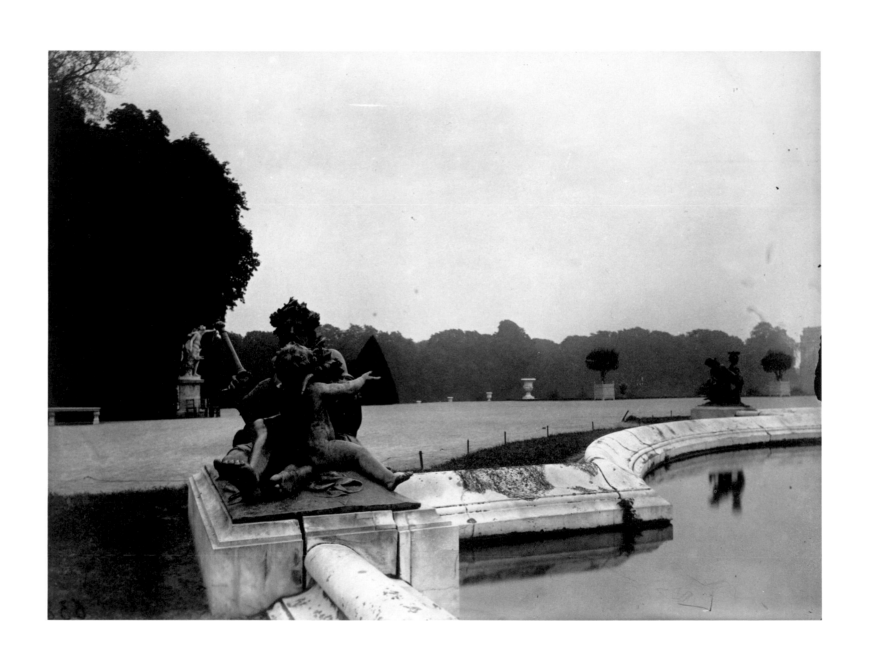

Pl. 4. Versailles, parc. (1902)

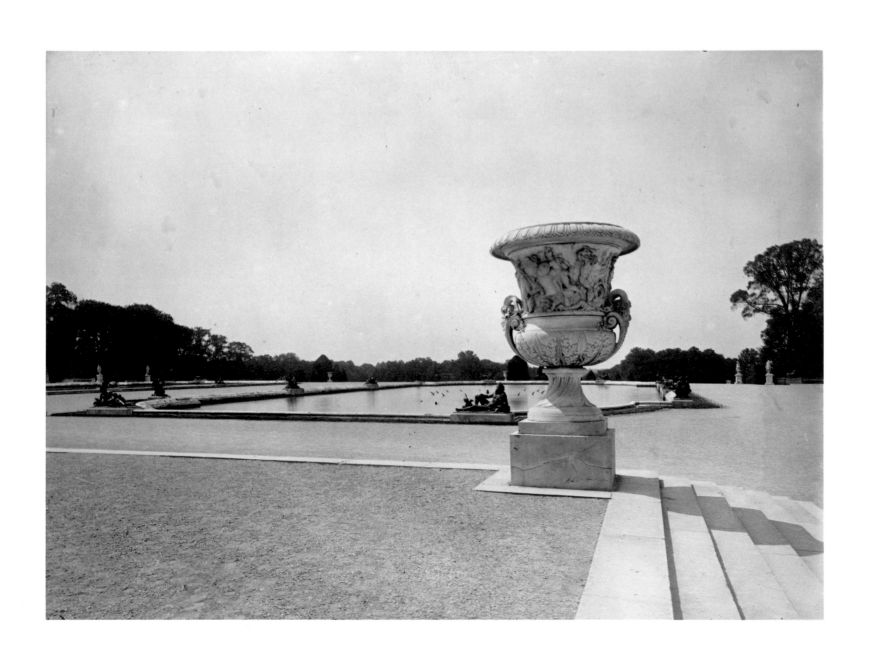

Pl. 5. Versailles, parc. Juillet 1901

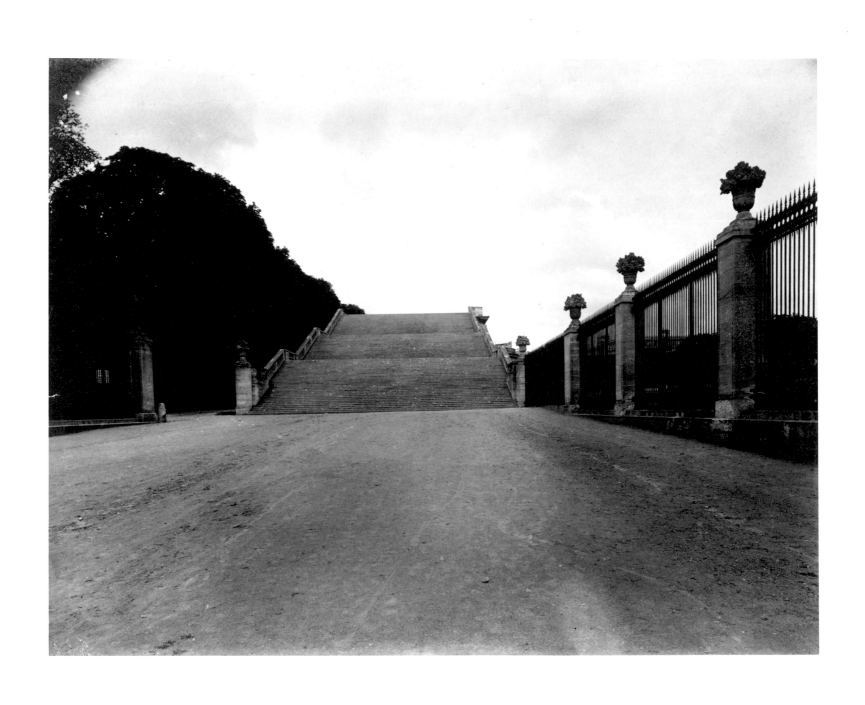

Pl. 6. Versailles, escalier de l'Orangerie, 103 degrés, 20 mètres de largeur. Juillet 1901

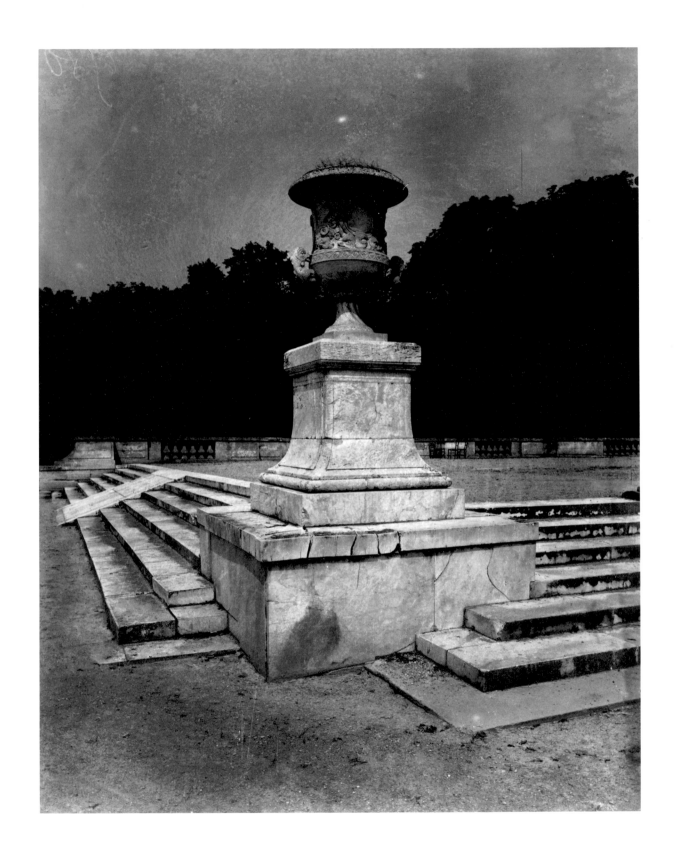

Pl. 7. Versailles. (1905)

43

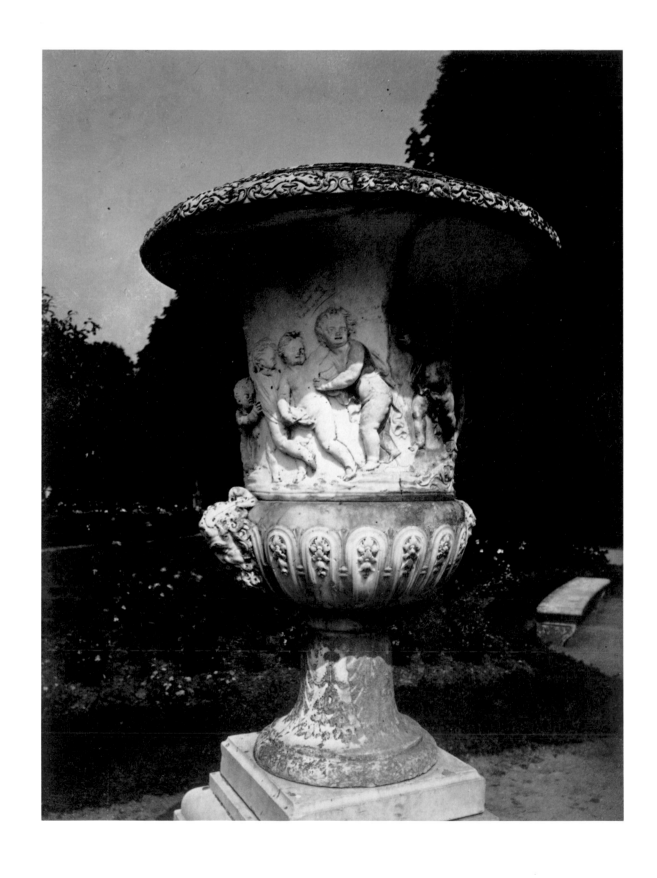

Pl. 8. Versailles, vase. (1905)

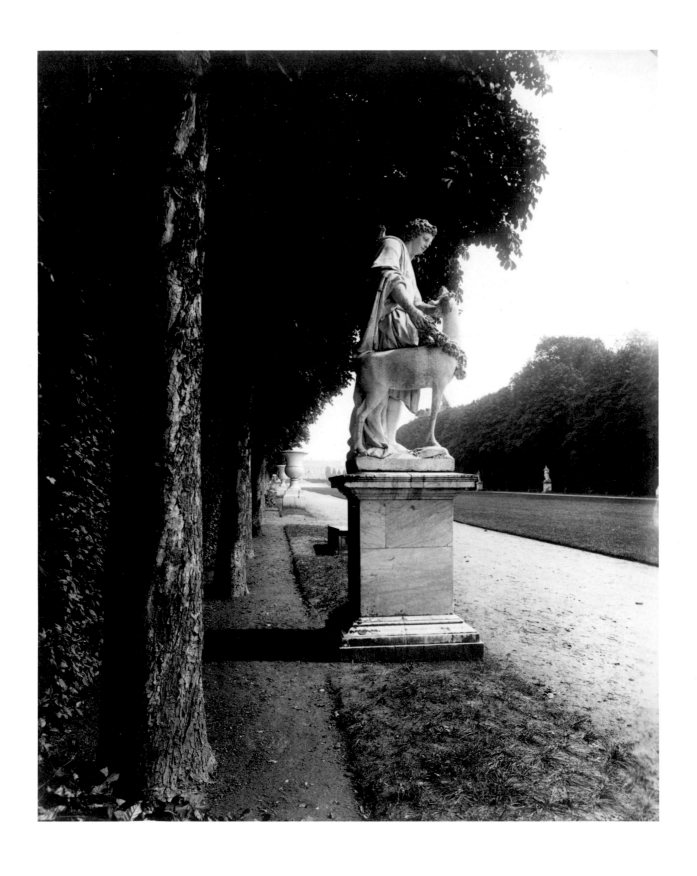

Pl. 9. Versailles, Cyparisse par Flamen. (*1902*)

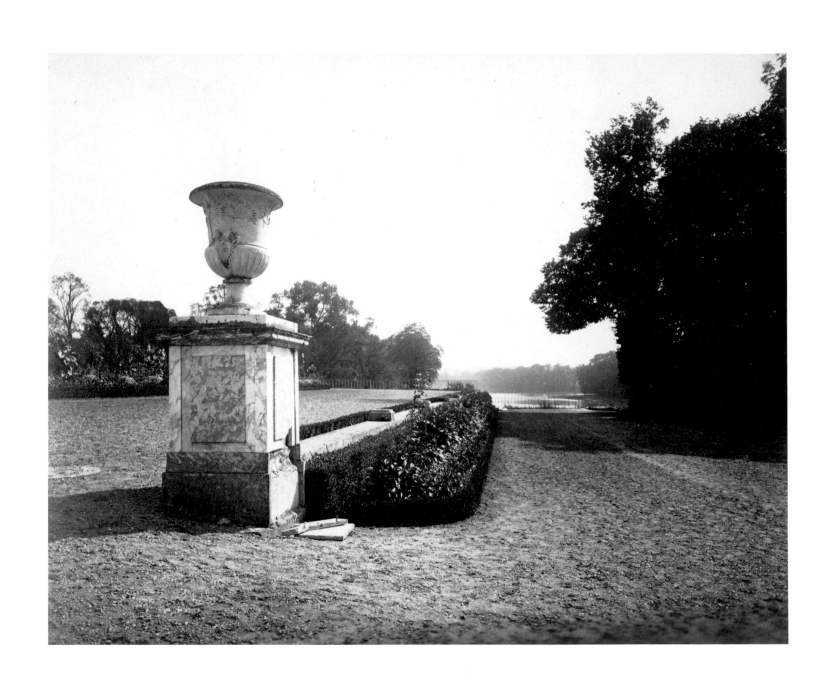

Pl. 10. Trianon. 1901

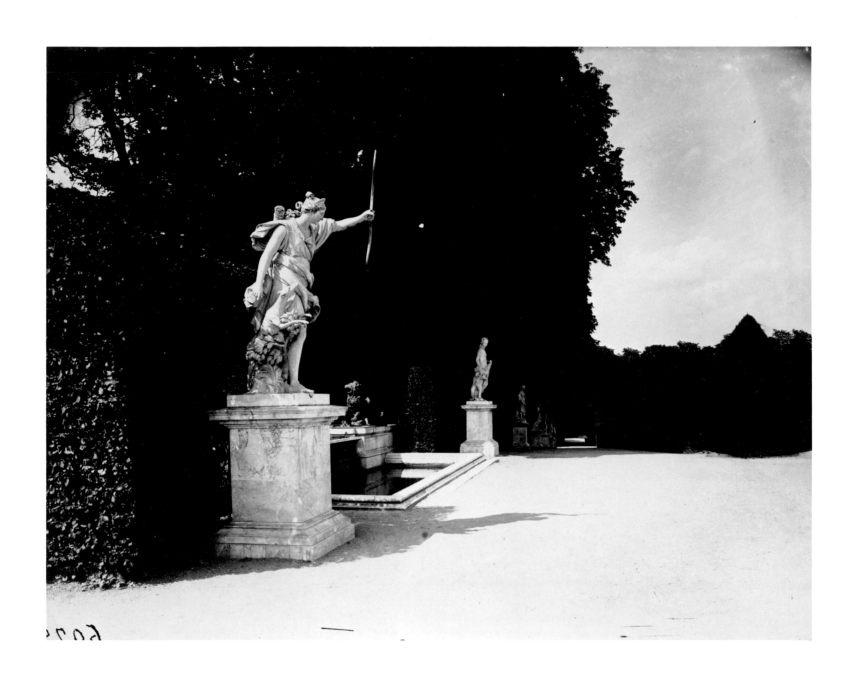

Pl. 11. Versailles. (1901)

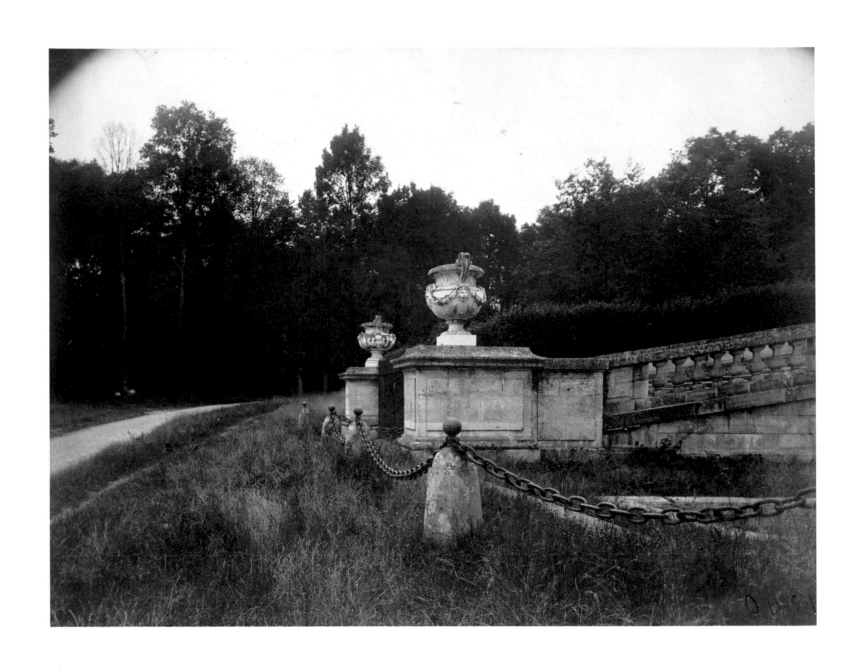

Pl. 12. Grand Trianon. (1923–24)

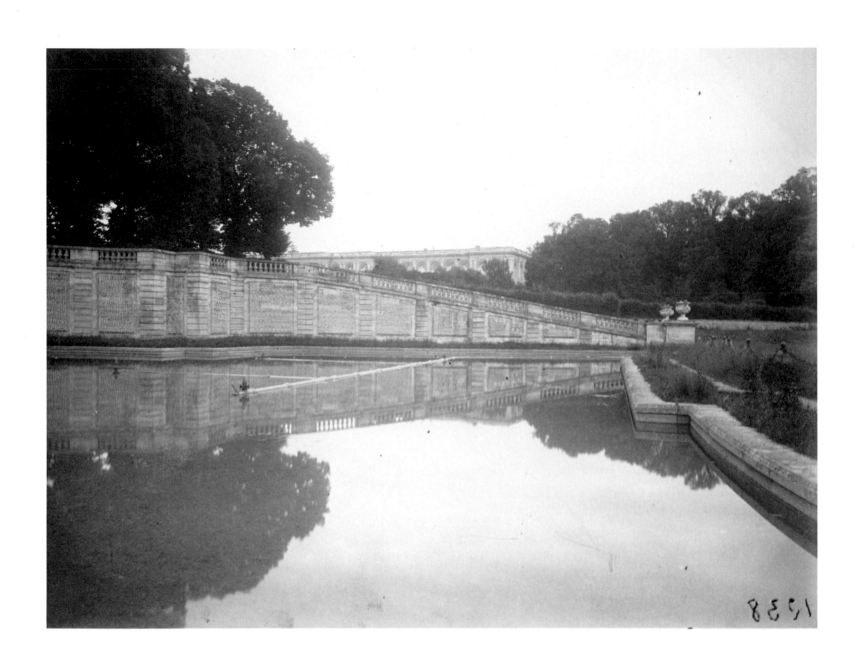

Pl. 13. Trianon. (1923–24)

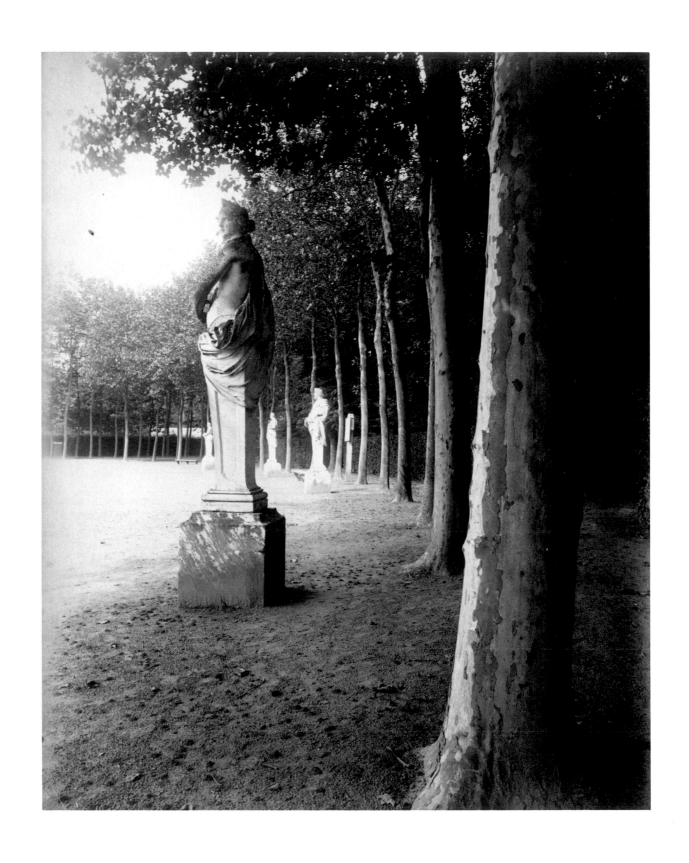

Pl. 14. Versailles, parc. (1902)

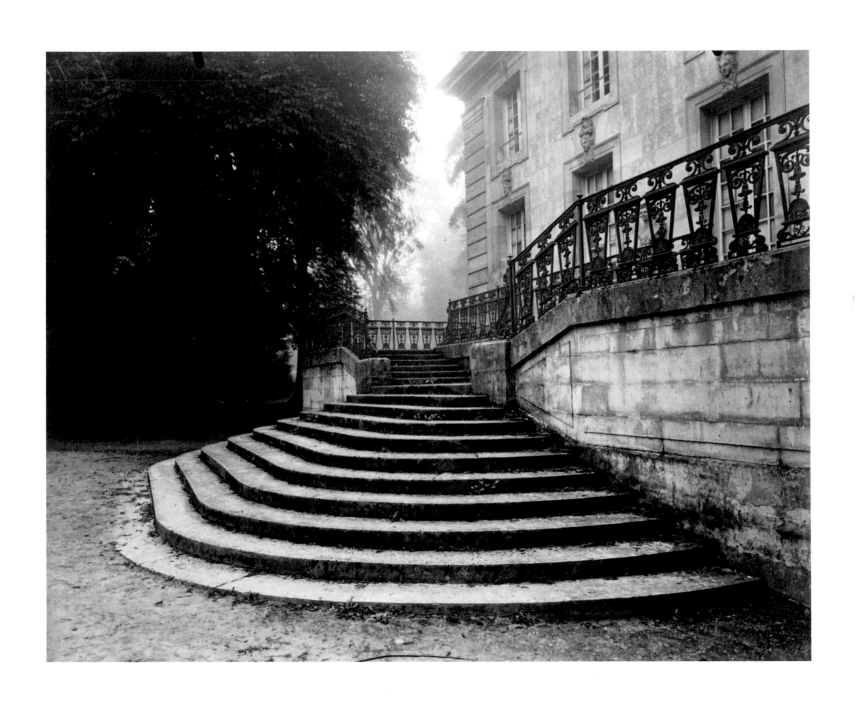

Pl. 15. Grand Trianon. (1923–24)

Pl. 16. Versailles. (1922–23)

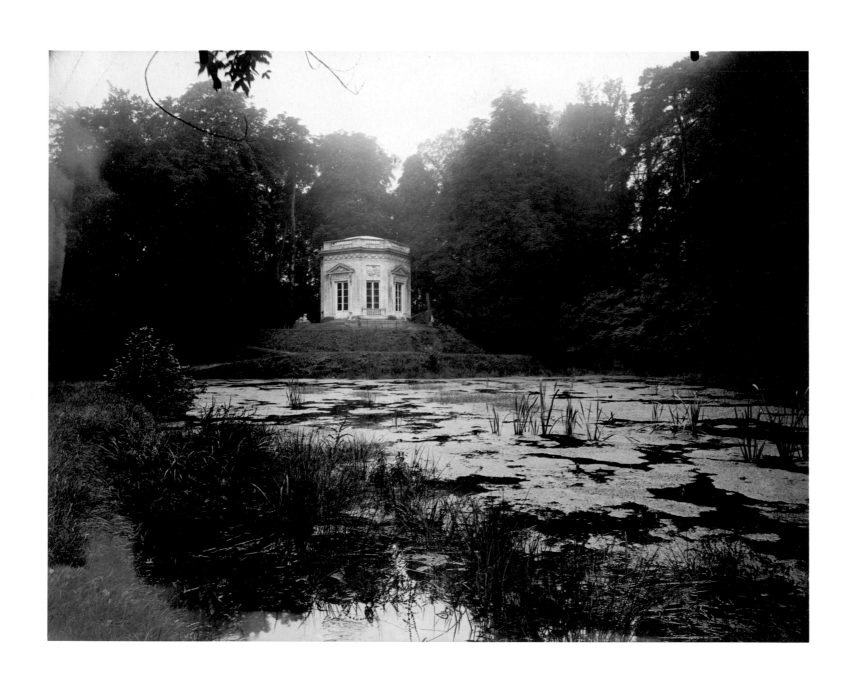

Pl. 17. Grand Trianon, Pavillon de musique. (1923–24)

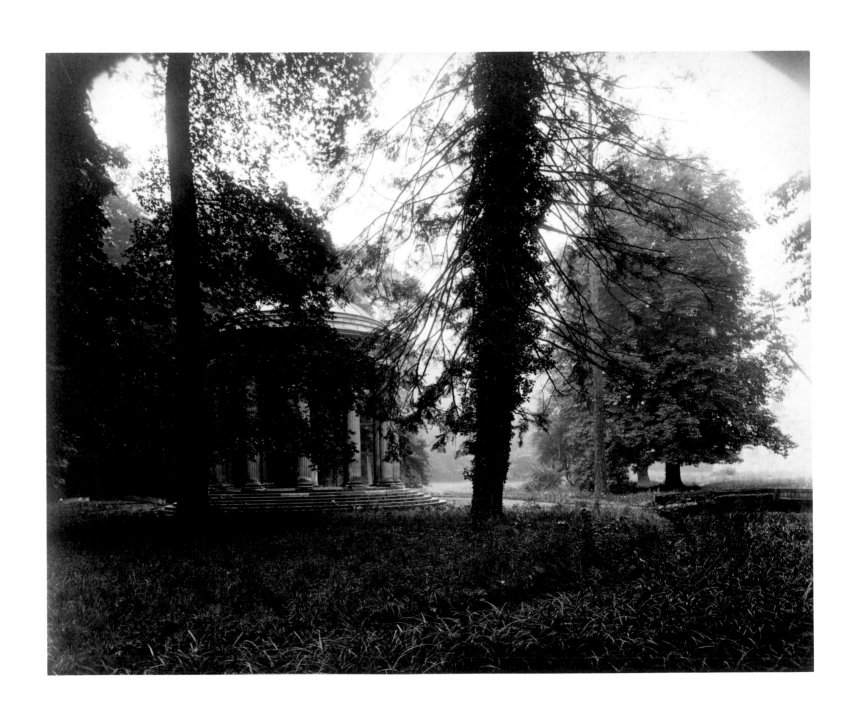

Pl. 18. Grand Trianon, Le Temple de l'Amour à travers les arbres. (1923–24)

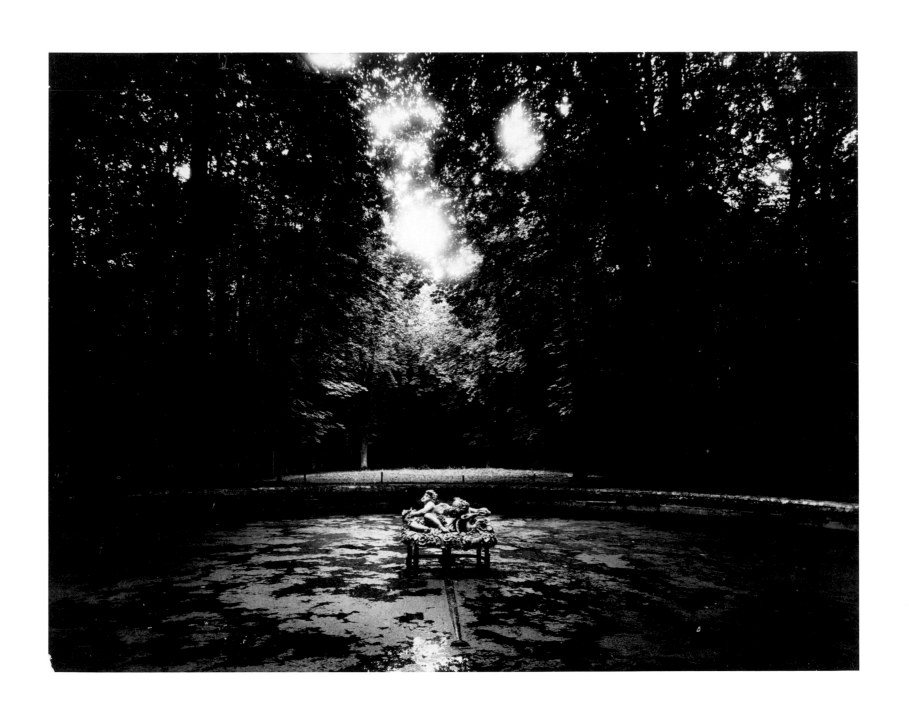

Pl. 19. Trianon. (1926)

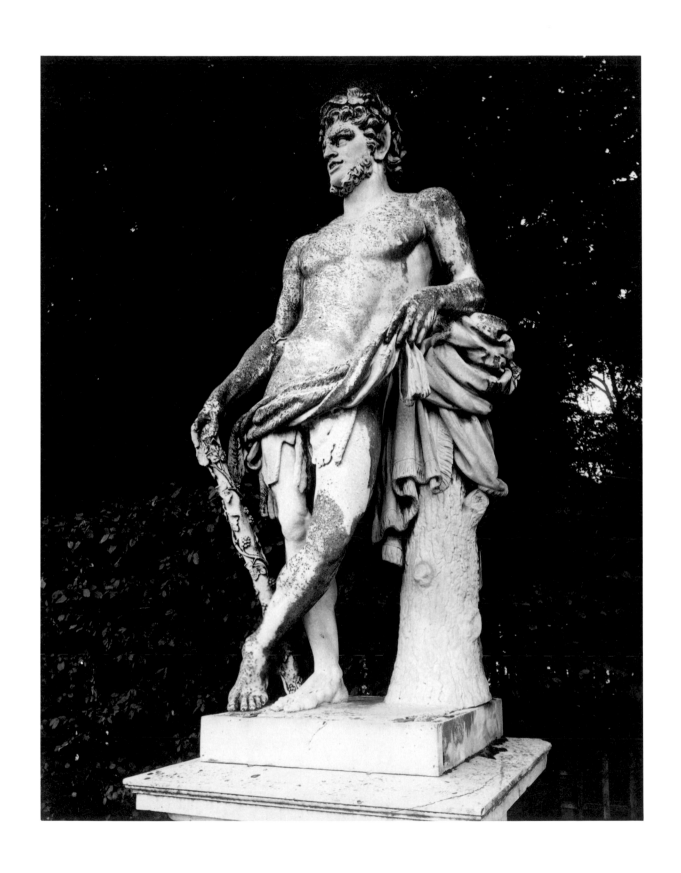

Pl. 20. Versailles, Poème Satirique. (1923–24)

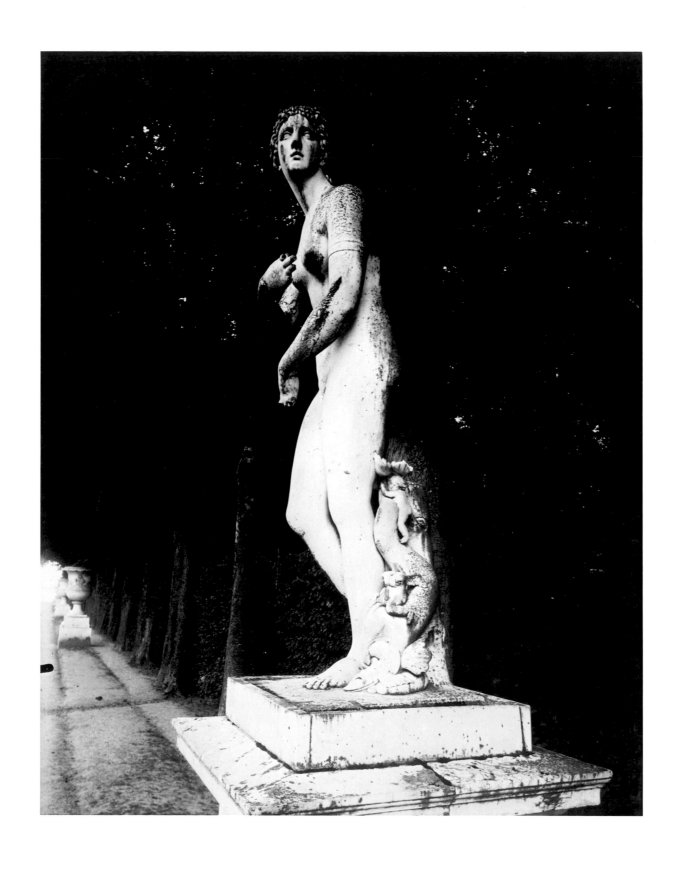

Pl. 21. Versailles, Vénus par Legros. (1923–24)

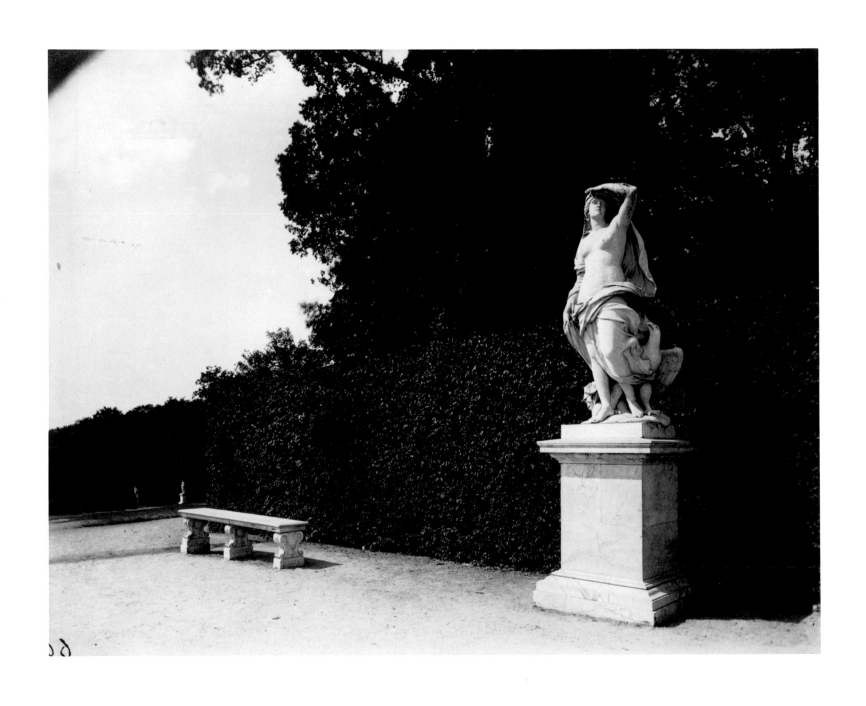

Pl. 22. Versailles, parc. (1901)

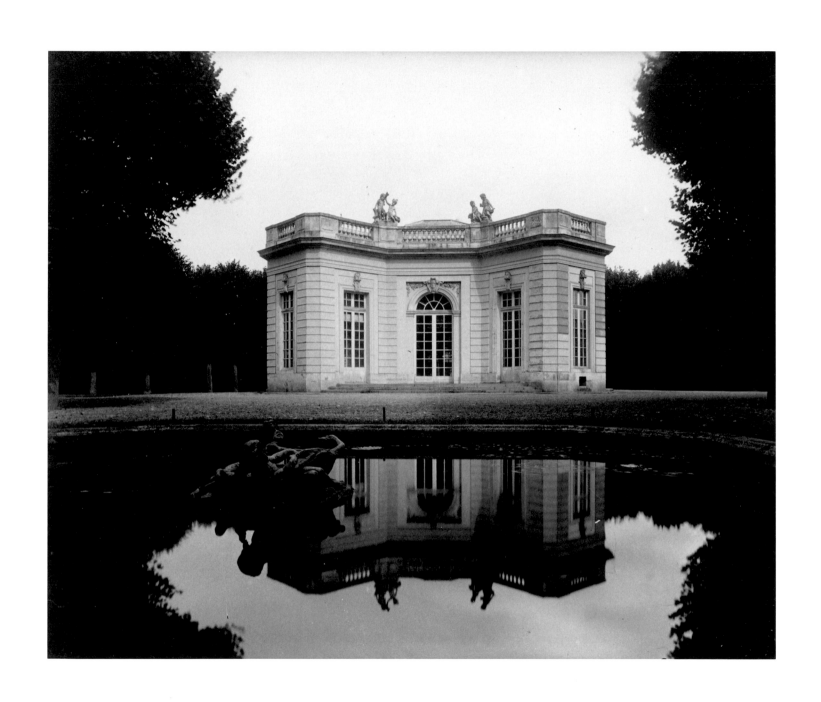

Pl. 23. [*Petit*] *Trianon* [*Pavillon Français*]. (*1923–24*)

Pl. 24. Trianon. (1923–24)

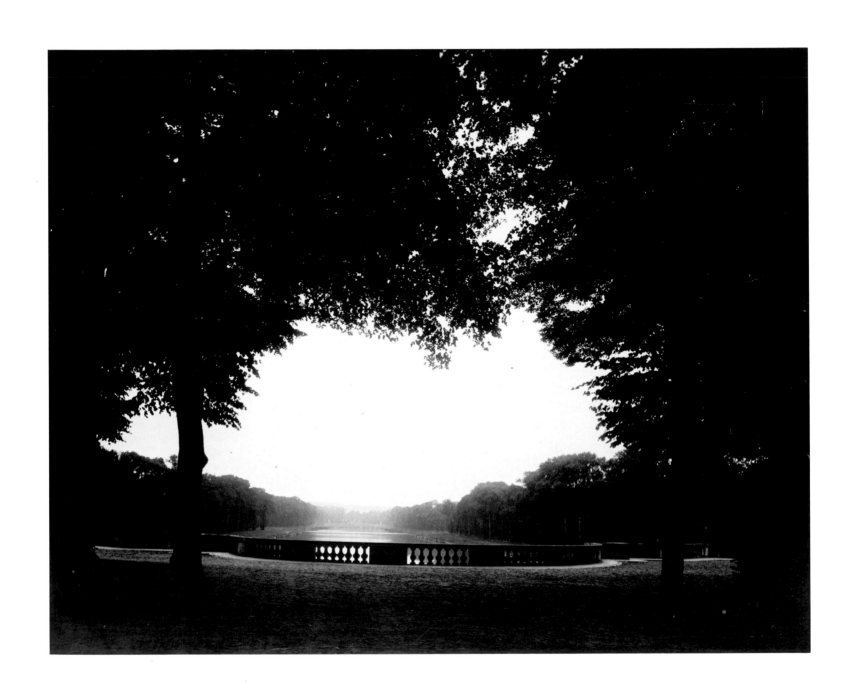

Pl. 25. Grand Trianon. (1924–25)

Pl. 26. Versailles, vase. (1905)

Pl. 27. Versailles, vase (détail). (1906)

Pl. 28. Versailles, vase (détail). (1906) *Pl. 29. Versailles, vase (détail).* (1906)

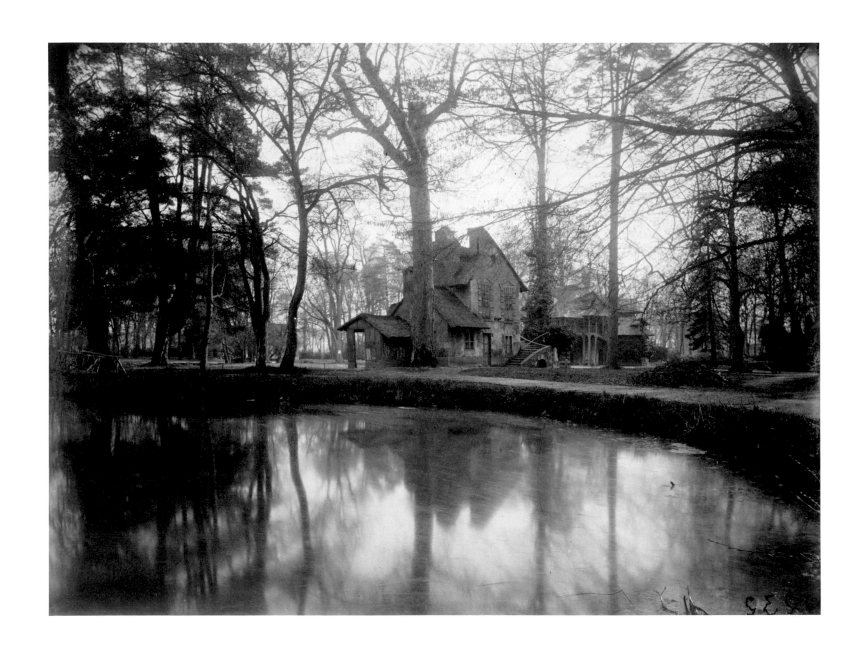

Pl. 30. Petit Trianon [Hameau]. (1923–24)

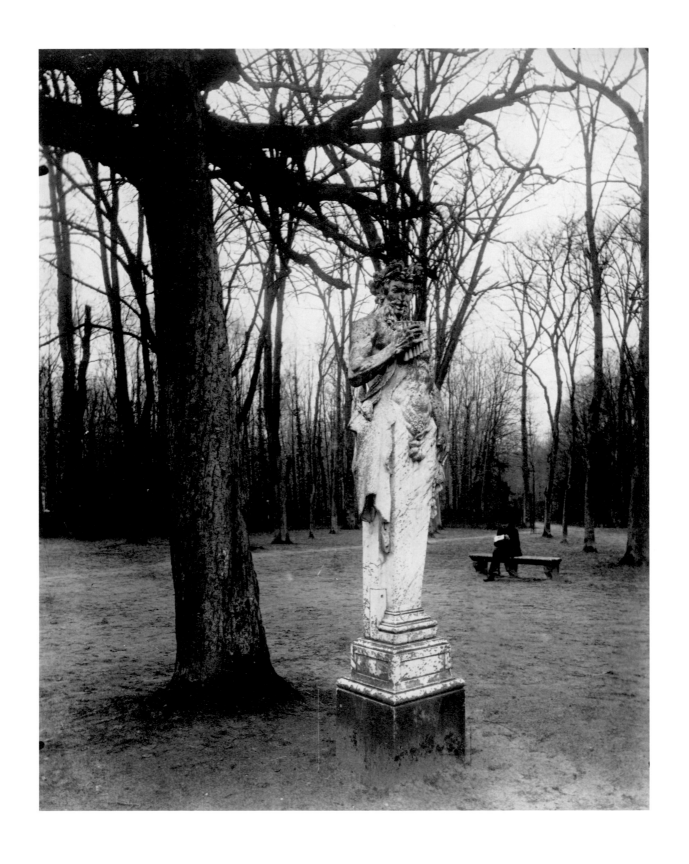

Pl. 31. Versailles, parc. (1906)

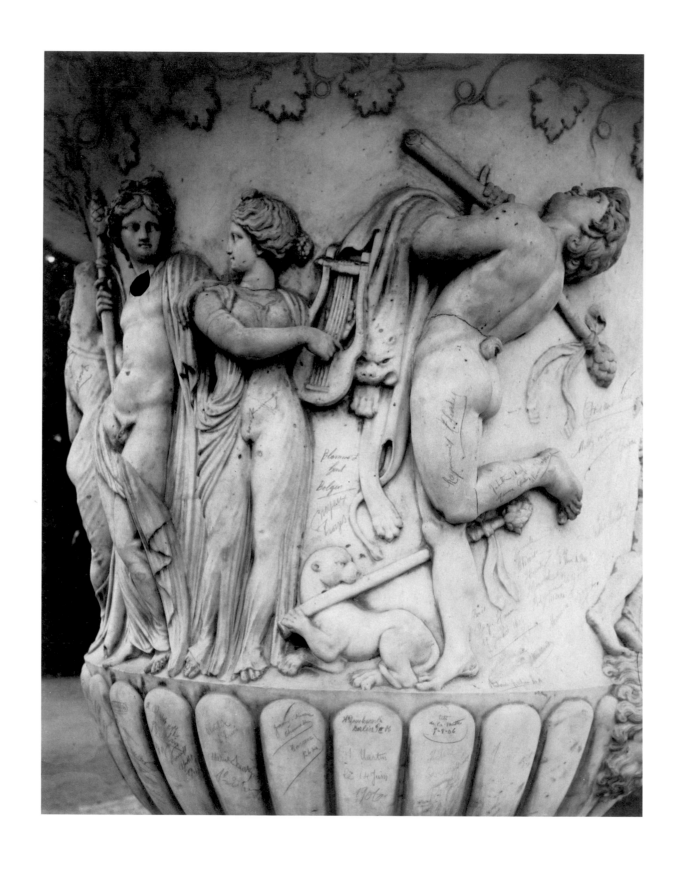

Pl. 32. Versailles, vase (détail). (1906)

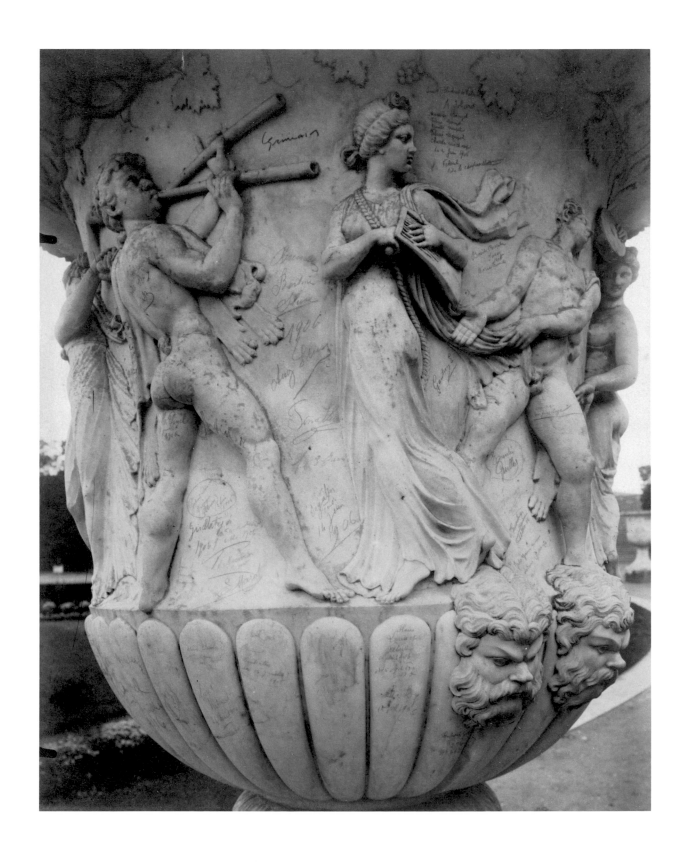

Pl. 33. Versailles, vase (détail). (1906)

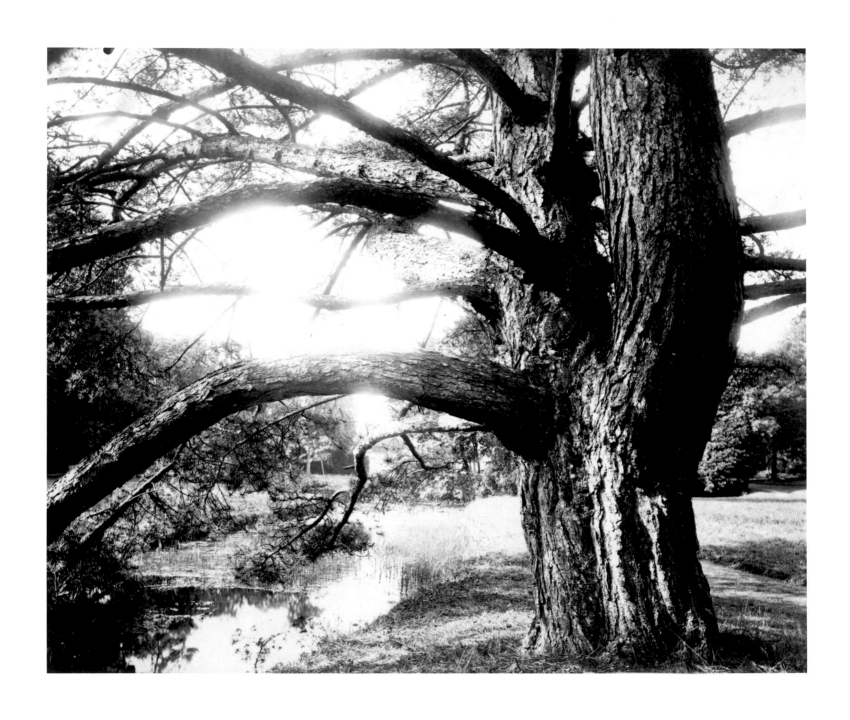

Pl. 34. Trianon. (1910–14)

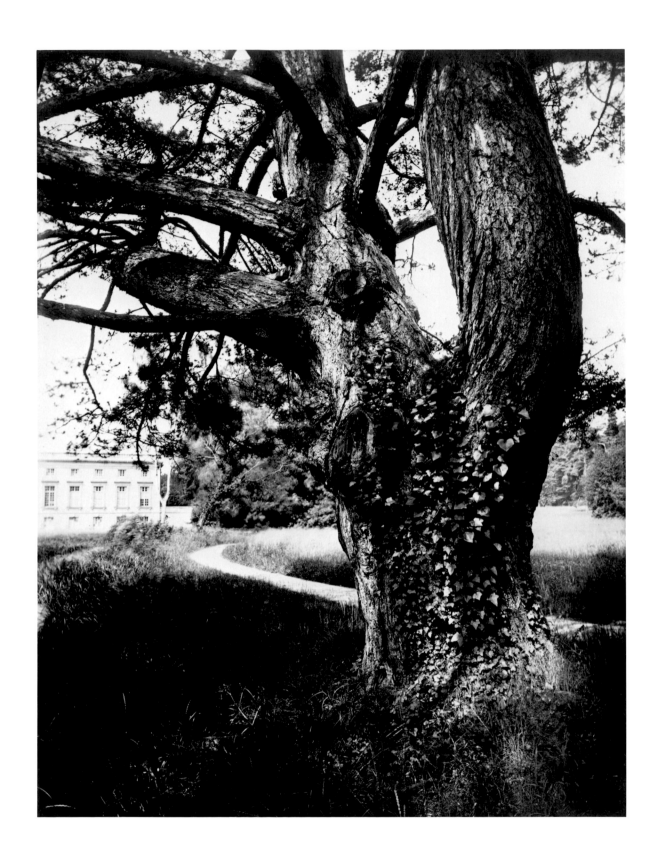

Pl. 35. Arbre, Trianon. (1919–21)

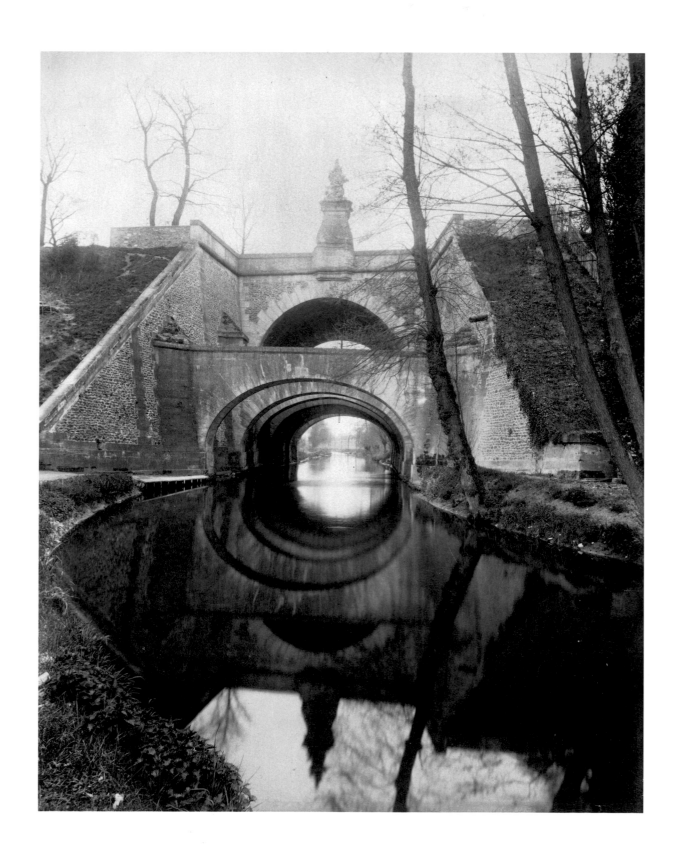

Pl. 36. Juvisy, Pont des Belles Fontaines. (1902)

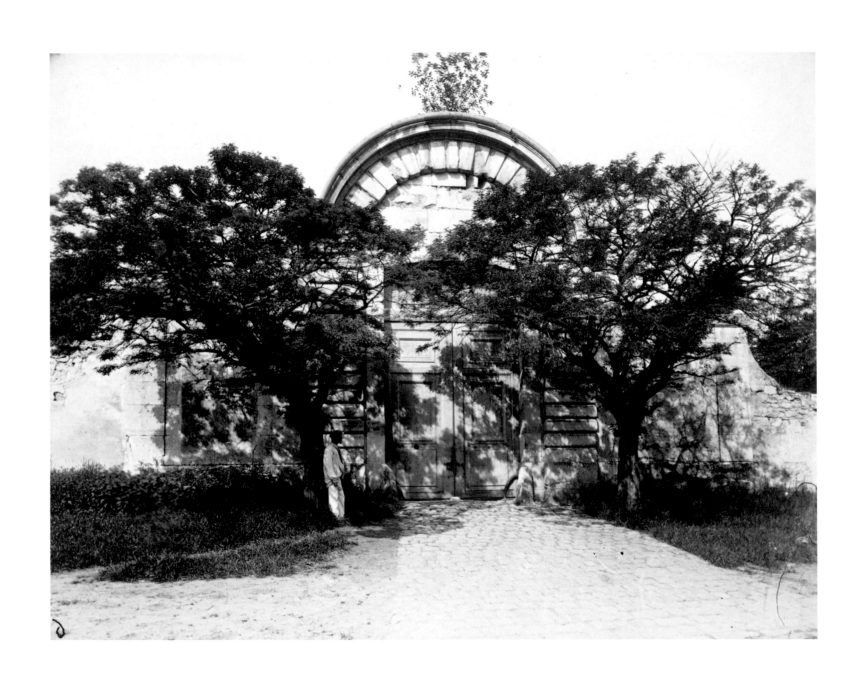

Pl. 37. Meudon, ancien château. (1902)

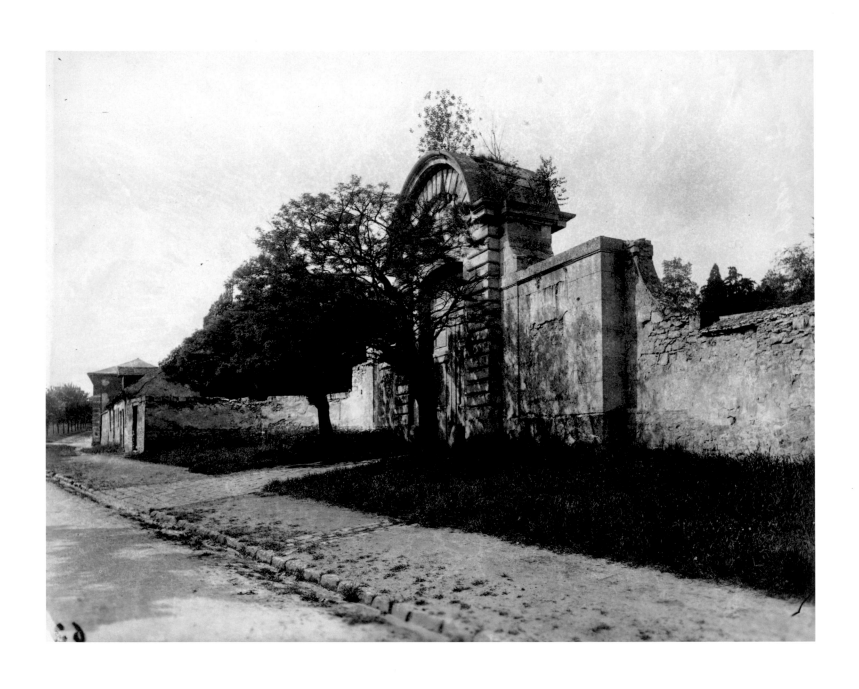

Pl. 38. Meudon, ancien château. (1902)

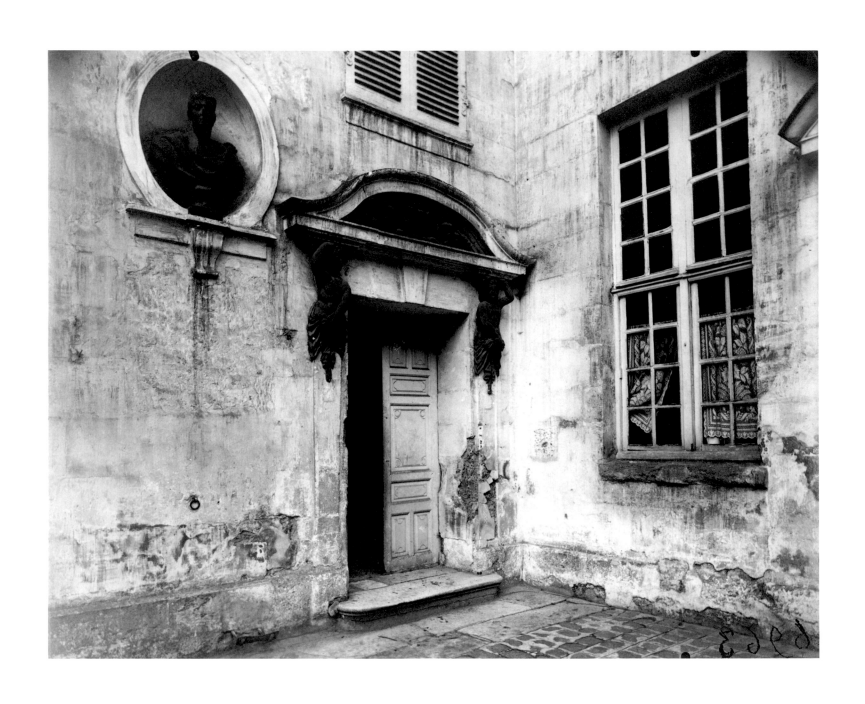

Pl. 39. Crépy-en-Valois, vieille demeure XVI^e siècle. (August 1921)

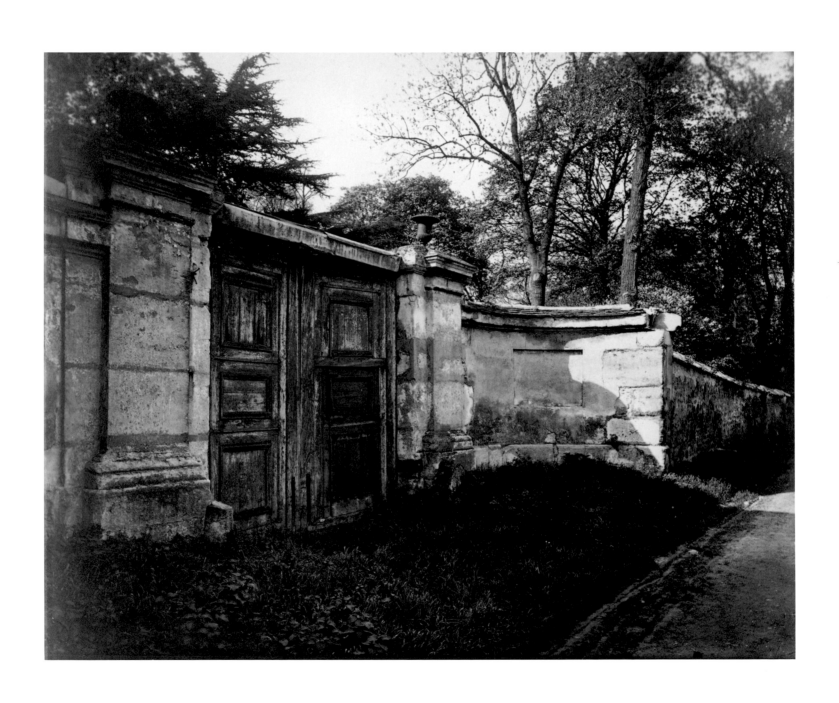

Pl. 40. Châtillon, porte ancien château, rue des Pierrettes. Mai 1916

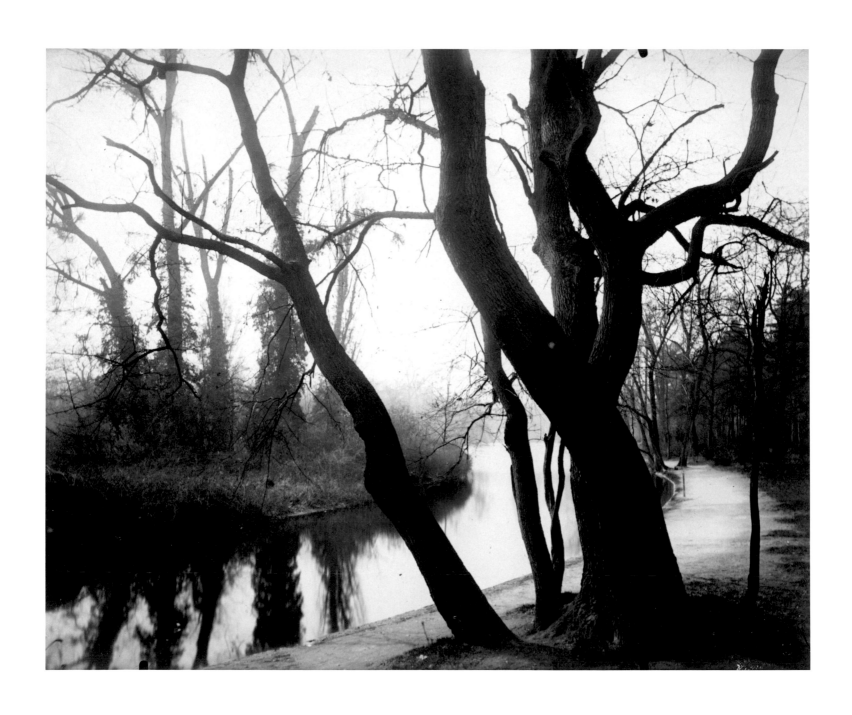

Pl. 41. Bois de Boulogne. (*March 1923*)

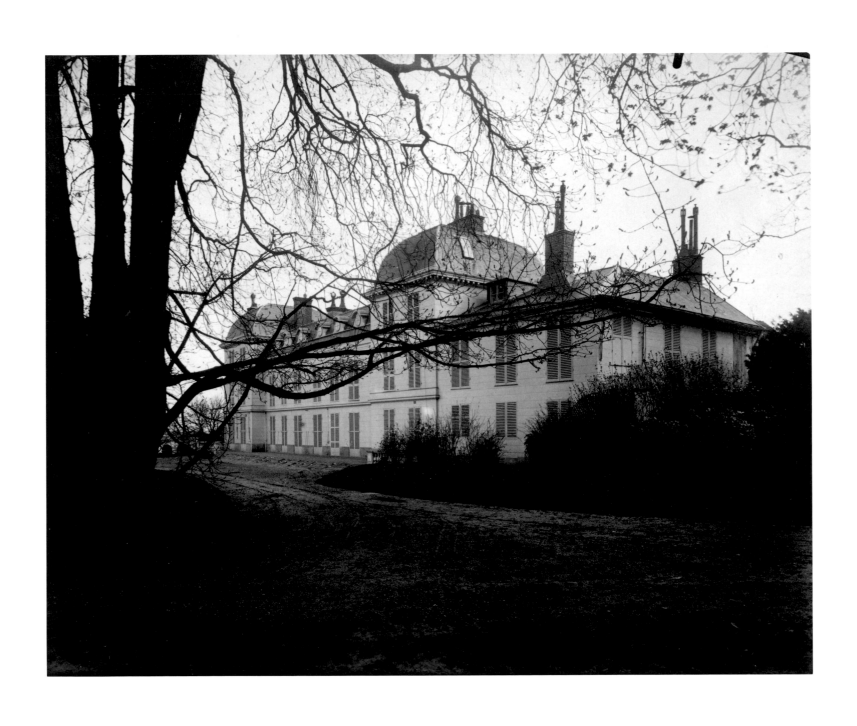

Pl. 42. Château de Sardou, Marly-le-Roi. (1905)

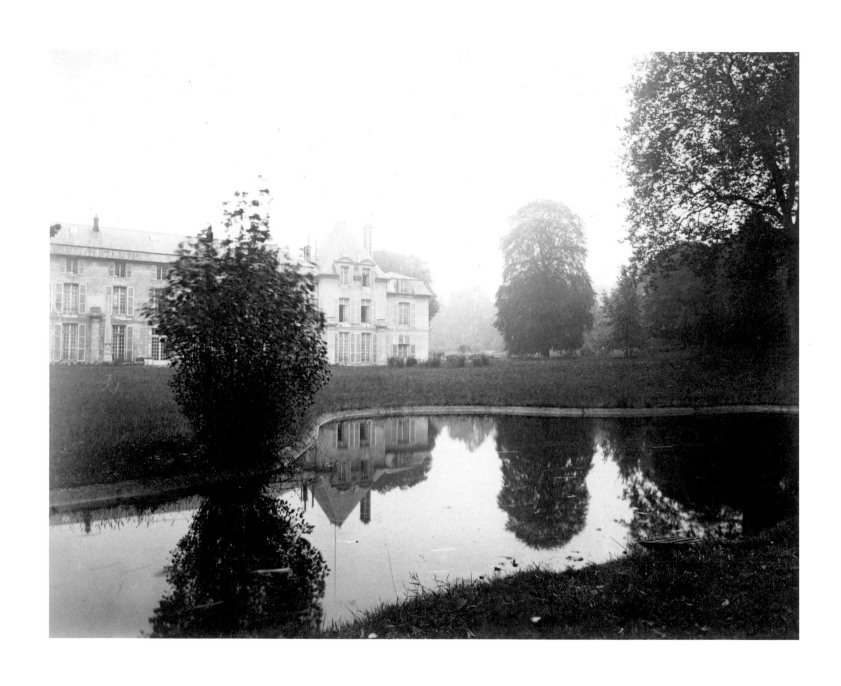

Pl. 43. Château, La Malmaison. (1919–21)

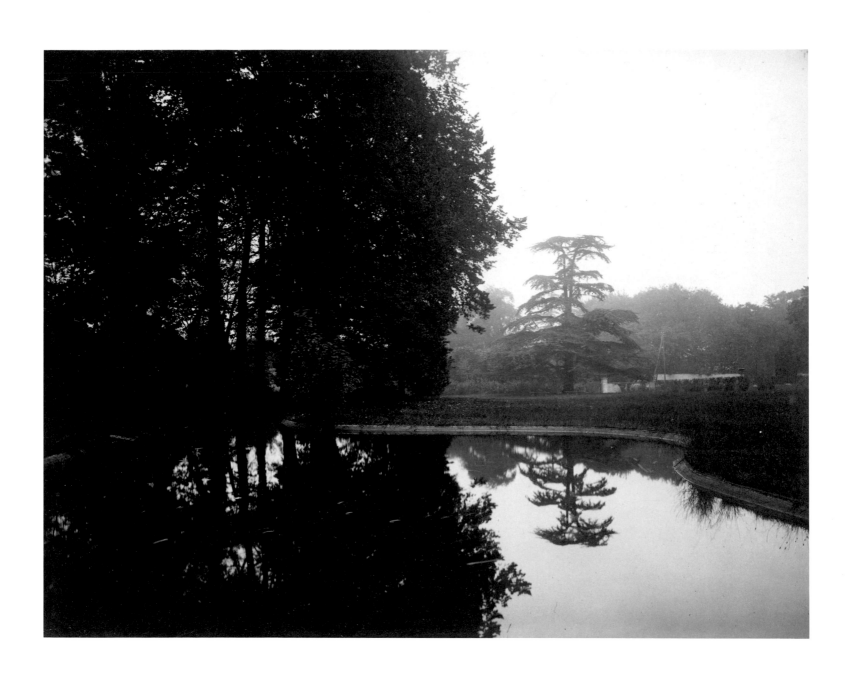

Pl. 44. Parc, La Malmaison. (1919–21)

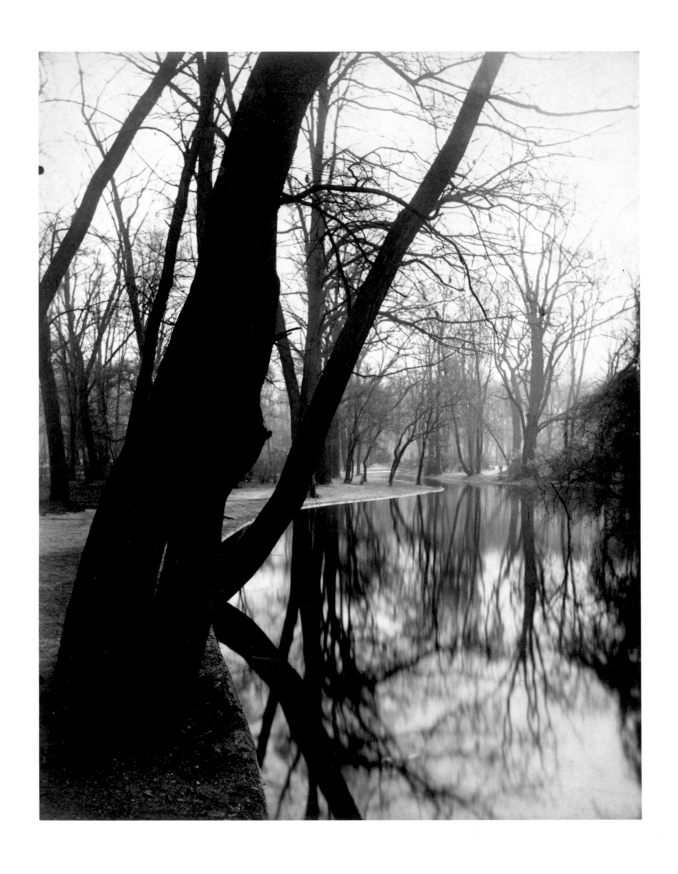

Pl. 45. Bois de Boulogne. (*March 1923*)

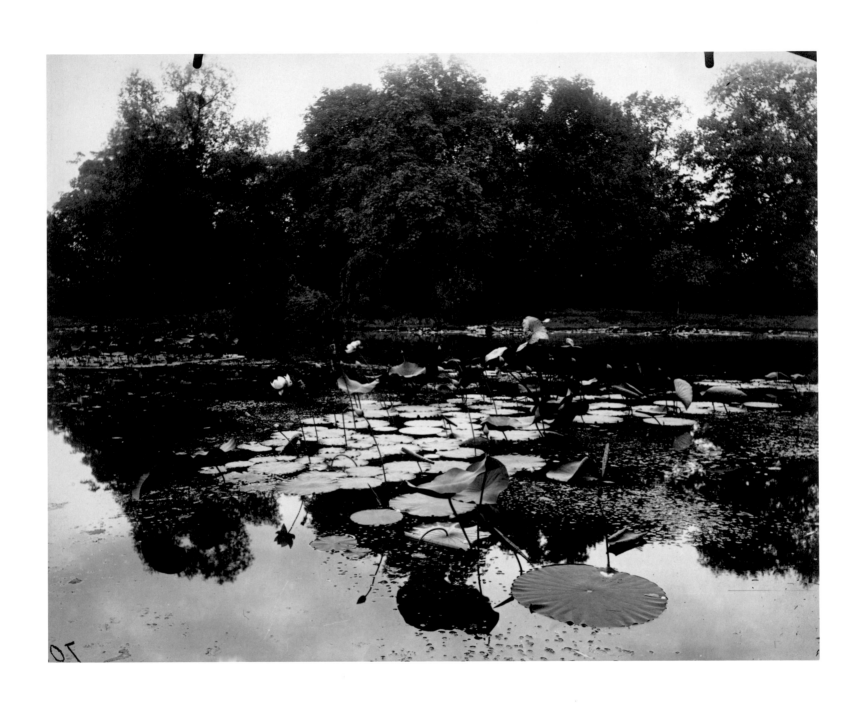

Pl. 46. Roses du Nil. (1910 or earlier)

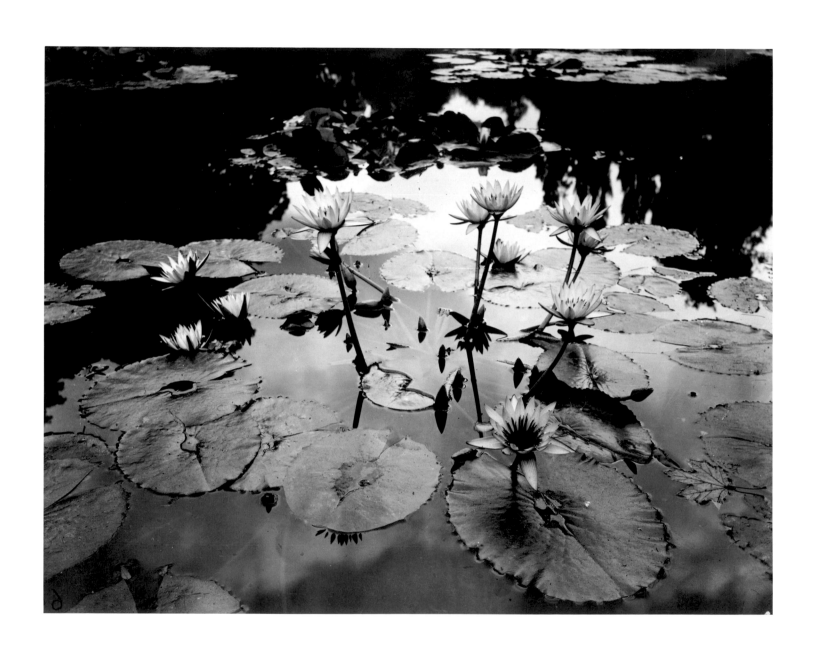

Pl. 47. Nymphéa. (1910 or earlier)

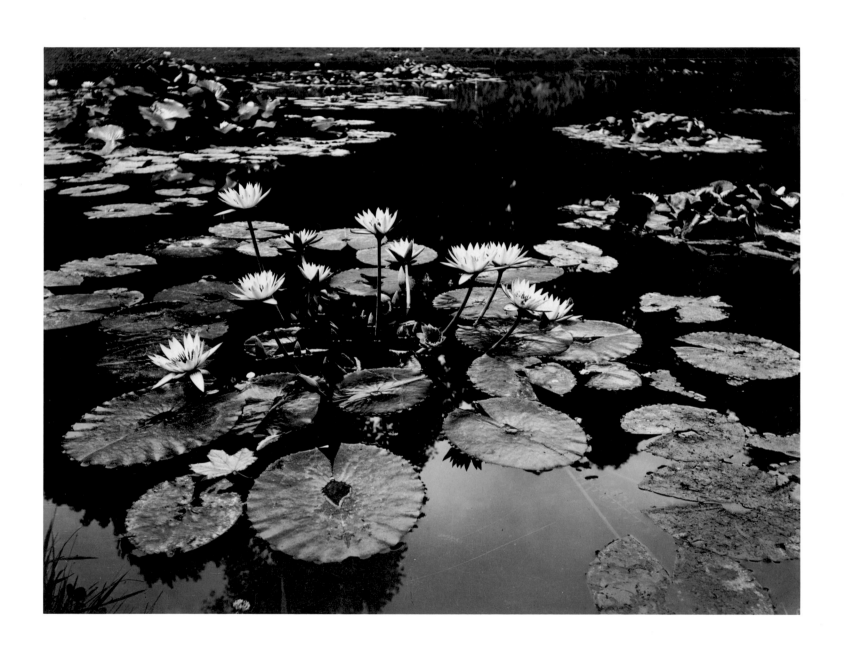

Pl. 48. Nymphéa. (*1910 or earlier*)

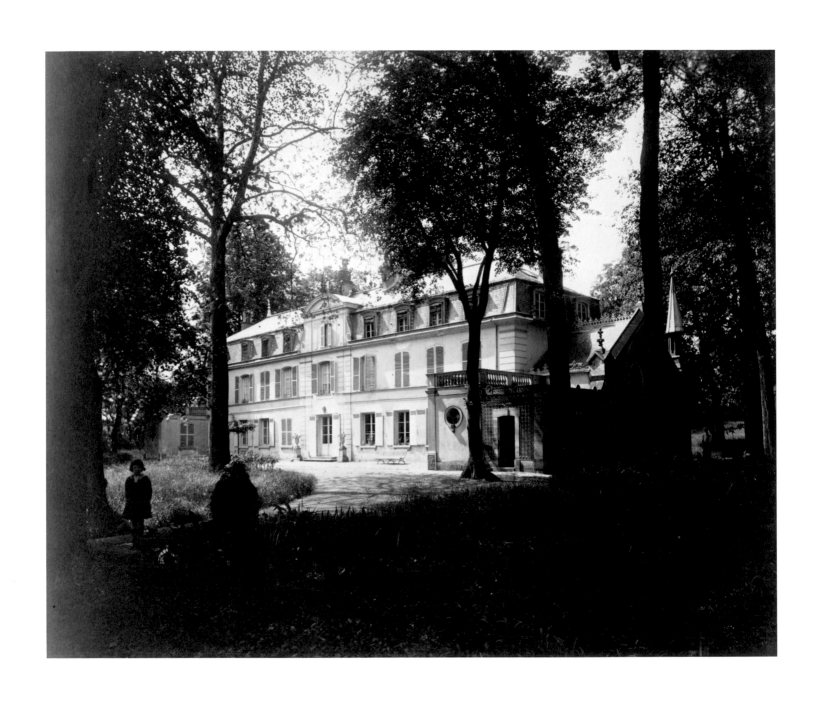

Pl. 49. Antony, château. (1923)

Pl. 50. Bagatelle, roseraie. (1921)

Pl. 51. Bagatelle, géranium. (*1922–23*)

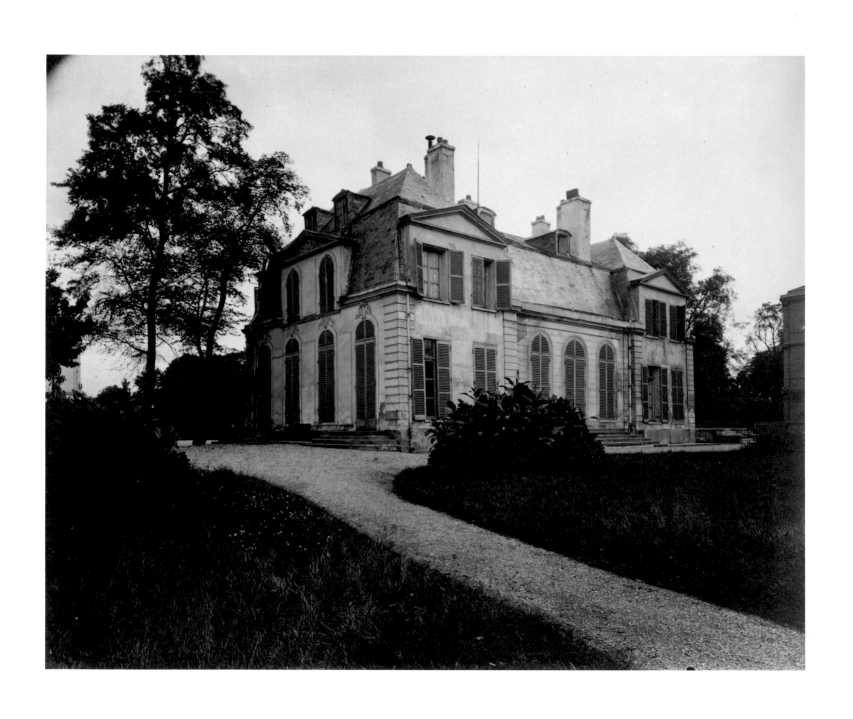

Pl. 52. Saint-Ouen, ancien château Rohan Soubise, 1735. (1901)

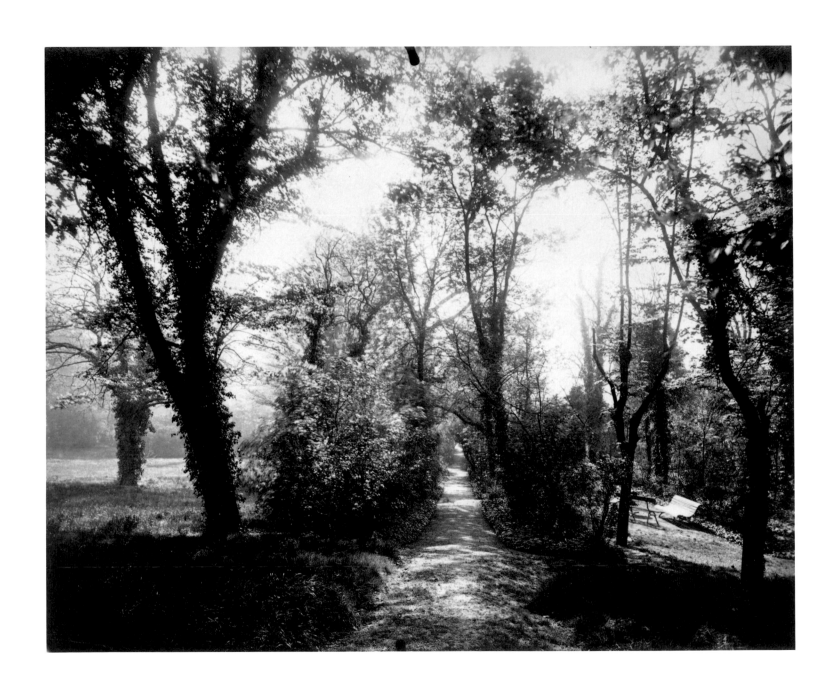

Pl. 53. Parc Delessert. (1914)

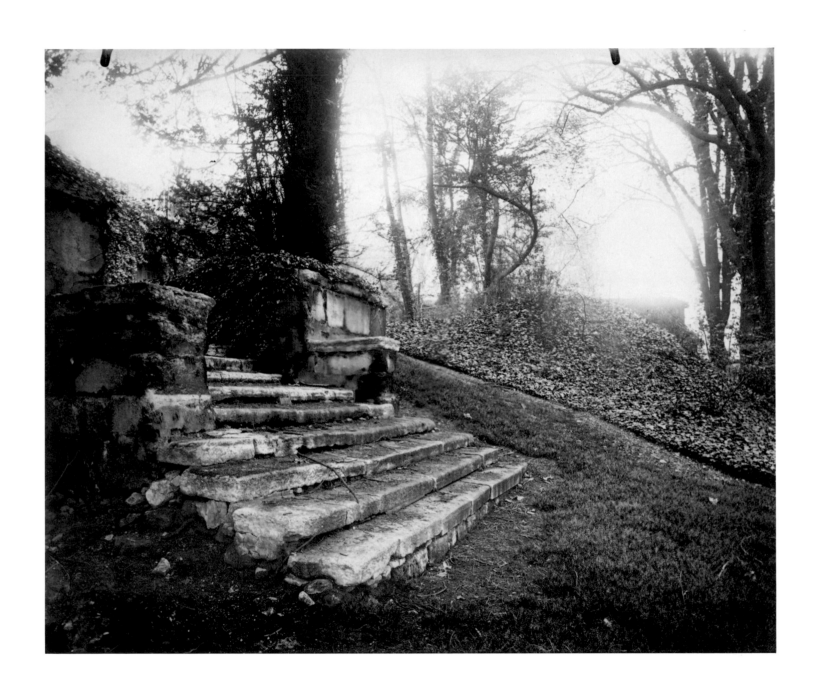

Pl. 54. Parc Delessert. (1914)

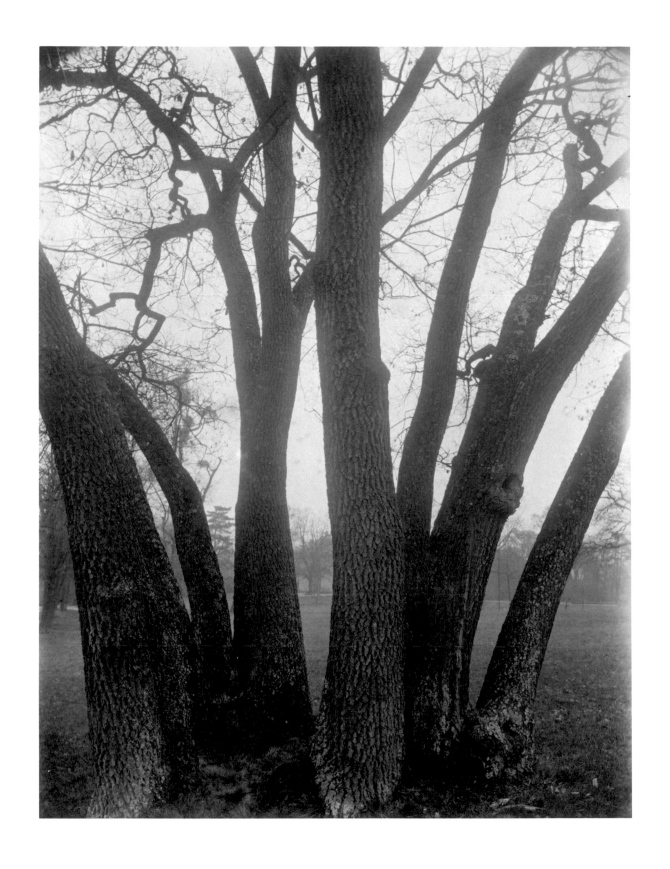

Pl. 55. Bagatelle. (1910 or earlier)

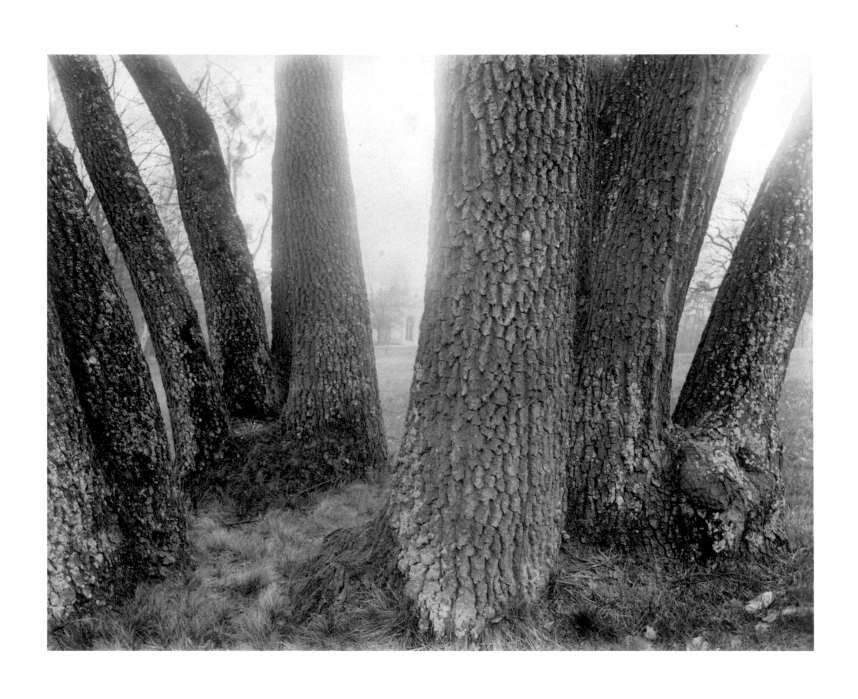

Pl. 56. Bagatelle. (*1910 or earlier*)

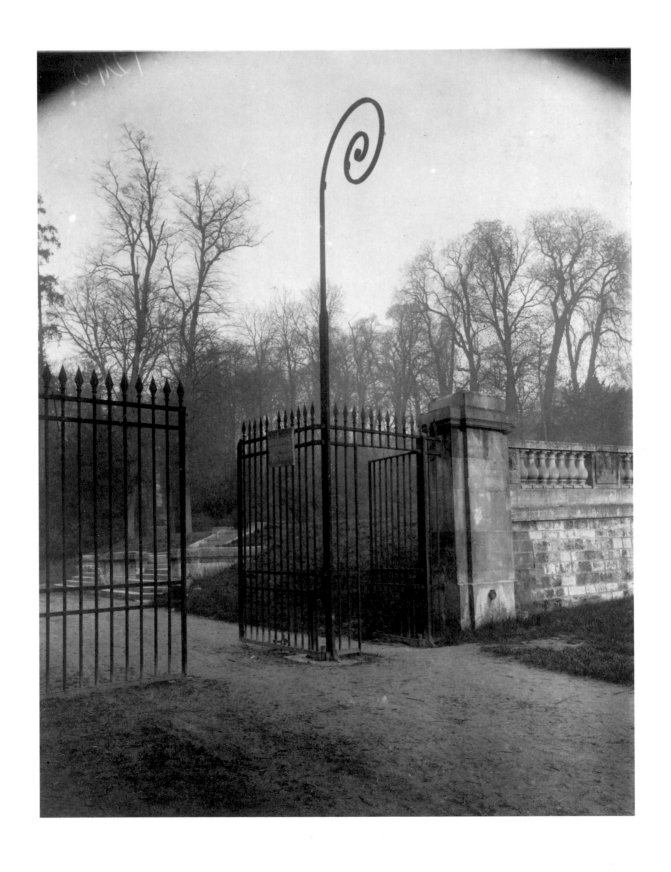

Pl. 57. Saint-Cloud. (1924)

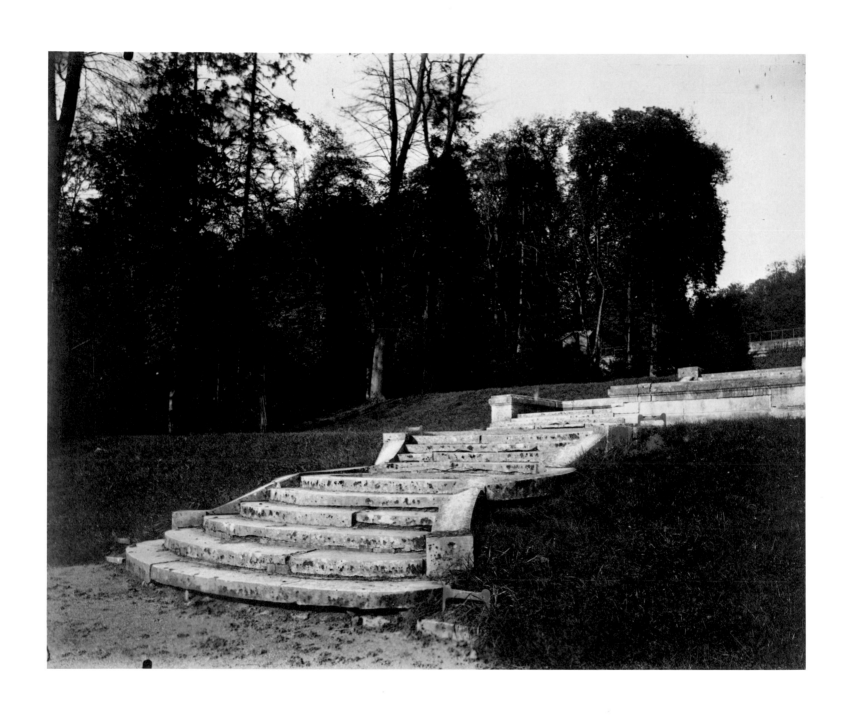

Pl. 58. Saint-Cloud. (1904)

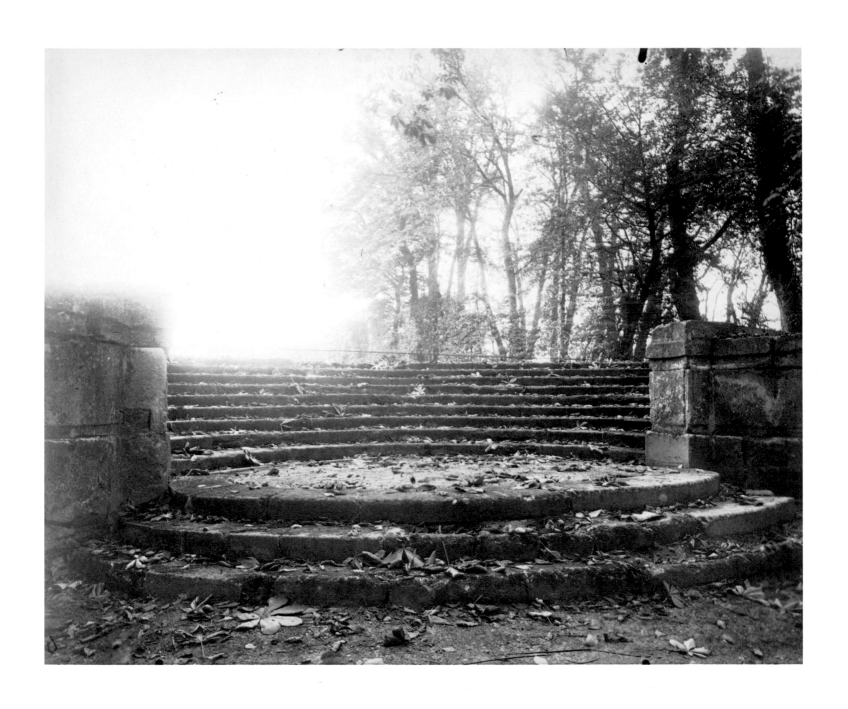

Pl. 59. Saint-Cloud. (1906)

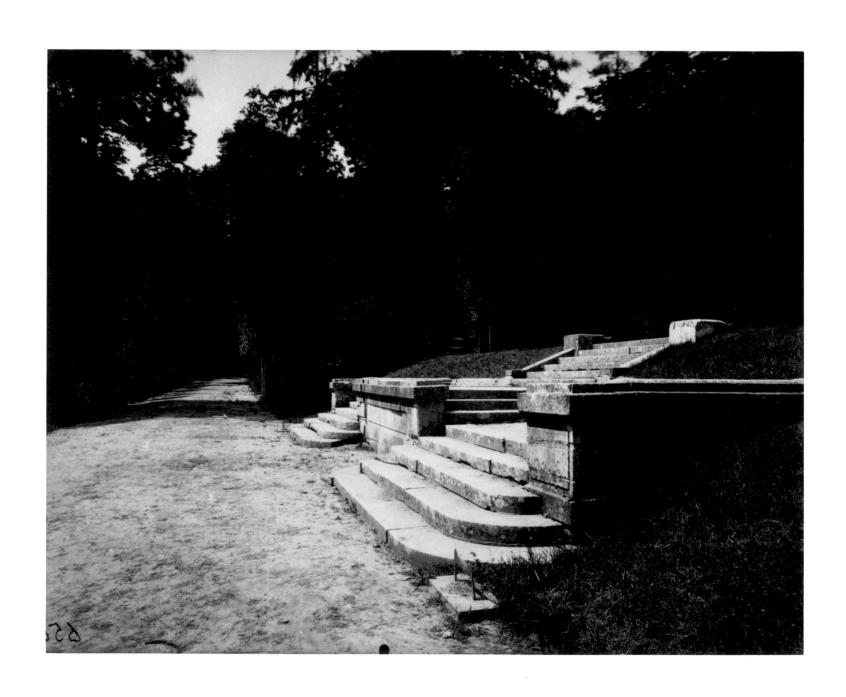

Pl. 60. Saint-Cloud. (1904)

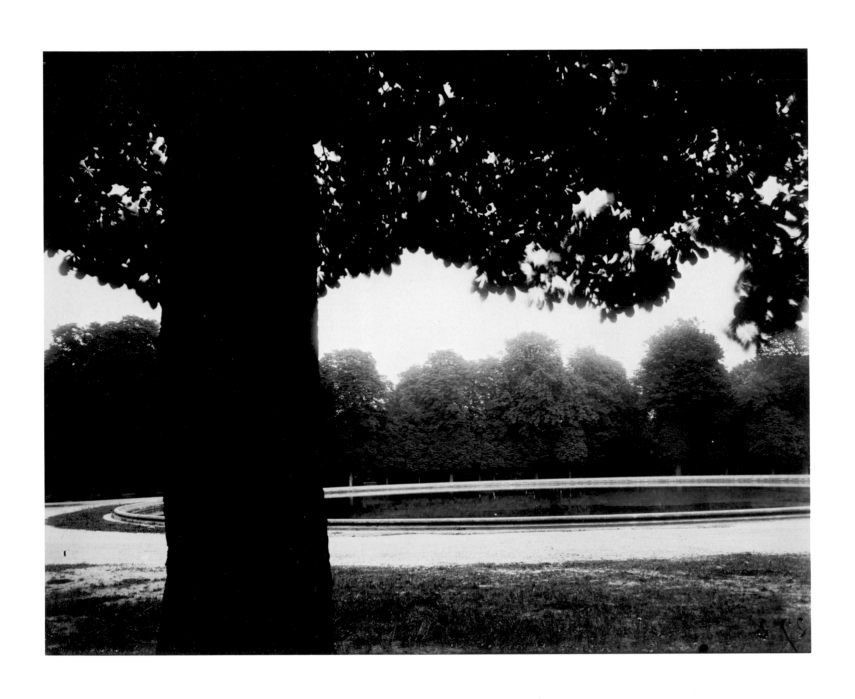

Pl. 61. Saint-Cloud. Juin 1926

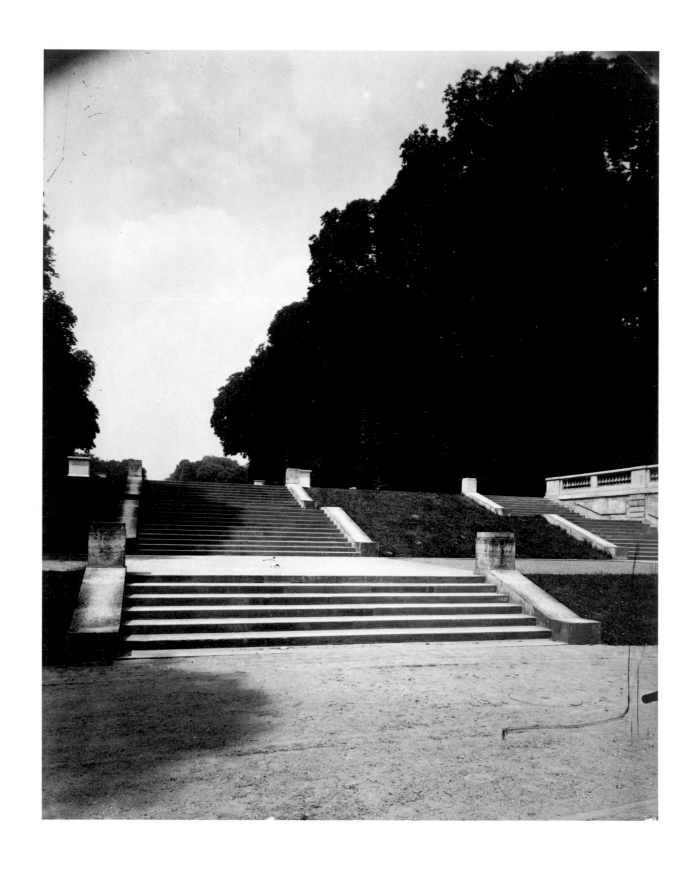

Pl. 62. Saint-Cloud. (1904)

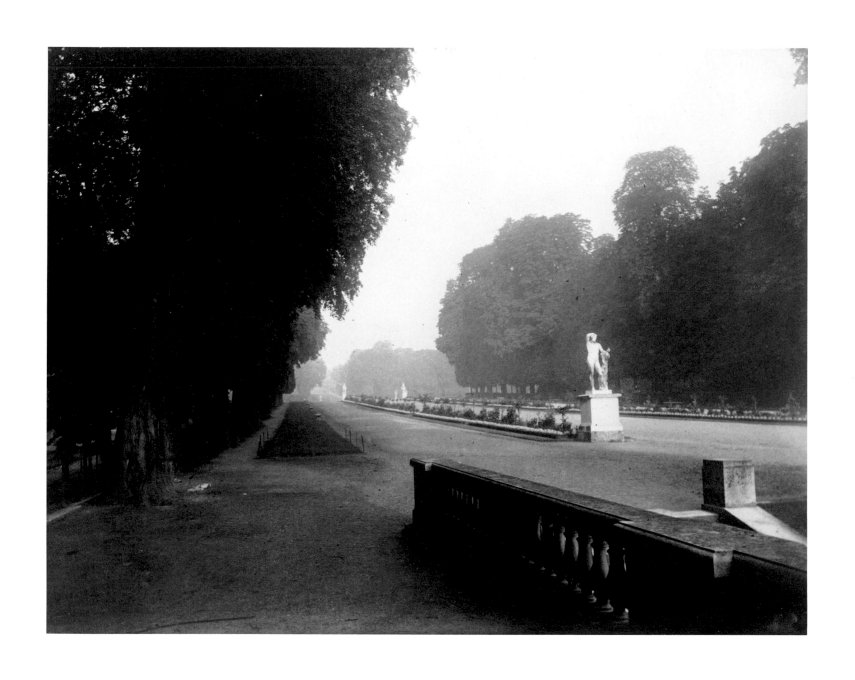

Pl. 63. Saint-Cloud. Fin août, 6 1/2 h., 1924

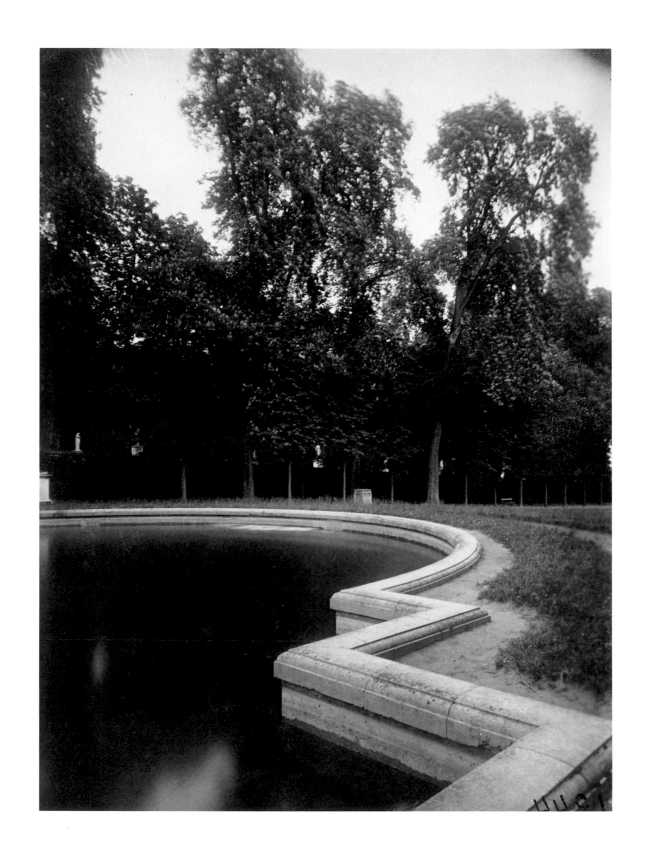

Pl. 64. Saint-Cloud. (*1924*)

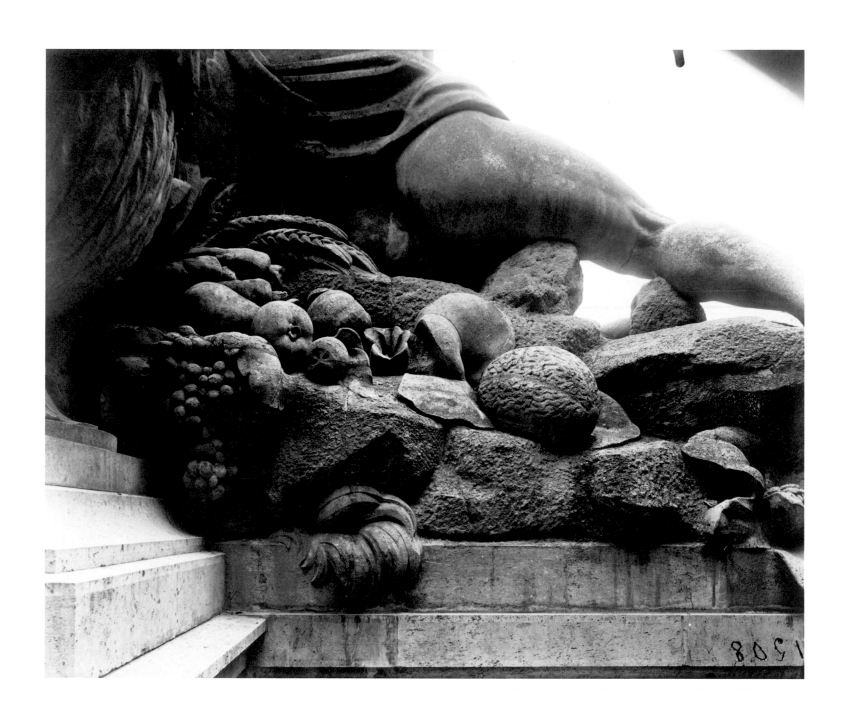

Pl. 65. Saint-Cloud. (1923)

Pl. 66. Saint-Cloud. (1924)

Pl. 67. Saint-Cloud. Fin août, 6 1/2 h., 1924

Pl. 68. Saint-Cloud. Mars 1926, 9 h. matin

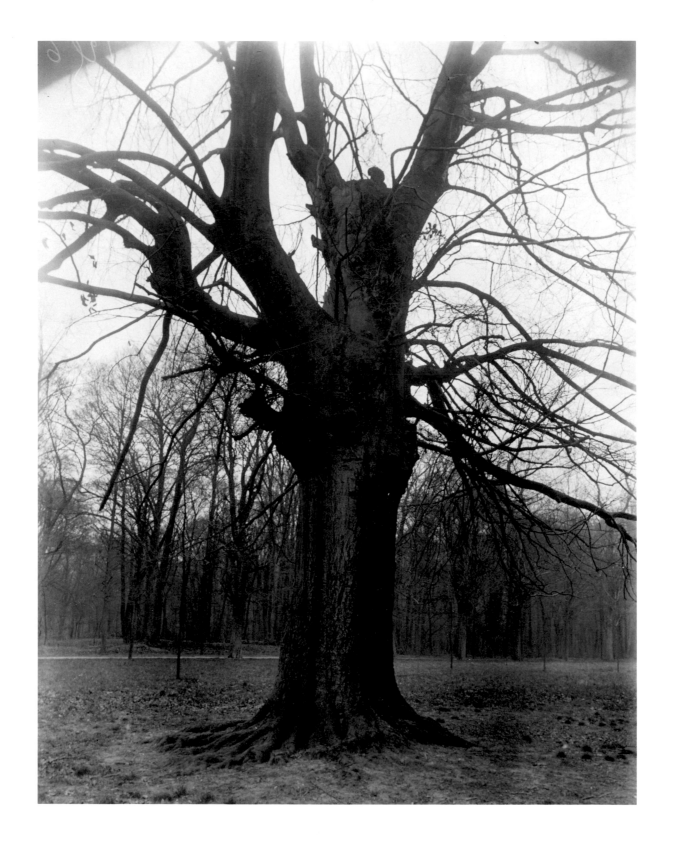

Pl. 69. Saint-Cloud. 1926

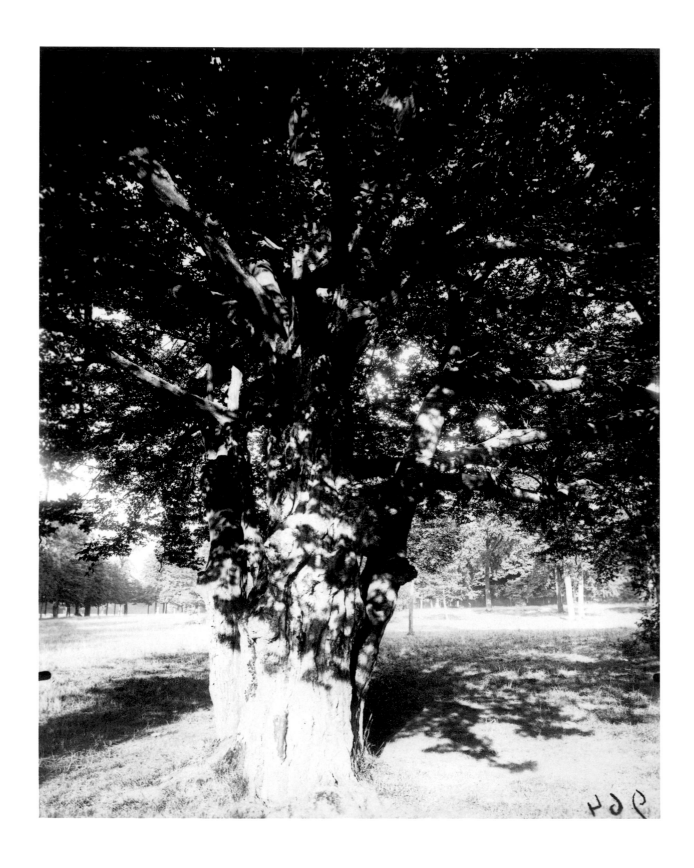

Pl. 70. Parc de Saint-Cloud, arbre. (*1919–21*)

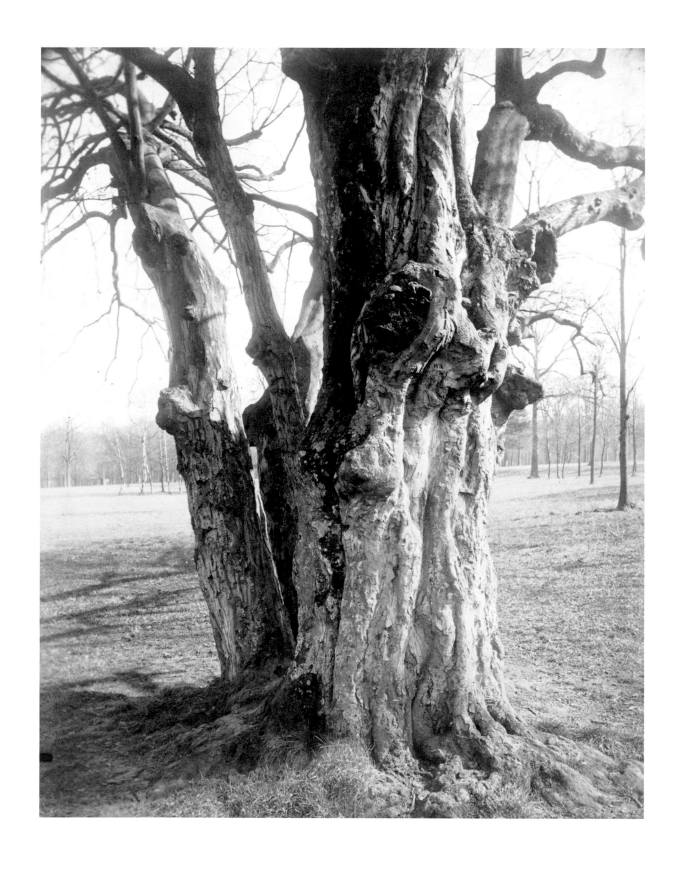

Pl. 71. Saint-Cloud. (*1924*)

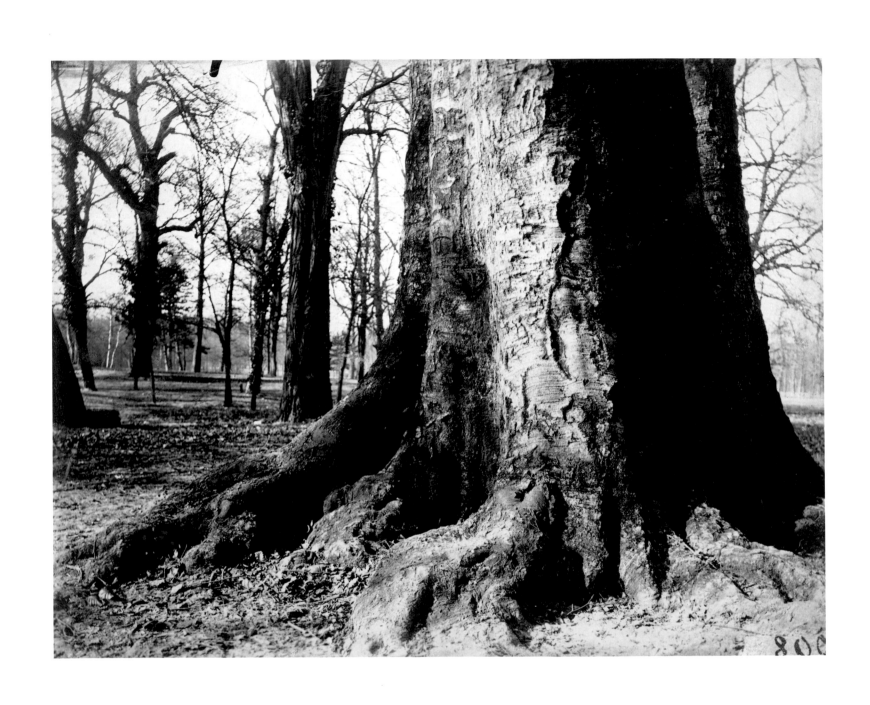

Pl. 72. Saint-Cloud, hêtre. (1919–21)

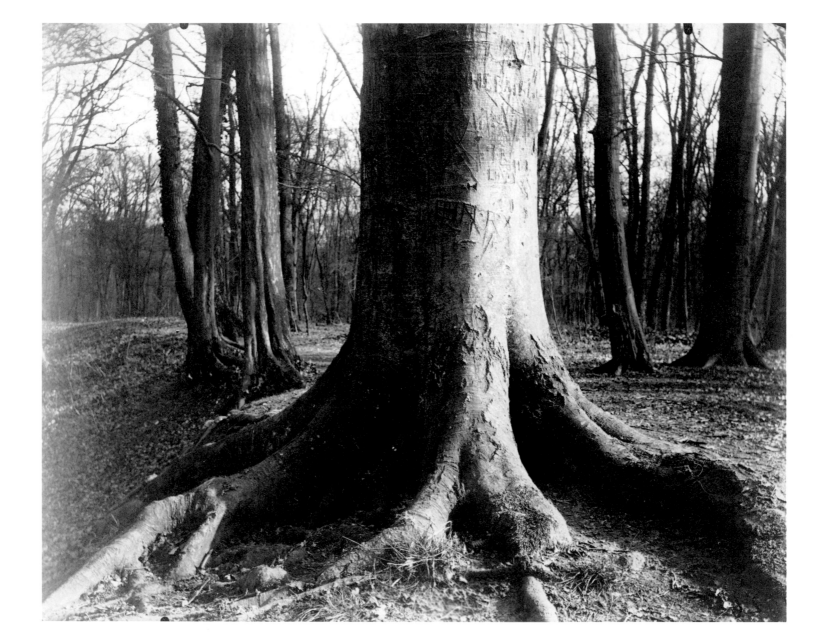

Pl. 73. Saint-Cloud, hêtre. (1921)

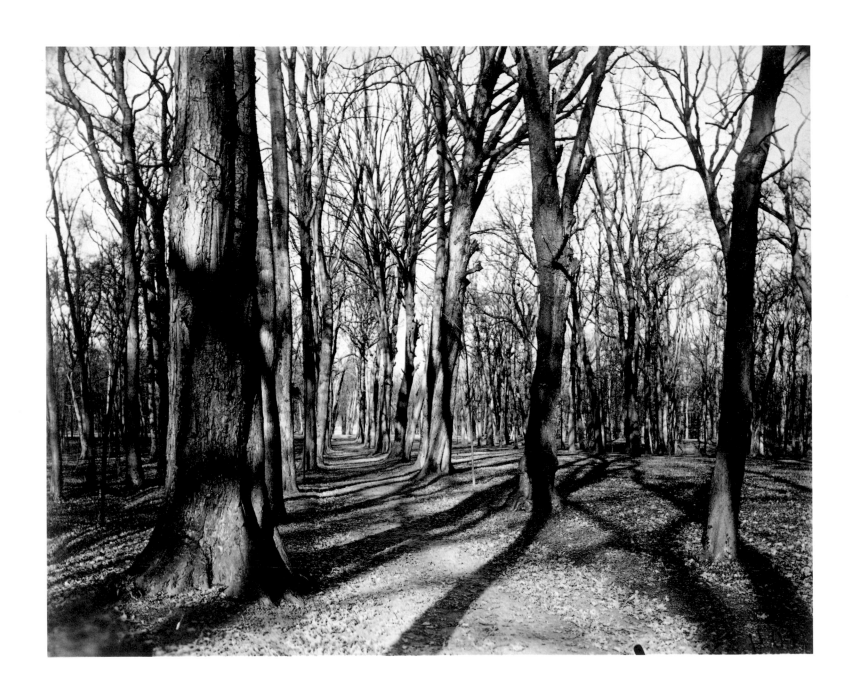

Pl. 74. Saint-Cloud. Fin mai, 7 h. soir (1922)

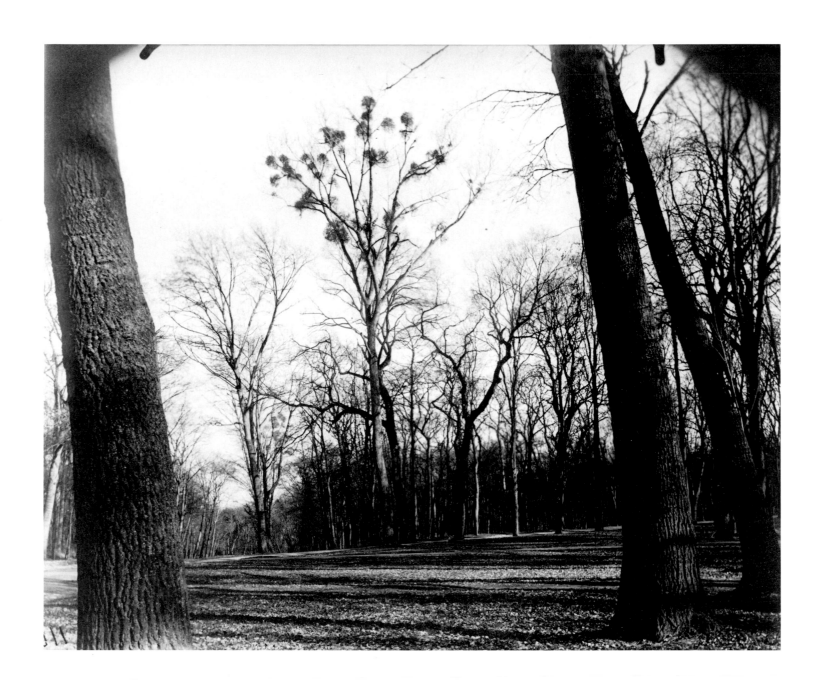

Pl. 75. Saint-Cloud. (*1922*)

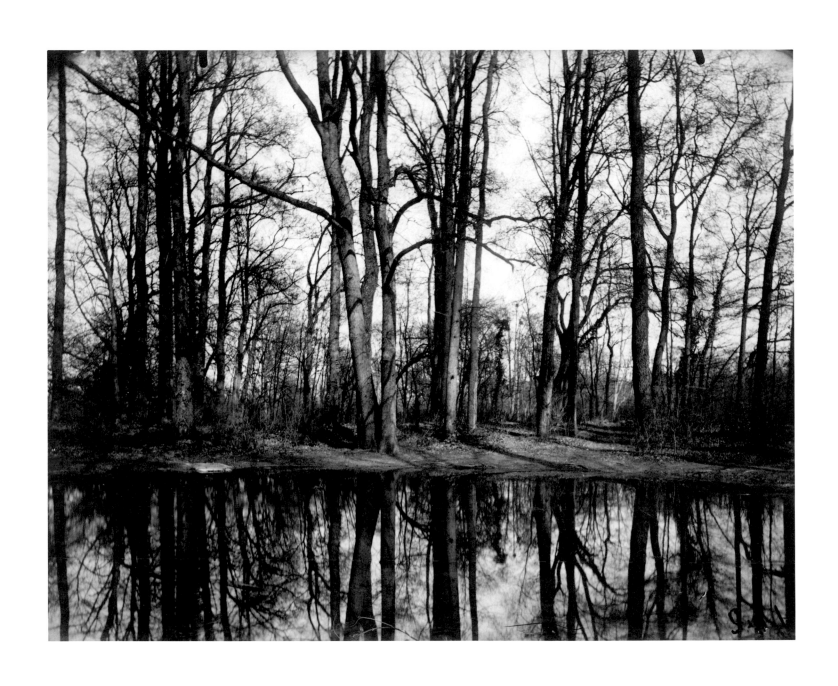

Pl. 76. Saint-Cloud. (1922)

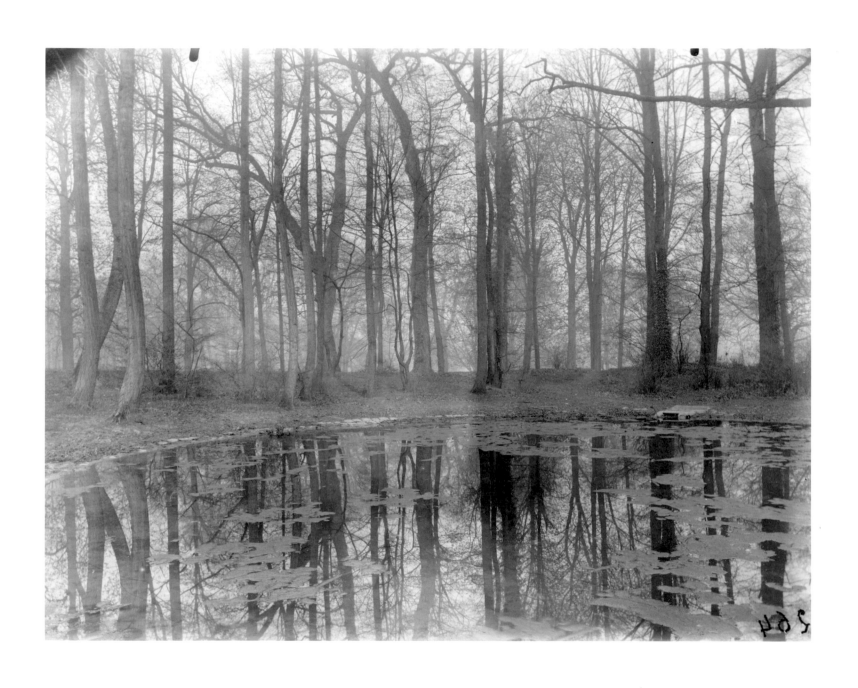

Pl. 77. Saint-Cloud, étang. 9 h. matin, avril 1926

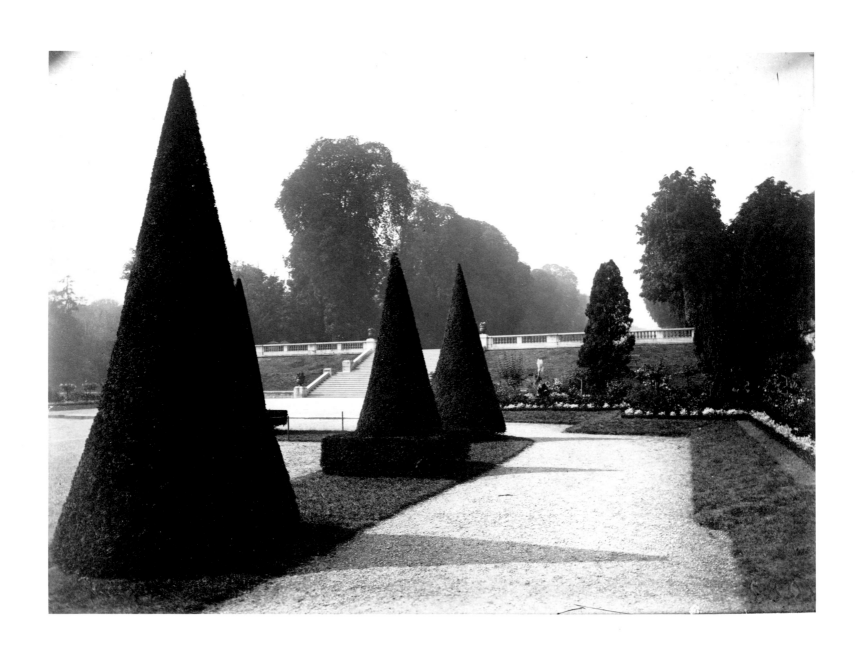

Pl. 78. Saint-Cloud. (1921–22)

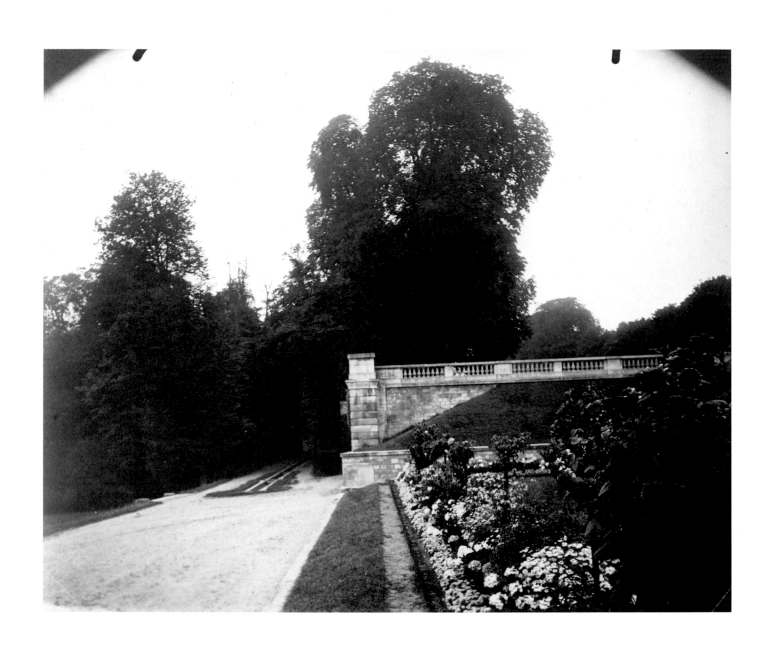

Pl. 79. Saint-Cloud. (1919–21)

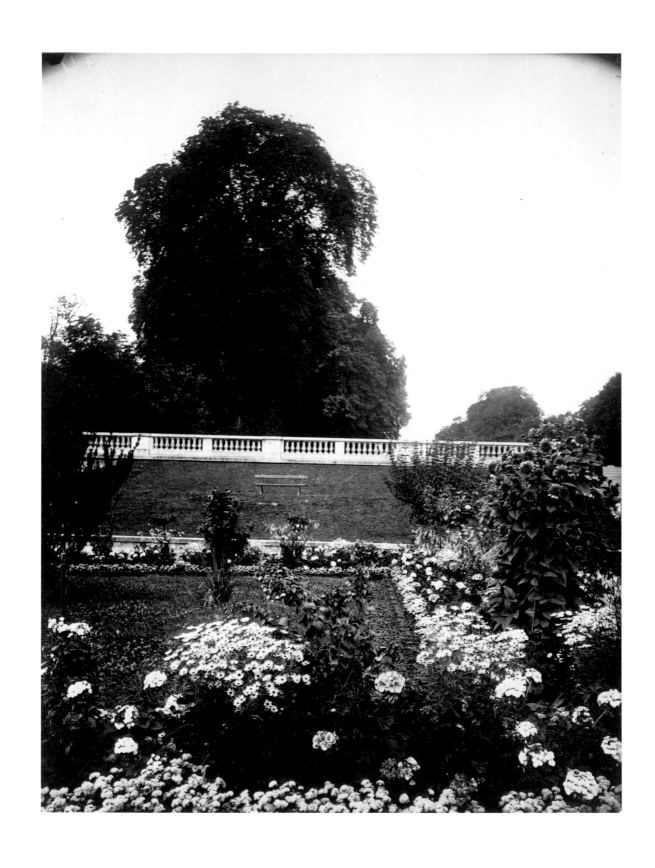

Pl. 80. Saint-Cloud. (*1919–21*)

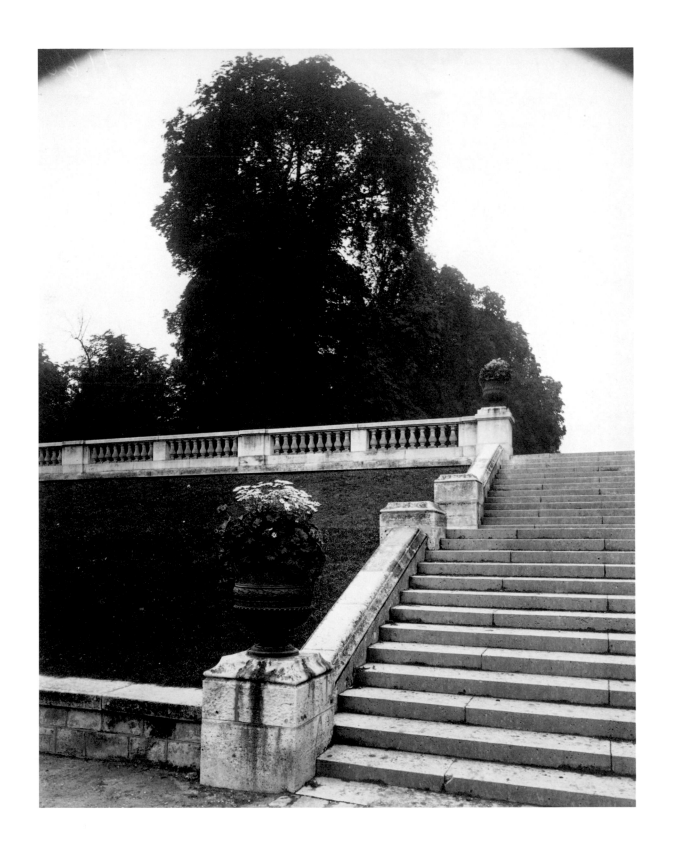

Pl. 81. Saint-Cloud. (1922)

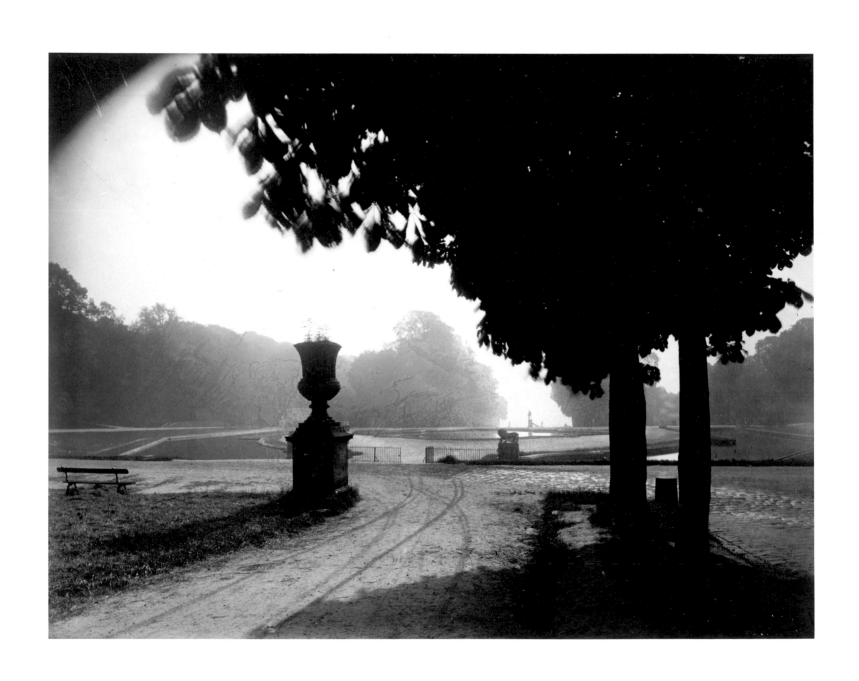

Pl. 82. Saint-Cloud. Juin 1926

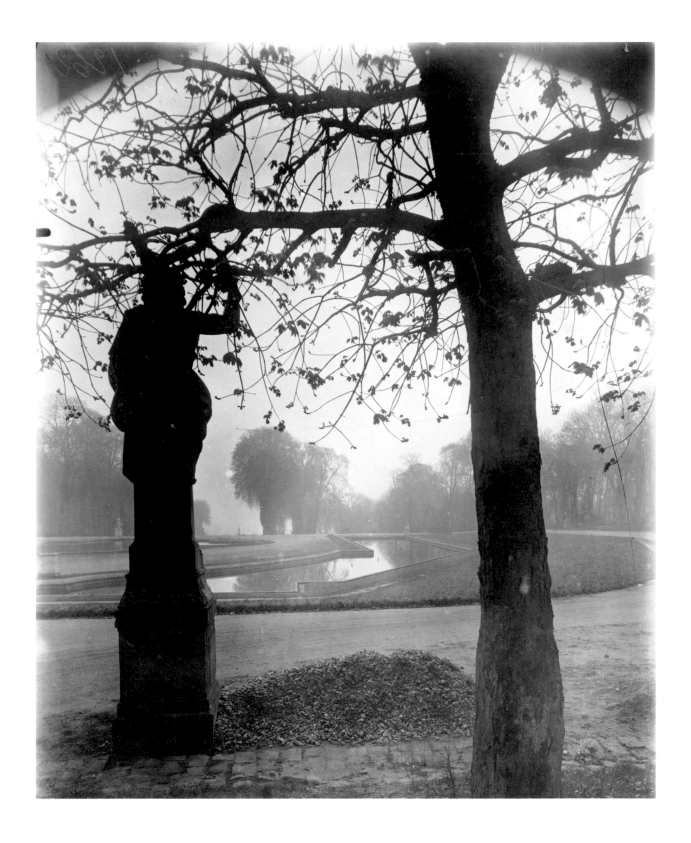

Pl. 83. Saint–Cloud. 9 h. matin, mars 1926

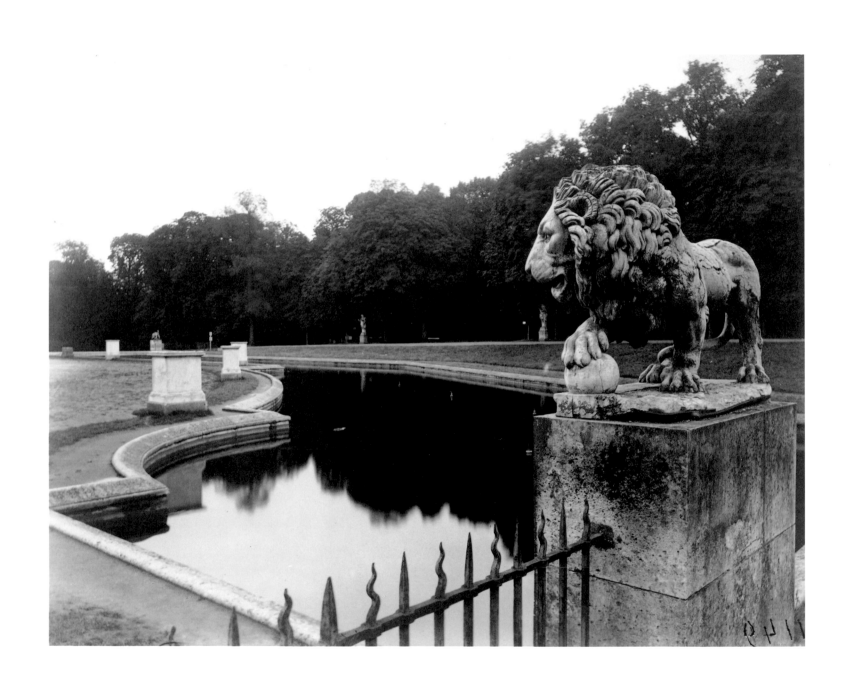

Pl. 84. Saint-Cloud. (*1922*)

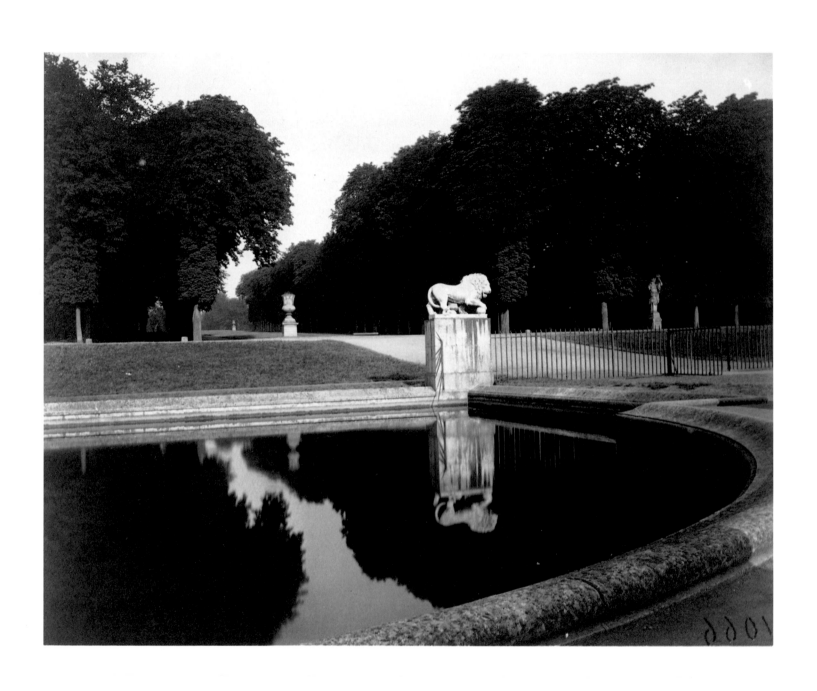

Pl. 85. Saint-Cloud. Matin 7 h., juillet (1921)

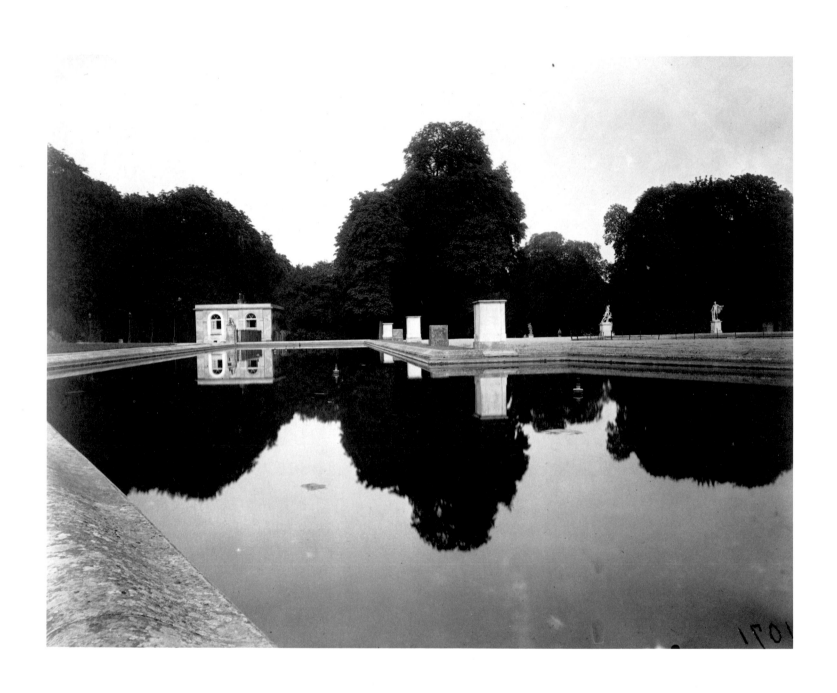

Pl. 86. Saint-Cloud. Le soir, 7 h. (1921)

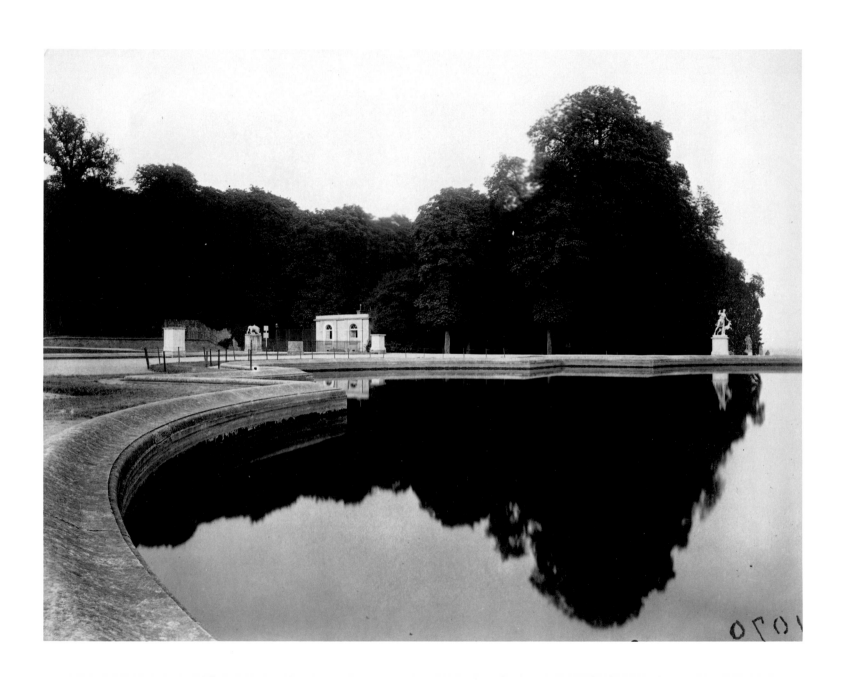

Pl. 87. Saint-Cloud. Le soir, 7 h. (1921)

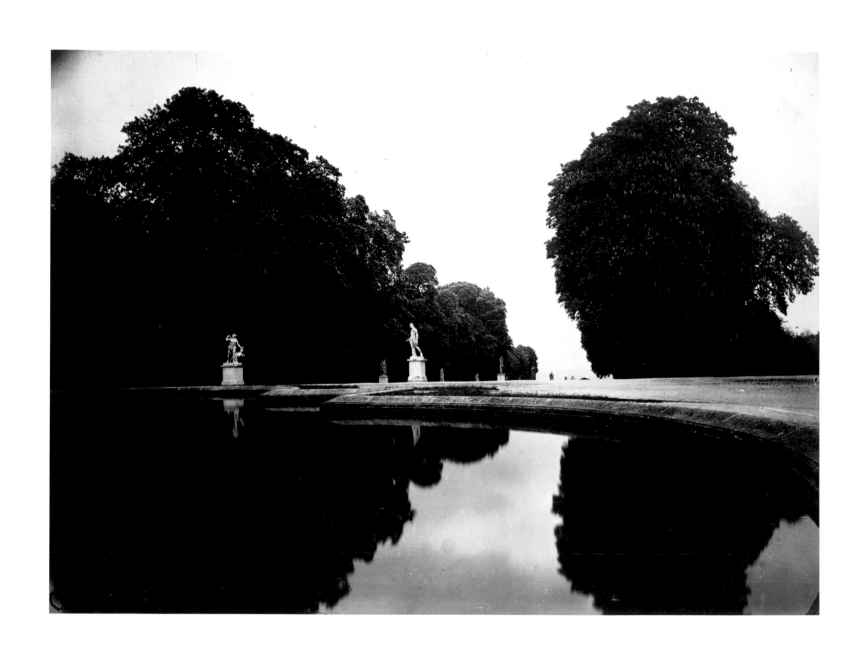

Pl. 88. Saint-Cloud. (1915–19)

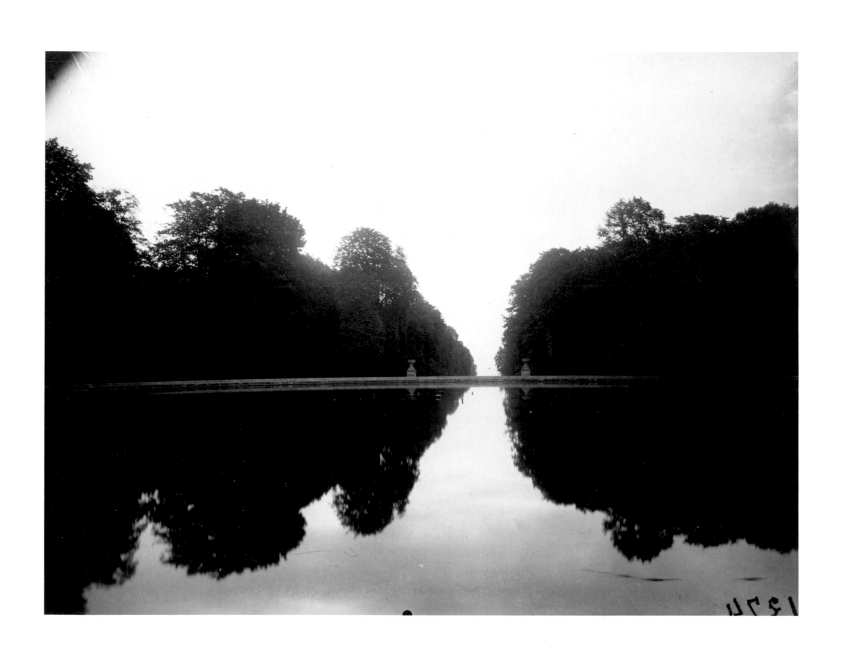

Pl. 89. Saint-Cloud. Juin 1926

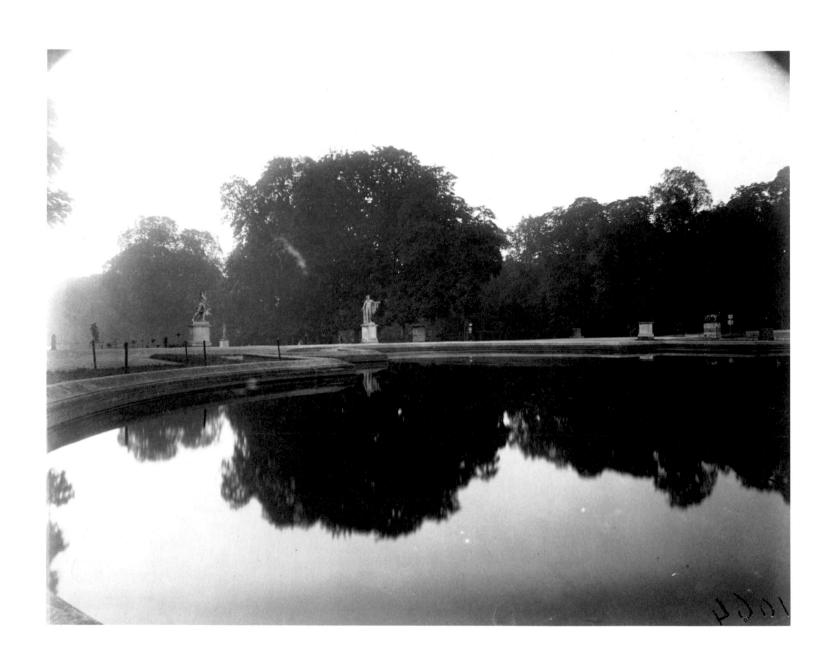

Pl. 90. Saint-Cloud. 6 h. matin (1921)

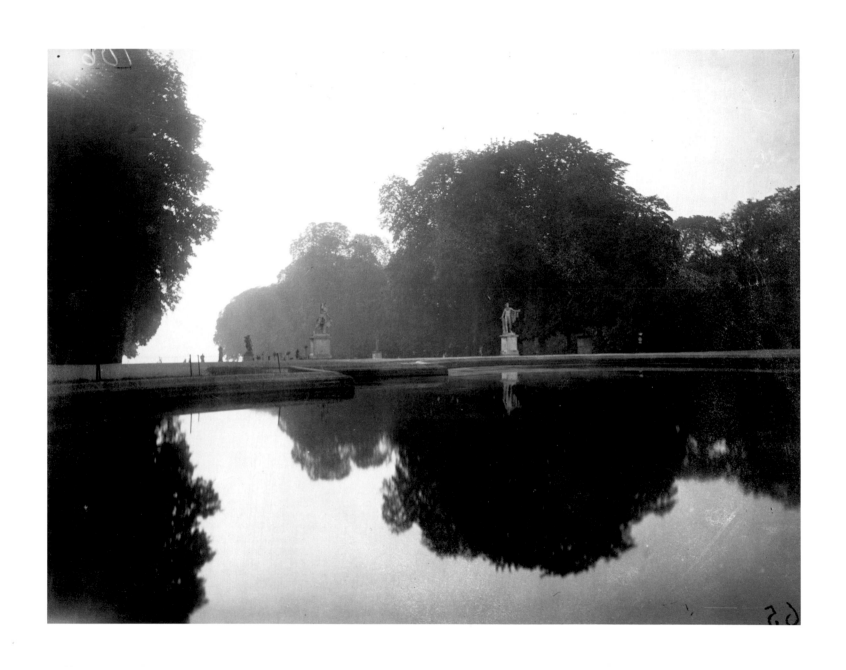

Pl. 91. Saint-Cloud. Matin, 6 1/2 h., juillet (1921)

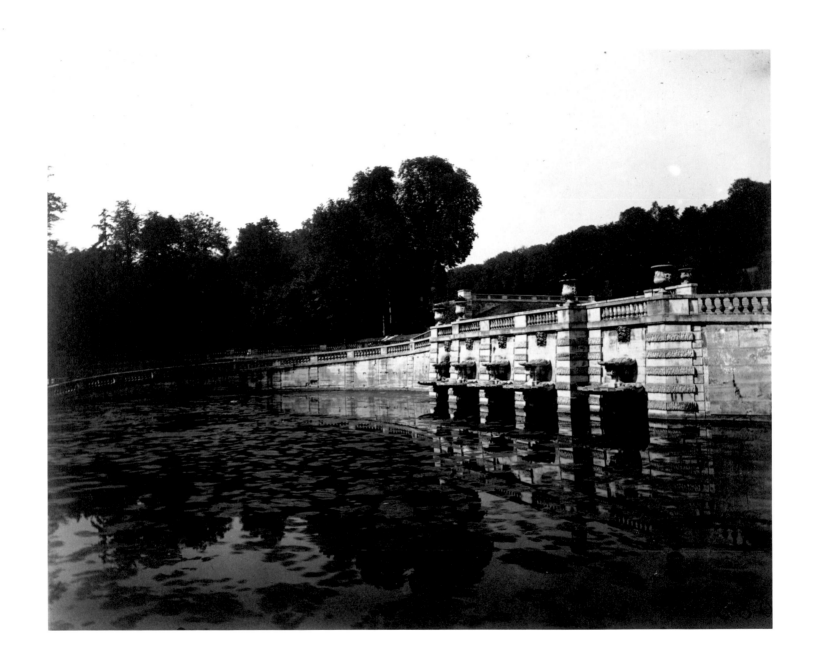

Pl. 92. Saint-Cloud. (1921–22)

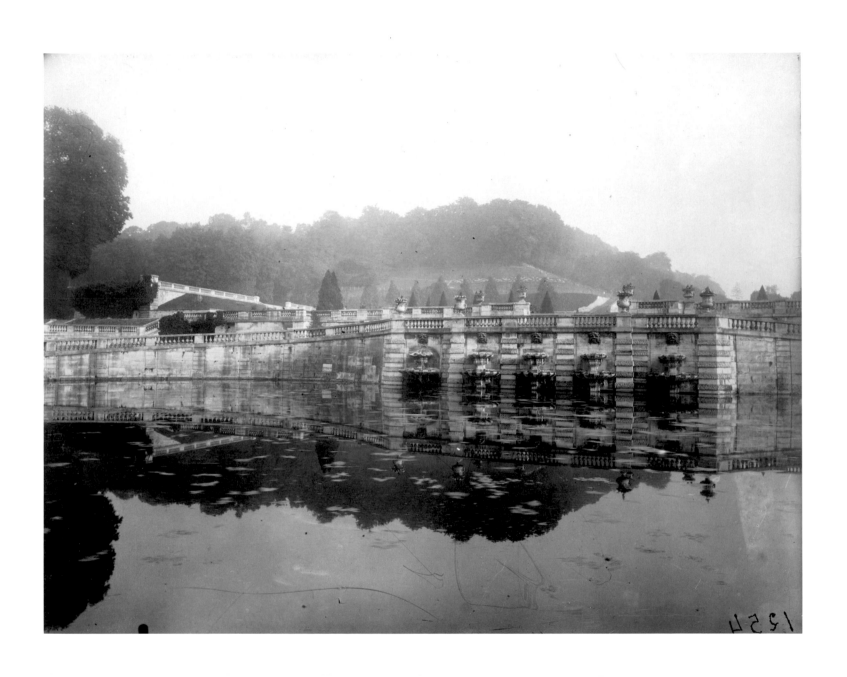

Pl. 93. Saint-Cloud. Fin août, 6 1/2 h., 1924

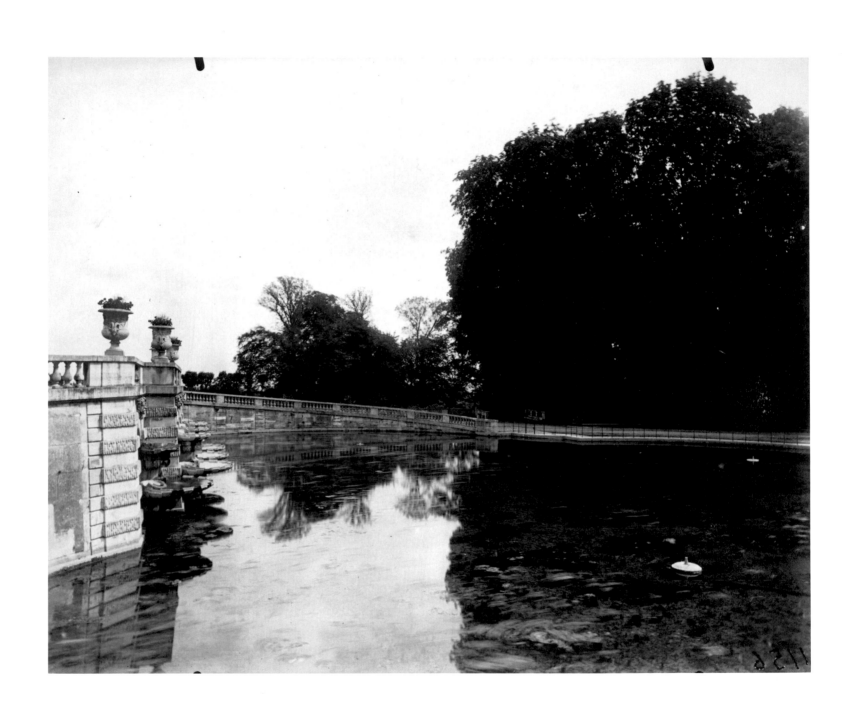

Pl. 94. Saint-Cloud. (*August 1922*)

Pl. 95. Saint-Cloud. (August 1922)

Pl. 96. Bourg-la-Reine, entrée du château. (1924)

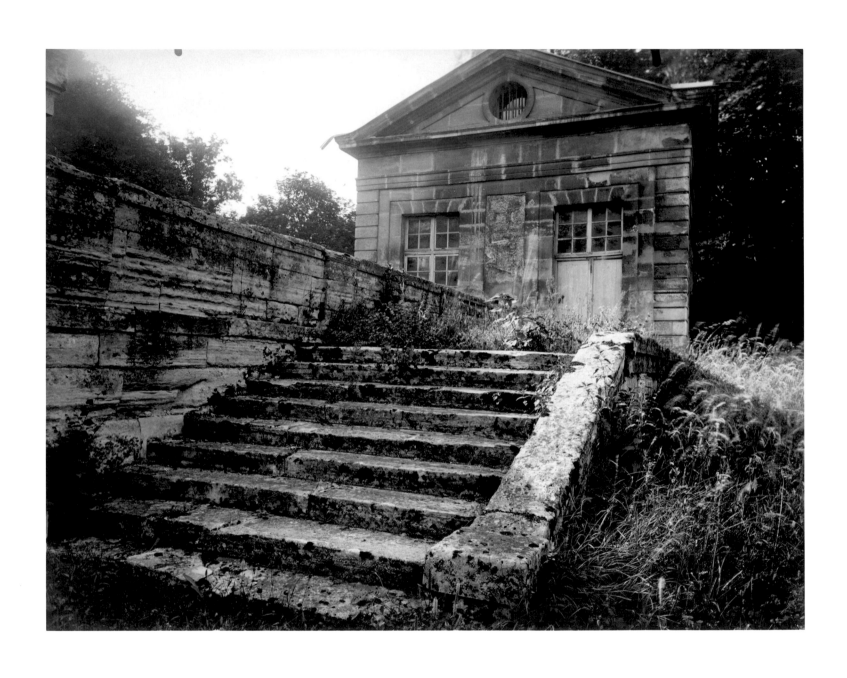

Pl. 97. Parc de Sceaux. Juin, 7 h. matin (1925)

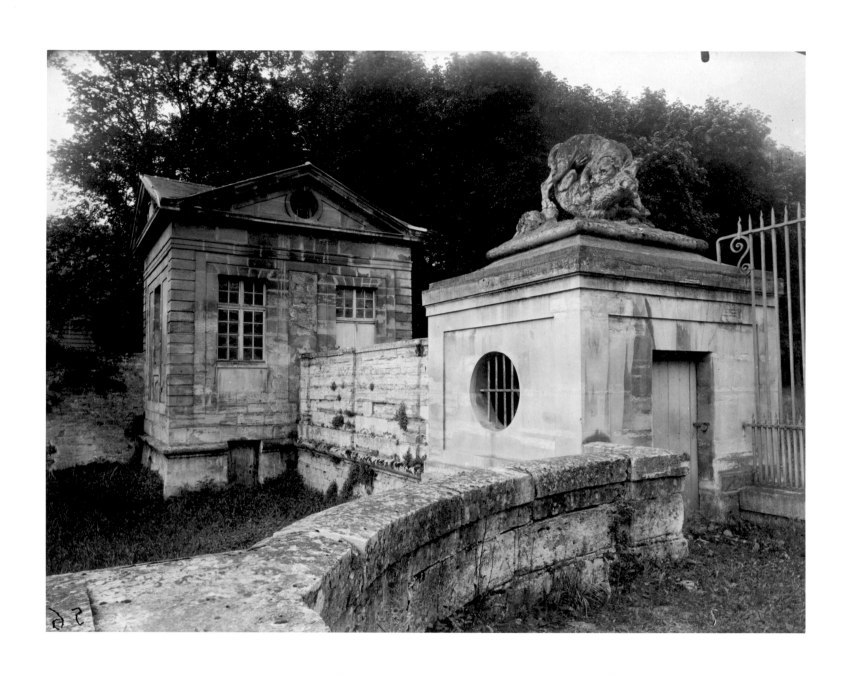

Pl. 98. *Entrée du parc de Sceaux. Mai, 8 h. matin* (1925)

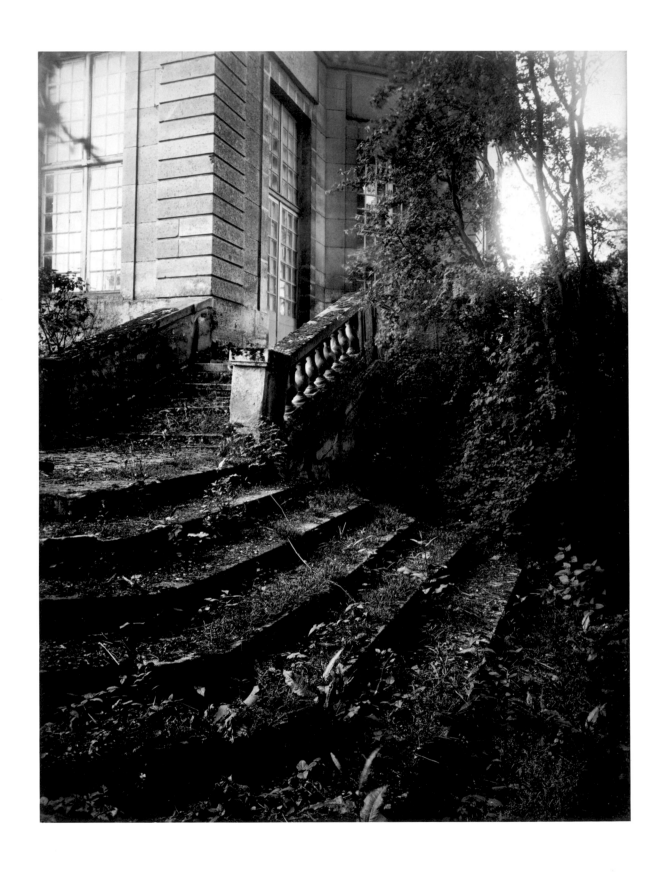

Pl. 99. Parc de Sceaux [Escalier, Pavillon de l'Aurore]. Mai, 8 h. matin (1925)

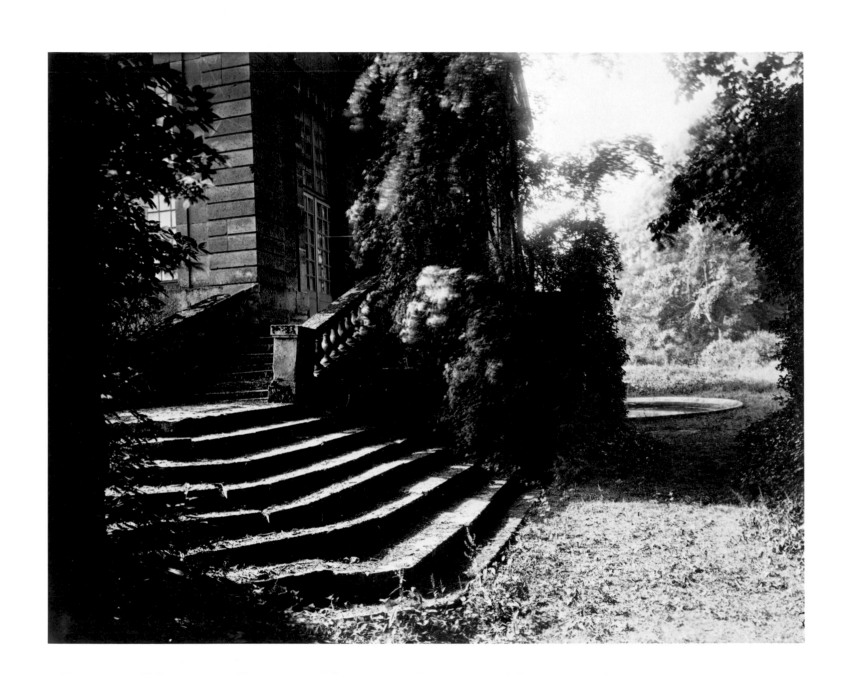

Pl. 100. Parc de Sceaux. (*June 1925*)

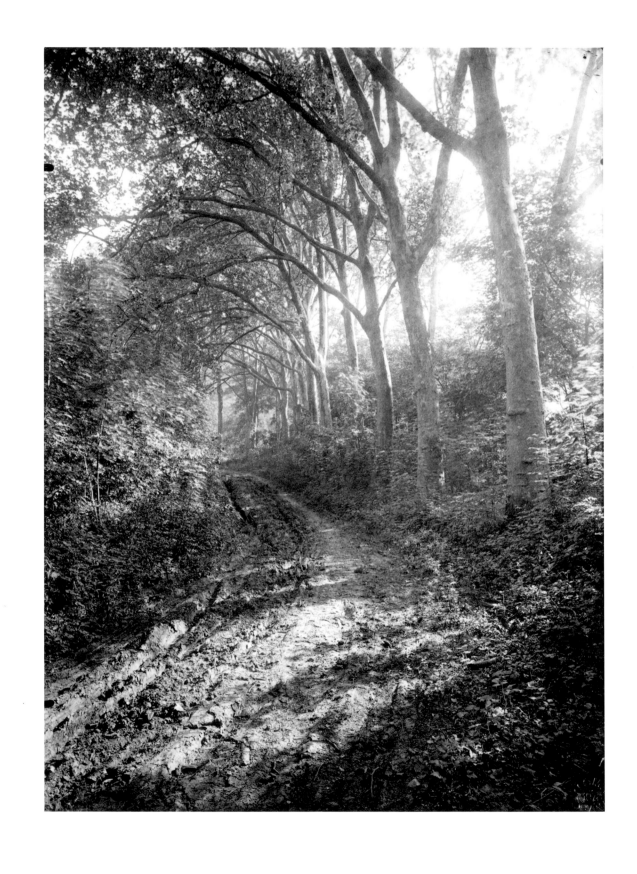

Pl. 101. Sceaux. Juin, 7 h. matin (1925)

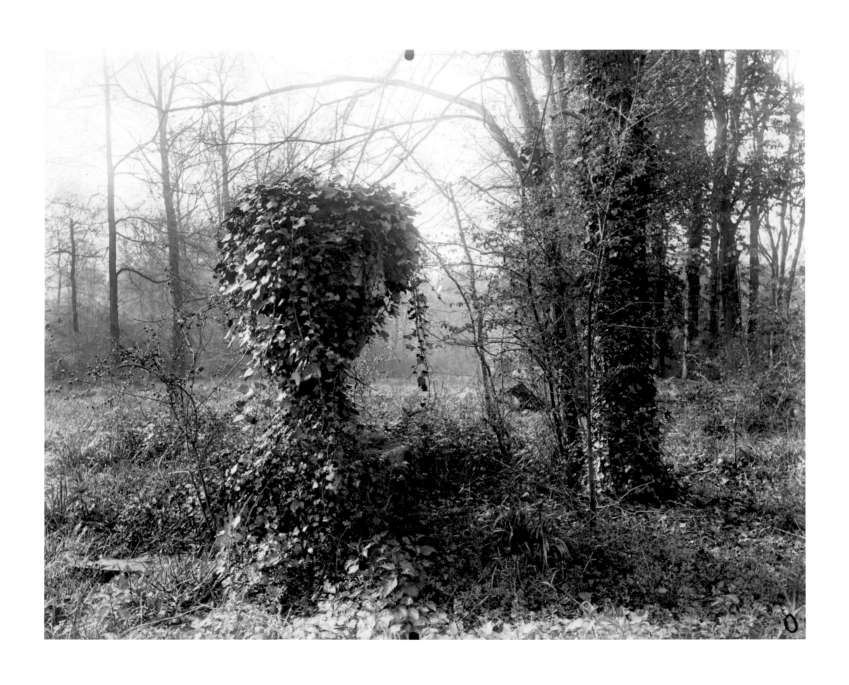

Pl. 102. Parc de Sceaux. Avril, 7 h. matin (1925)

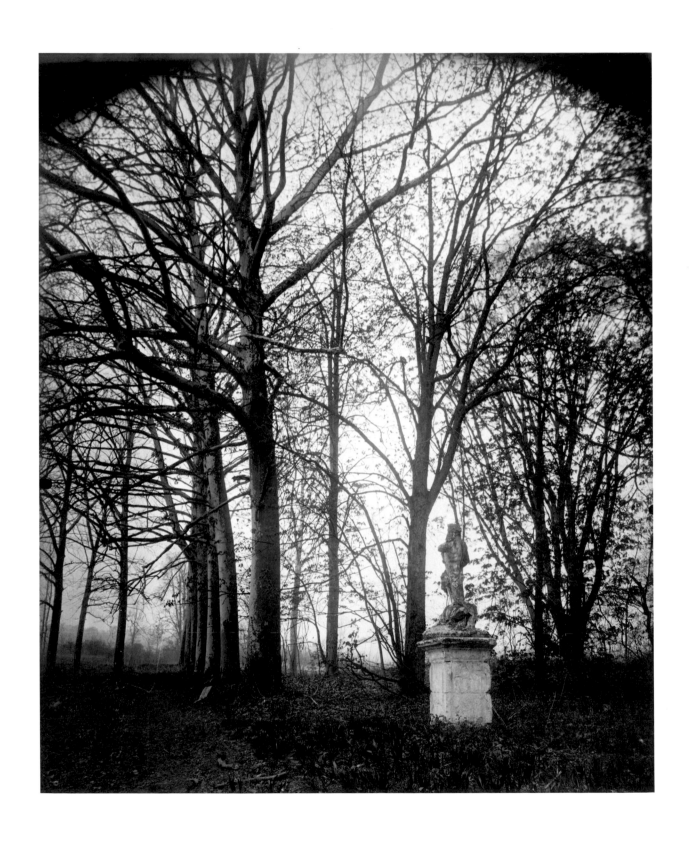

Pl. 103. Parc de Sceaux. Avril, 7 h. matin (1925)

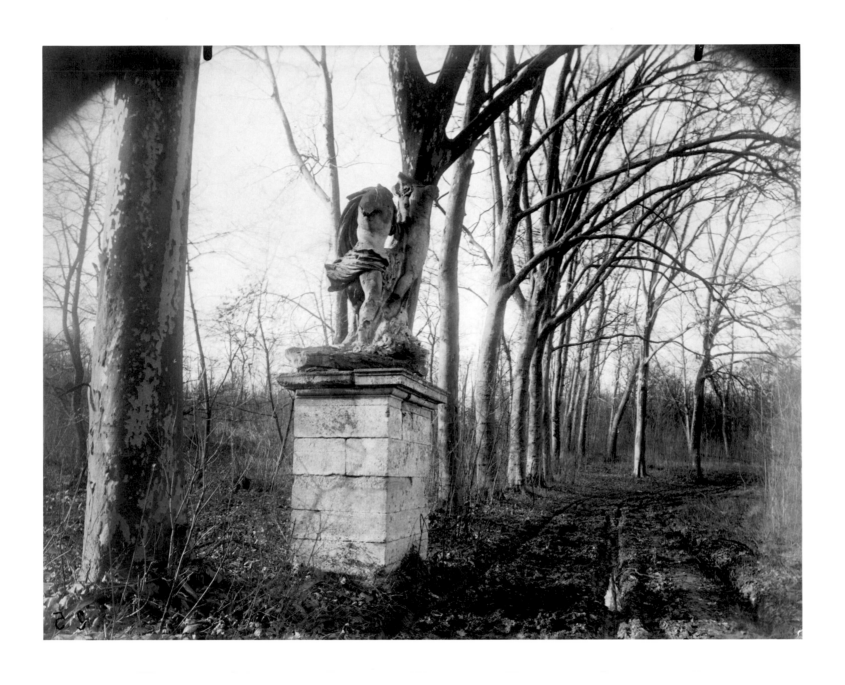

Pl. 104. Parc de Sceaux. Mars, 8 h. matin (1925)

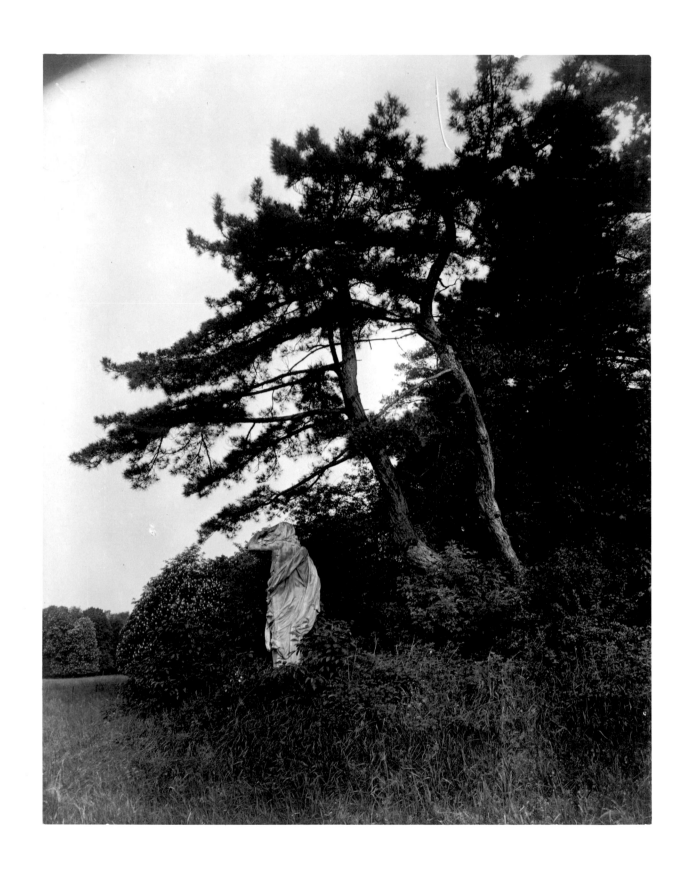

Pl. 105. Parc de Sceaux. Mai, 7 h. matin (1925)

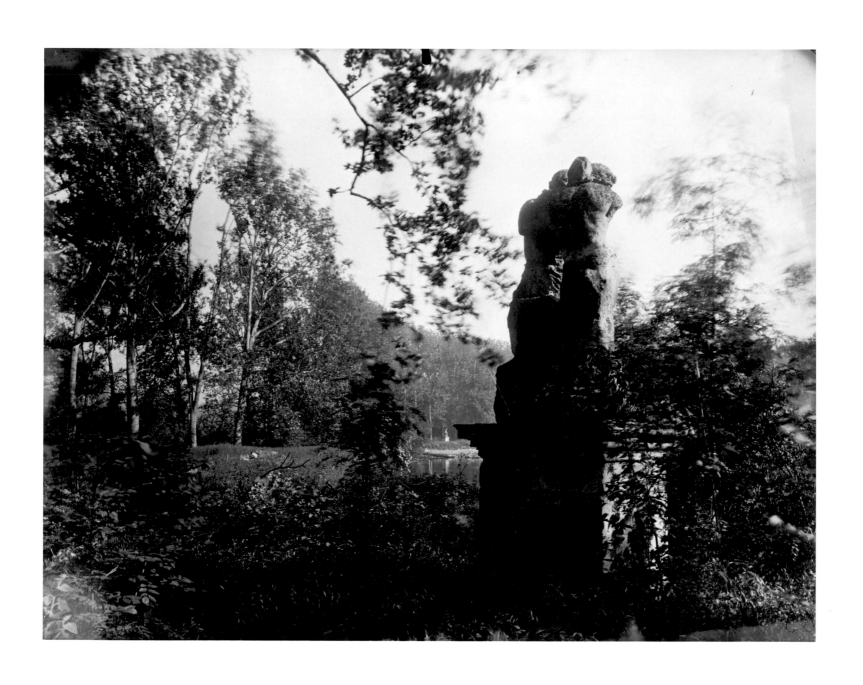

Pl. 106. Parc de Sceaux. Juin, 7 h. matin (1925)

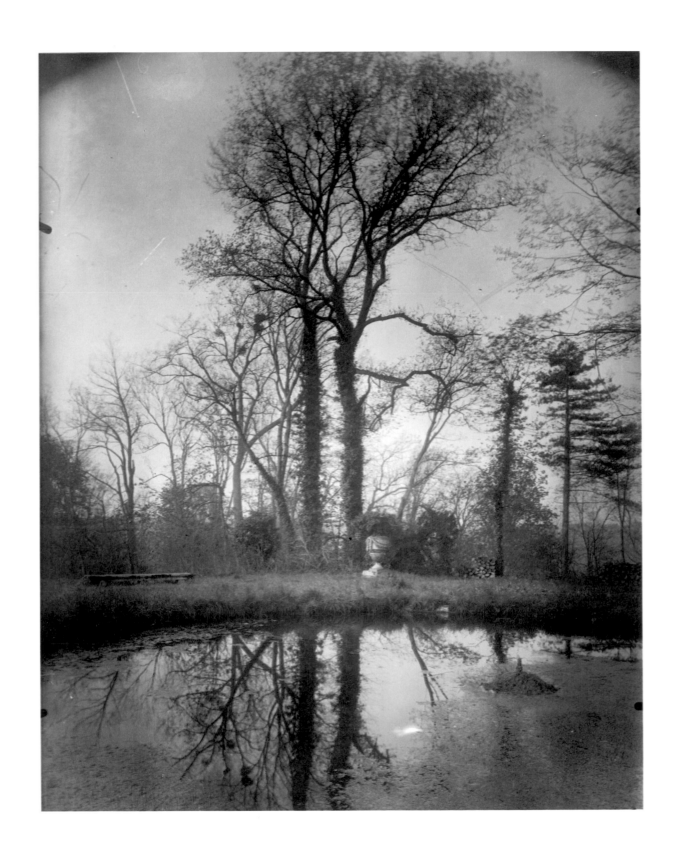

Pl. 107. Parc de Sceaux. Avril 1925, 7 h. matin

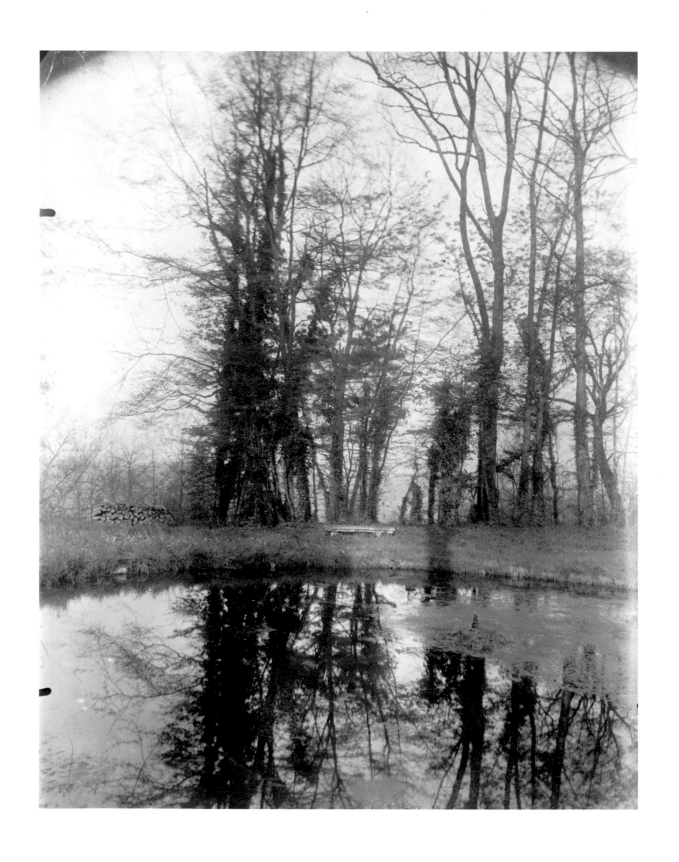

Pl. 108. Parc de Sceaux. Avril, 7 h. matin (1925)

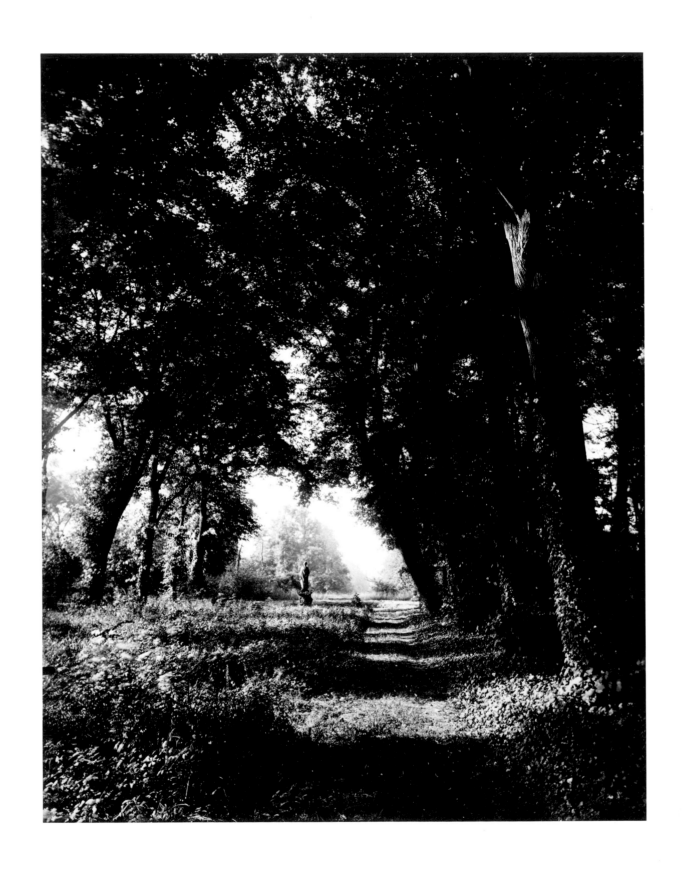

Pl. 109. Parc de Sceaux. Juin, 7 h. matin (1925)

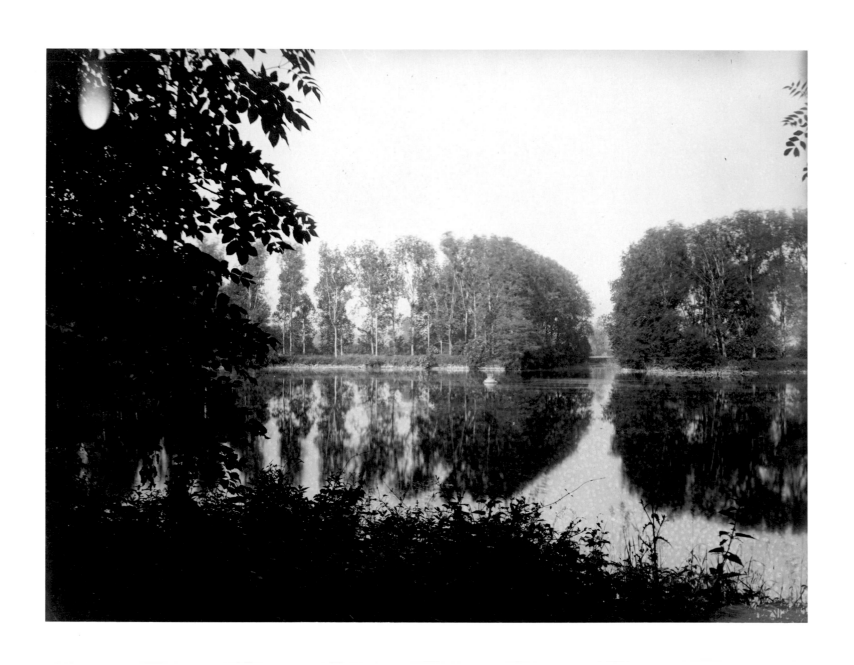

Pl. 110. Parc de Sceaux. Juin, 7 h. matin (1925)

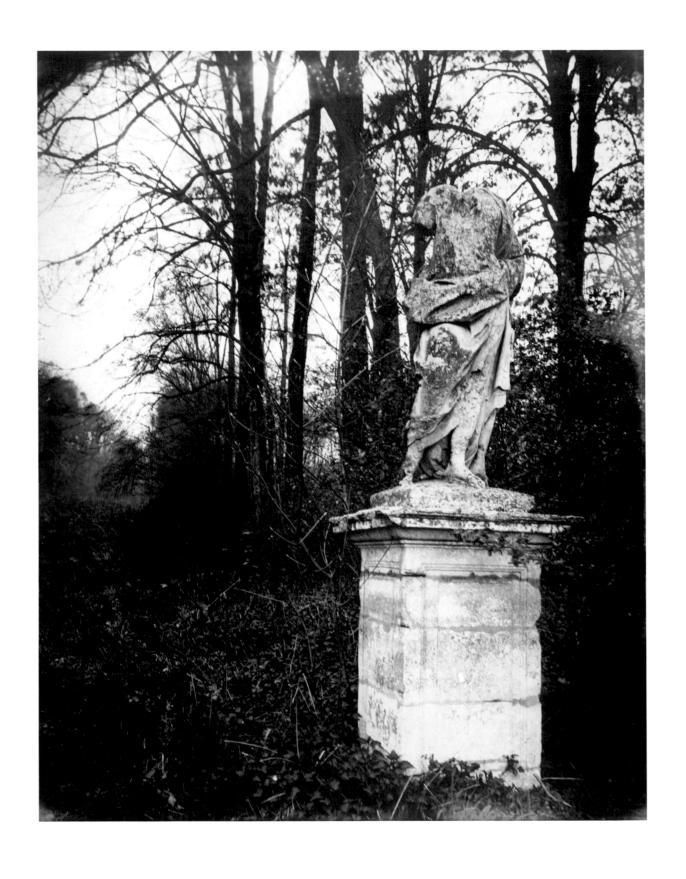

Pl. 111. Parc de Sceaux. Avril, 7 h. matin (1925)

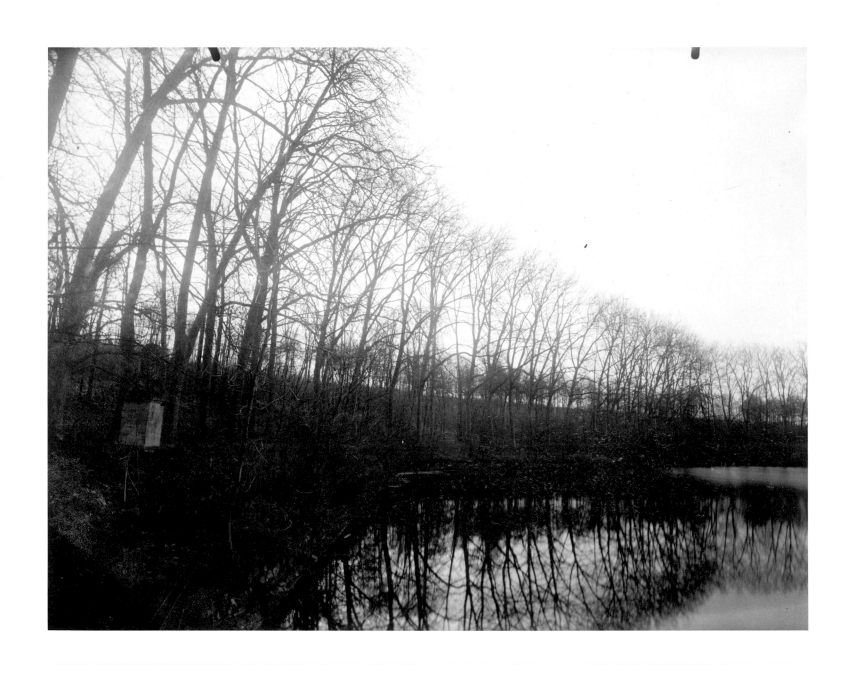

Pl. 112. Parc de Sceaux. Mars, 7 h. matin (1925)

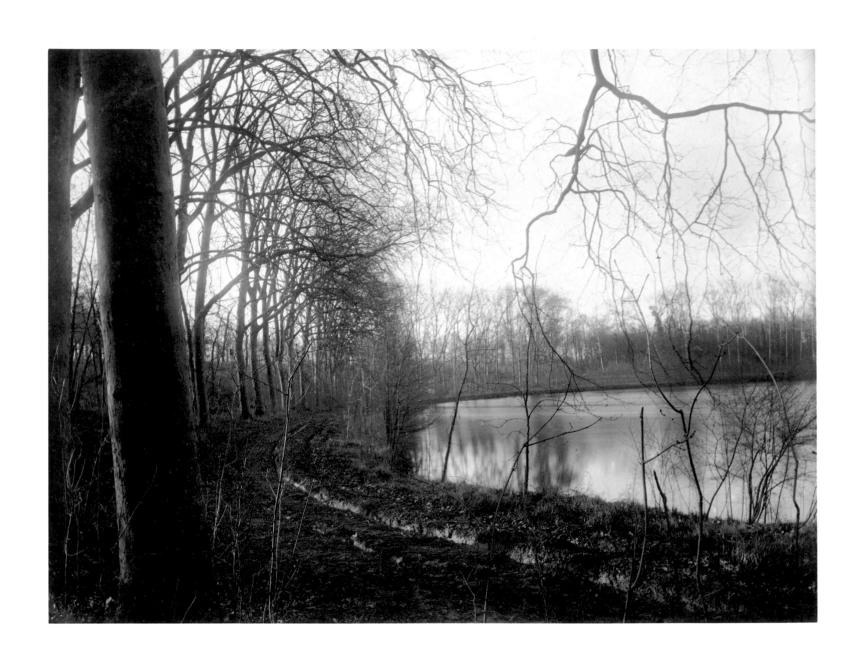

Pl. 113. Parc de Sceaux. Mars, 7 h. matin (1925)

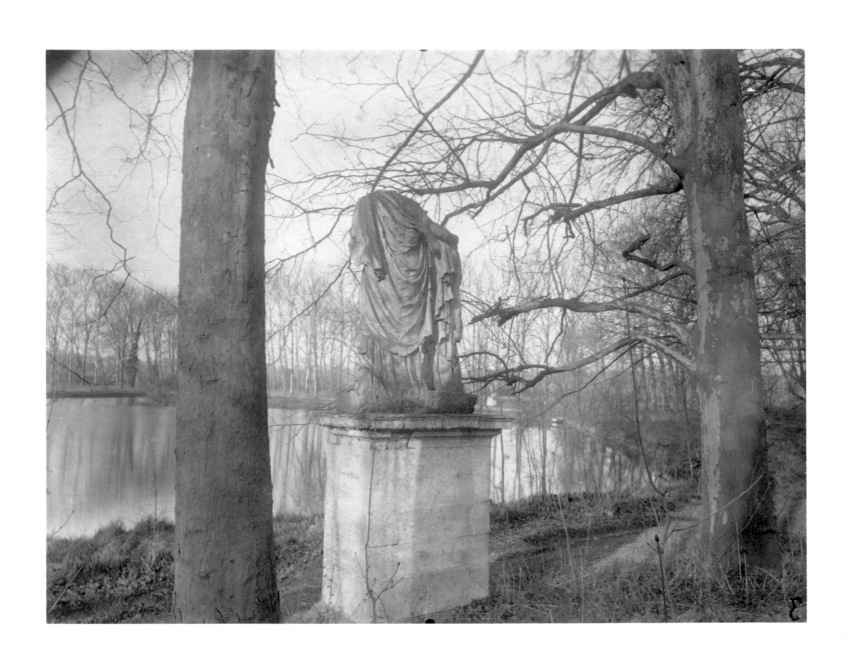

Pl. 114. Parc de Sceaux. Mars, 7 1/2 h. matin (1925)

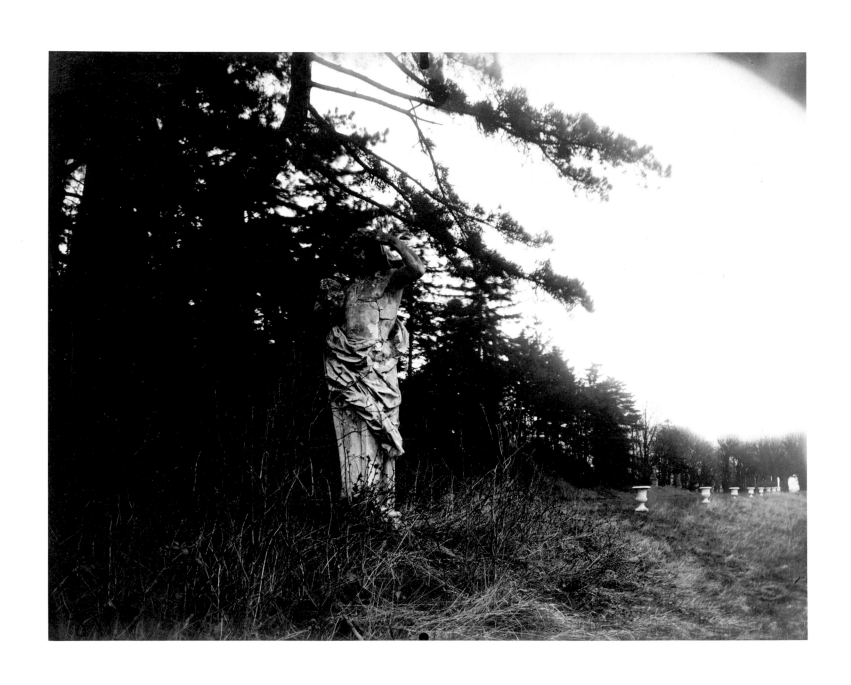

Pl. 115. Parc de Sceaux. Mars, 7 h. matin (1925)

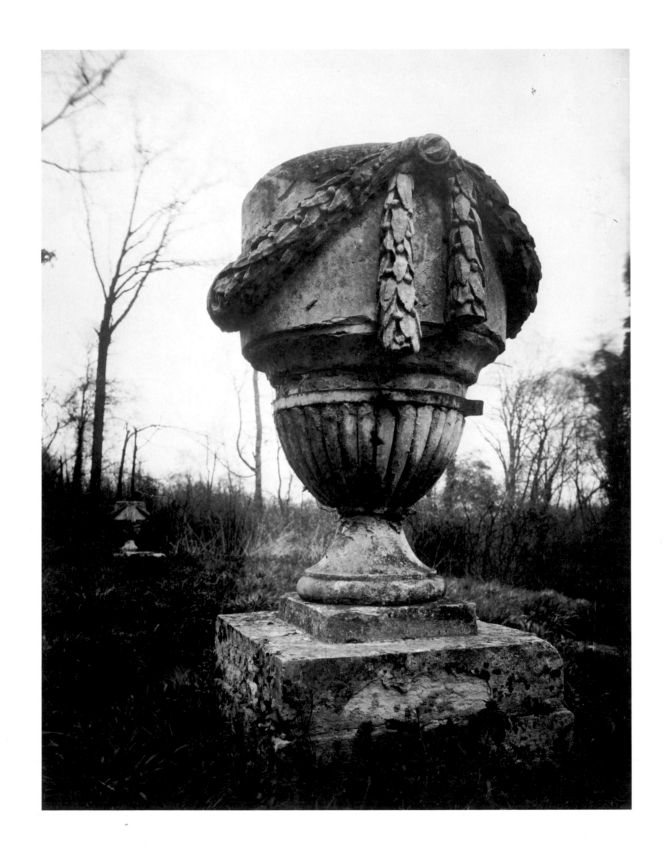

Pl. 116. Parc de Sceaux, vase. Avril, 7 h. matin (1925)

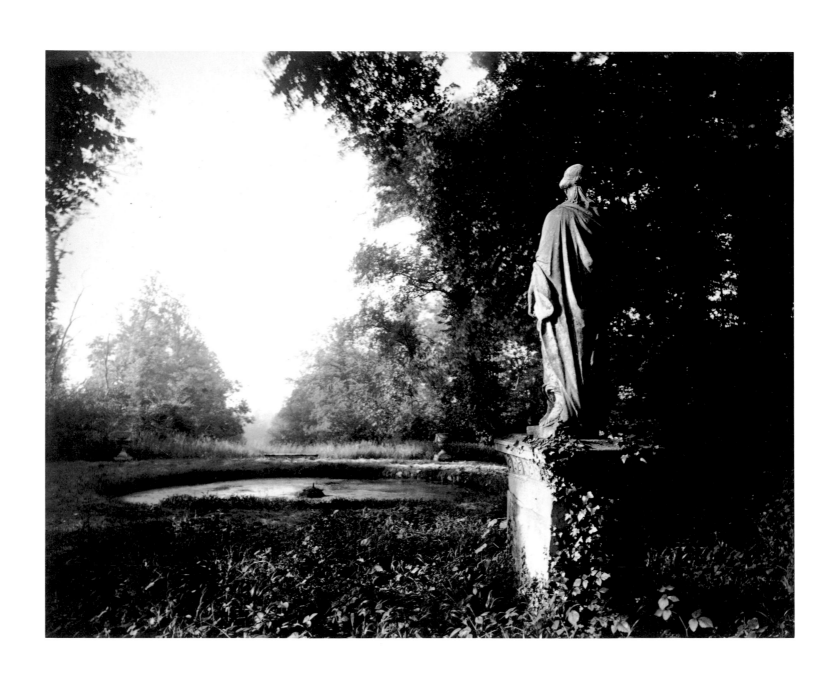

Pl. 117. Parc de Sceaux. (*June 1925*)

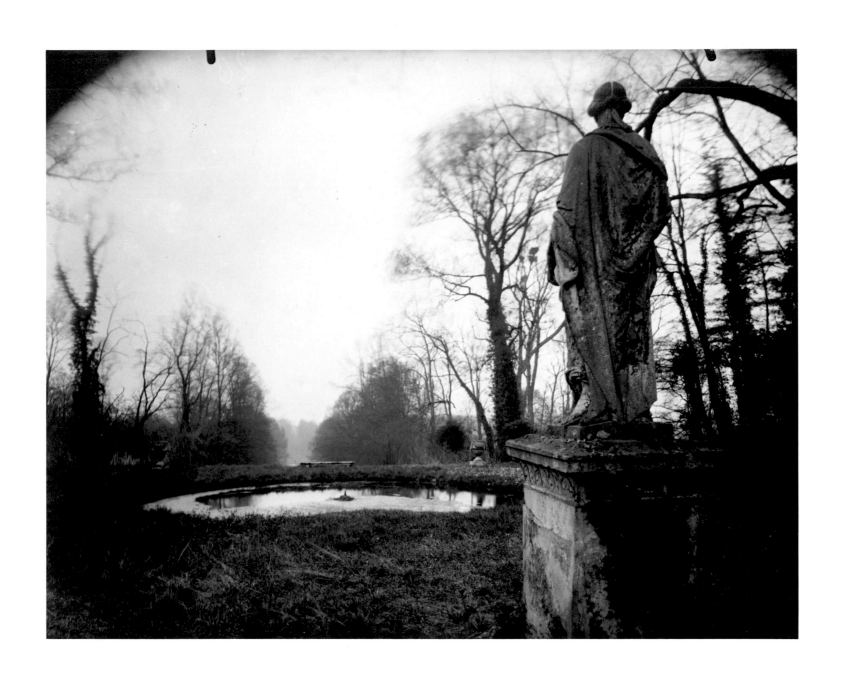

Pl. 118. Parc de Sceaux. Mars, 8 h. matin (1925)

Pl. 119. Parc de Sceaux. Mars, 7 h. matin (1925)

Notes to the Plates

ALL MEN have lived in modern times. The old dispensations have been defined in retrospect; in France there was no Ancien Régime until 1789, when the Revolution created it. That great change transformed the past into a clear idea.

Even in these relative terms, the title of this volume of Atget's work is both too broad and too simple. The real subject of this volume is Atget's view of three great and ambitious gardens created during the century and a quarter before the Revolution, plus a few more modest subjects that seem related in fact or in spirit to the Bourbon idea of civilized landscape.

Of all the arts, gardening is the most ephemeral. The parks that Atget photographed were not quite those that André Le Nôtre had designed for Louis XIV, or even those presided over a century later by Marie Antoinette. They had been changed by art and by nature. What a gardener sees in the morning is not quite what he left at sunset, and even Le Nôtre, with an army of assistants and the King's wealth, could not keep the trees from growing or keep the flowers in bloom—although he certainly tried. Supposedly he did not have a high opinion of the role of flowers in a garden, but Christopher Thacker quotes him as saying that there were two million flower pots in use at the Grand Trianon alone, so that the flowers in the parterres might, if it was so desired, be changed twice a day.*

The Renaissance garden—of which Versailles was the grandest and perhaps even the finest example—was a child of the invention of perspective. It expressed a way of ordering space that began with the spot from which one person viewed the world. (The medieval garden had been the creature of its wall; it was a small world within which art was achieved by division. It was conceived as a plan, and its order was best seen from above.) Versailles was conceived as a series of views, each presupposing a viewer—the King, standing in the right place, eyes some five feet above the ground. The spot where he stood was the most important place in the Western world, the apex of the hierarchical triangle, from which he looked down the long regimented *allées* to the ends of the earth.

Louis XIV had inherited Versailles from his father. The original château had been quite a modest residence for a king; Louis XIII had used it as a hunting lodge, and his son, a passionate hunter, might have been content to let it remain as such had it not been for the unseemly grandeur of Vaux-le-Vicomte, the new château of Nicolas Fouquet, Louis's minister of finance. In 1661, after attending the extravagantly magnificent housewarming—graced by a new comedy of Molière's, dinner on gold and silver plate for six thousand guests, and fireworks—Louis imprisoned Fouquet and confiscated his property for crimes that were doubtless real, thus demonstrating (as Will and Ariel Durant put it) that the appropriation of public funds for private pleasure was a prerogative of the king.†

Louis accepted the challenge of Vaux, and for the next forty years devoted a major portion of his astonishing energy and his country's wealth to the building of a monument that would be a fitting symbol for the greatest king in Christendom, beyond the ambition of French underlings or foreign monarchs.

With Fouquet in prison, Louis adopted his chief artists: the architect Louis Le Vau, the painter Charles Le Brun, and the landscape designer André Le Nôtre. Le Nôtre was a special favorite; years later, when he was eighty-eight, he would be carried around the immense gardens in his own chair, side by side with the King's. It is not known whether they followed the precise and dogmatic instructions that the King himself had written, defining the proper etiquette for viewing the gardens, which began: "1. Leaving the Château by the vestibule which is below the King's chamber, go to the terrace. Stop at the top of the steps to consider the gardens . . ."‡

The influence of Versailles was enormous and enduring; nevertheless, by the mid-eighteenth century, with Louis XIV dead for a generation, a reaction had begun. In England, Lancelot "Capability" Brown demonstrated that a garden need not be so severely regimented, that it could be more intimately and ambiguously a part of the landscape that surrounded and inspired it. Brown was not yet quite born when Addison complained in the *Spectator* that formal gardens gave us not orchards in flower, but "Cones, Globes, and Pyramids. . . . We see the marks of the Scissars upon every Plant and Bush."§ But Addison's ideas, and those of Alexander Pope soon afterward, helped undermine the authority of Le Nôtre's followers. In 1795 Humphrey Repton advised (too late for the Bourbons) that "it is not by vast labour, or great expense, that nature is generally to be improved; on the contrary,

'Insult not Nature with absurd expense,
Nor spoil her simple charms by vain pretence;
Weigh well the subject, be with caution bold,
Profuse of genius, not profuse of gold.' "‖

Brown's own follower Thomas Blaikie worked in France in the late eighteenth century, although not altogether happily. He complained in his diary that the French "look upon a house and a garden as two objects that do not correspond with each other."# Whatever justice there may have been in Blaikie's complaint, French gardens, including Versailles, had changed substantially by the time of Louis XVI, who felt much less like an absolute monarch than his great-great-great-grandfather. After the disastrous wars of the aging Louis XIV, the style of the court during the remainder of the eighteenth century was

* Christopher Thacker, *The History of Gardens* (Berkeley and Los Angeles: University of California Press, 1979), p. 157.

† Will and Ariel Durant, *The Age of Louis XIV* (New York: Simon and Schuster, 1963), p. 20.

‡ Thacker, op. cit., p. 149. Thacker's full translation of "La Manière de montrer les jardins de Versailles" can be found in *Garden History*, 1 (Sept. 1972).

§ Quoted in Thacker, *The History of Gardens*, p. 181.

‖ Humphrey Repton, "Sketches and Hints on Landscape Gardening" (1795), in *The Art of Landscape Gardening*, ed. John Nolen (Boston: Houghton Mifflin and Co., 1907), p. 3.

William H. Adams, *The French Garden 1500–1800* (New York: George Braziller, 1979), p. 125.

one that seemed less imperial, if not more modest, and the kings were served by designers who gave them softer and more private gardens. When Louis XVI ascended the throne in 1774, he gave Marie Antoinette the Petit Trianon for her own, and she proceeded immediately to refashion its grounds into a *jardin anglais*. One astonished visitor, surveying the result, said that "never have two acres of land so completely changed their form, nor cost so much money."*

The gardens that Atget photographed had been changed by inexorable nature and by shifts in taste that were both aesthetic and political. Nevertheless, the basic lineaments of Versailles remained, and a photographer who wished to do so could have seen the place more or less as Le Nôtre would have wanted it seen, with emphasis on its mathematical clarity, its immensity, its severe authoritarian grandeur. Other photographers of the time managed this better than Atget, by standing in the obvious places—on the axes of the vast facades, great alleys, and parterres. Atget was evidently looking for something else. It would be reckless to state that he never once, during all his years at Versailles, pointed his camera straight down the axis of an avenue or canal, but this writer does not recall an example.

It is characteristic of Atget that he avoided a ninety-degree approach to his subjects. (Even his photographs of Parisian doors generally are subtly oblique; perhaps the quality of the light, or the relief of frame and moldings, was better described from a vantage point slightly off the theoretically correct one, or perhaps the grid of perfect parallel lines simply seemed rigid and boring.)

It is also true that Atget was not impressed by size, and seemed to have a positive distaste for the grandiose. Among the remarkable aspects of his work at Versailles are the facts that he clearly loved to make pictures there, in spite of its immensity and its almost Roman arrogance, and that he managed, without exactly lying, to recreate the place in a more human scale, animated by more natural rhythms.

* * *

Atget's work in the great parks, when viewed chronologically, suggests that the major projects under this heading were more clearly discrete in Atget's mind than this viewer would have assumed. It had seemed to me that the Versailles series and the Saint-Cloud series would have naturally marched together, the successes and discoveries made in one eighteenth-century park surely being transplantable to another a few kilometers away. This assumption now seems less tenable. One might suppose instead that Atget approached the two places as an actor might approach two roles, each requiring a special understanding and a distinct voice. Advances in craft would be carried from one theater to the other, but in the more difficult matter of defining the special essence of a given character (or a given place), previous successes need not help.

The style of Atget's work at Versailles changed considerably

during the quarter-century he worked there; nevertheless, an enduring element in his vision of that place was his sense of it as a great outdoor museum, an exhibition of works of art and facts of history that produced, even in the mind of a free-thinker, an attitude not untouched by the sentiment of patriotism. Versailles, for better and worse, was a diorama of France at a time of unparalleled grandeur.

Saint-Cloud, although splendid, had not quite the same status, nor was it so rich a repository of venerable objects; it was closer to a park in the sense that a modern American, or Australian, might understand the word—a beautiful half-natural place with less clear political connotations. To the degree that the park of Saint-Cloud represented for Atget's time an idea, that idea perhaps touched less the known and recent history of the Bourbons than an ancient and intuited remembrance of the Mediterranean. It was a popular place for ordinary Frenchmen on those Sundays when the water was turned on; the cascade was an exuberant spectacle that was perhaps less neoclassical than truly Greek. Saint-Cloud was a place where one might confront a landscape related to Rousseau's myth, evoking an authority that was not modern and European but permanent and pagan.

Or, to retreat a little from such reckless speculation, one might simply observe that Atget's pictures at Saint-Cloud, in comparison with those at Versailles, are typically more abstract, less specifically informative, and more willful in their effort to describe the ineffable.

Atget began his work at Versailles in 1901 and at Saint-Cloud in 1904, and he returned to both parks many times during the years that followed; after the war, especially, these places assumed an even greater proportional role in his slower, more fastidious production, except in the year 1925, in which it seems he visited neither place.

By a great stroke of good luck, Atget apparently did not discover the abandoned, decayed gardens of Sceaux until the autumn of 1924, and he did not begin photographing them until the next spring. The year 1925 was perhaps his very best; it would seem that wherever he looked that year he found a beautiful picture. His mind and his eye now seemed scarcely distinguishable; after a lifetime of hard-won successes, paid for by uncounted failures, he was awarded a season of grace, during which almost everything he tried succeeded. In terms of the special opportunity of Sceaux he was doubly lucky; he began his work in March, and by July the park had begun to be restored. In four months he had made sixty-six plates, before the eloquent ruin was converted into a handsome public park.

In 1926 Atget returned to Versailles, where he made perhaps as many as a dozen pictures, and to Saint-Cloud, where he made twenty-five. Fifteen of these twenty-five are reproduced as plates or figures in this volume or in the first volume of this book.

By the next year his health had broken; there is no evidence that he made a picture after May, and in August he died. He did not visit Versailles that spring, but he did go once more to Saint-Cloud, and exposed four plates. It was perhaps an act of

* Ian Dunlop, *Versailles* (London: B. T. Batsford Ltd., 1956), p. 207.

simple homage. He attempted no new motifs but revisited places that he had photographed many times, avoiding now the steps down into the lowest terraces. His final picture there (fig. 45) is the last of six variants of the subject. He had photographed the same spot before in 1904, 1922, 1923, 1924.

In a world of perfect poetic justice the last photographs would not have been necessary. He might have ended the series in his last working summer, perhaps with the picture reproduced here as plate 89: the last and simplest and perhaps the most moving in his long series of Saint-Cloud's reflecting pools. There is little remaining here of information valuable to students of Le Nôtre and the sculptors and engineers who helped realize his beautiful scheme. One might say that this long sequence of pictures came finally to consider the meaning of the horizon; the line that defines the limits of perspective's philosophy, the line that separates day from night, understanding from knowing, ambition from longing.

* * *

The following notes to the plates and related illustrations (figures) that reproduce photographs by Atget provide the following information: title, date, Atget negative number, and Museum of Modern Art acquisition number. The titles are those he wrote on the back of his prints or in the paper albums in which he stored them. Where inconsistencies occur in the form of the title of a given subject, we have for the sake of clarity sometimes adopted the most common form. Clarifications or additions to Atget's titles are enclosed in brackets. Dates in parentheses have been attributed on the basis of the dating charts reproduced in this volume; those without parentheses were recorded by Atget on the prints or in the albums. The letters that precede Atget's negative numbers indicate the series to which the picture belongs; these letters do not appear on Atget's plates or prints. (See the explanation of the dating charts, p. 181.) All Atget photographs reproduced in this volume are from prints by Atget, with the exception of plate 101, by the Chicago Albumen Works, and figure 45, by Richard Benson. Acquisition numbers beginning "1.69 . . ." indicate prints from the Abbott-Levy Collection, acquired by the Museum in 1968; those ending in ".50" were acquired from Berenice Abbott in 1950. All the Atget prints reproduced in this volume are contact prints reproduced from plates measuring 18×24 cm.

J.S.

Fig. 1

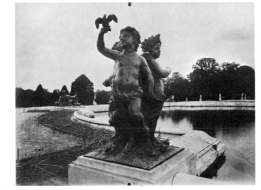

Fig. 2

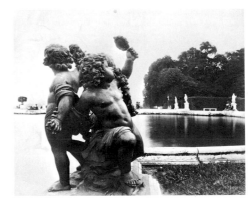

Fig. 3

Frontispiece. *Versailles, parc, Le Printemps par Magnier.*
(1901.) E:6167. MoMA 1.69.2775

Fig. 1. *Versailles, Bassin de Neptune.* (1901.) E:6049. MoMA
1.69.208

Fig. 2. *Versailles, parc.* (1901.) E:6050. MoMA 1.69.2785

Fig. 3. *Versailles, parc.* (1901.) E:6099. MoMA 1.69.39

Atget first photographed Versailles during the growing season
of 1901. Before the end of 1902 he appears to have visited the
park no less than sixteen times, and to have made approximately
150 negatives there. (When the numbering sequence of which
these pictures are a part is interrupted by subjects from other
locations, the interruption is assumed to mark separate trips.)

The frontispiece shows one of the characteristic pictorial so-
lutions that Atget discovered during 1901 and that he repeated
frequently during this and the following year (see pls. 9, 11,
22). A strongly lighted principal figure is placed off-center
against a flat backdrop of dark foliage; on the other side a diag-
onal path penetrates into deep space. The contrasts offered by
the organic freedom of the massed tree forms, the ordered con-
tainment of the sculptures, and the mathematical severity of the
architectural context allowed a wide variety of solutions within
the basic formula.

Figures 1 and 2 show two of five pictures that Atget appar-
ently made on his first visit to Versailles. Figure 1 is interesting
in its inclusion of so many of the elements that would occupy
him in the parks of the great châteaux, but the picture is tergi-
versating in its aim and meandering in its effect. The coinci-
dence of the rim of the vase with the rim of the pool was
presumably inadvertent, and the many details of the architec-
ture and the landscape that interrupt the profile of the vase
confuse the description both in graphic and spatial terms.

Figure 2 is a much clearer and more confident picture, but
nevertheless seems slightly tentative if compared to figure 3,
made of a related sculpture three or four trips later in the year.
The compositional scheme here is an inversion of the device
described above in reference to the frontispiece. The dark fig-
ures are now silhouetted against the bright sky (and its reflection

in the pool), and the reference to deep space is achieved by
inclusion of the distant figures against the dark trees. Here and
in its more typical formulation this family of pictures is charac-
terized by a dynamic asymmetry that combines graphic sim-
plicity with energy and athletic grace.

Pl. 1. *Versailles, vase.* (1905.) E:6572. MoMA 118.50

The park of Versailles was not only a garden but a museum,
filled with an enormous quantity of sculpture and vases that
generally had been created for the park, and were in some cases
still there in Atget's time. During his first four years at Ver-
sailles, Atget tended to see the great vases as compositional ele-
ments in the architectural landscape (see pls. 2, 5, 10). From
1905 onward he becomes increasingly interested in the vases
themselves, both for their referential import and as independent
sculptures. Plates 1 and 7, perhaps made on the same day, may
be seen as transitional; the earlier interest in deep space remains
evident, but the vase itself assumes a central importance, a pres-
ence that transcends the formal role of space modulator. The
change in the character of Atget's attention can also be seen in
the difference between plate 2 and plate 7, separated by four
years. The elements of the two pictures are very similar, but the
first shows us a noble architectural space, the second a myste-
rious artifact, a relic that commands our attention by force of
its own crumbling beauty.

Plate 1 is in formal terms one of Atget's more flamboyant
pictures. The vase is centered over a very powerfully indicated
vanishing point, which produces a heightened tension between
the contradictory claims of pattern and depth.

Pl. 2. *Versailles, parc.* (1901.) E:6078. MoMA 1.69.2827

Fig. 4. Neurdein Frères (X. Phot.). *Parc de Versailles,
Le Bassin de Latone.* (No date.) No. 259

Fig. 5. *Versailles, le château.* (1901.) E:6065. MoMA 1.69.2804

Fig. 6. *Versailles, cour d'honneur.* (1901.) E:6064. MoMA
1.69.2817

163

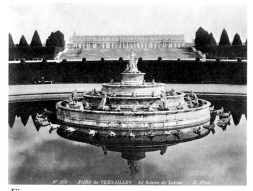

Fig. 4

Fig. 5

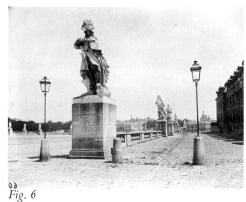

Fig. 6

Fig. 7. *Versailles [le château, fin octobre soir, effet d'orage,*
vue prise du Parterre du Nord]. (1903.) E:6446. MoMA
1.69.2809

Fig. 8. *Versailles, le château.* (1905.) E:6581. MoMA 1.69.120

Fig. 9. *Versailles.* (1922–23.) V:1202. MoMA 1.69.2811

Atget's reluctance to place his camera in the obvious place sometimes seems almost perverse, and never more so than in his apparent refusal—over the course of twelve years of photographing Versailles—to produce one standard elevation view of Le Vau's and Mansart's great château. (See fig. 4, by Neurdein Frères, one of the several firms with which Atget competed.) Here as elsewhere, Atget's preference was for the oblique, the tangential, the fragmentary. One might be tempted to speculate that the very enormity of the château, its massive authoritarian weight, was incompatible with Atget's sense of measure and propriety, but it would probably be more to the point to say that he approached it much as he did a simple farmhouse, using those parts and aspects that seemed good grist for his mill, and ignoring the rest without prejudice.

It appears that Atget first attempted the château on his second trip to Versailles (fig. 5) and satisfied himself, for whatever reason, with recording one small corner of the sprawling complex. On the same trip he photographed the Cour d'Honneur (fig. 6), making a rather indecisive and pedestrian picture that nevertheless contains the seeds of plate 2 and other similar successes that he would make in the weeks to come.

Figure 6 is unusual in that it was made on the side of the château that faced the city; subsequently almost all of his pictures of the palace are from the garden side, and show it as an element of the park. Figures 7, 8, and 9, spanning a period of twenty years, show as much of the château as Atget seems to have attempted. In figure 7 Atget tried to darken the sky by "burning," that is, by giving additional exposure to that portion of the picture during its printing. Other prints from the same negative are marginally more successful—or less clearly failures—in this attempt. It does not appear that Atget repeated the experiment with other negatives.

In figure 8 the complexity and weight of the building are unified and lightened by the soft atmospheric mist. The dark garden further serves to dematerialize the château and make it an element in a coherent pictorial scheme. In figure 9, perhaps more completely than in any of his previous attempts, he succeeds in subjugating the architect Mansart to the gardener Le Nôtre without actually ignoring the building.

Pl. 3. *[Petit] Trianon.* (1902.) E:6239. MoMA 1.69.154

Either carelessness or genuine confusion caused Atget to identify this building as the Grand Trianon, mistaking J.-A. Gabriel's pavilion of the later eighteenth century, shown here, with Mansart's very different work of almost a century earlier.

Pl. 4. *Versailles, parc.* (1902.) E:6381. MoMA 1.69.984

Pl. 5. *Versailles, parc.* Juillet 1901. E:6116. MoMA 1.69.2828

Until late in his life, Atget seldom dated the prints in his own files, although he generally assigned a year to the pictures that he sold to the various official libraries—presumably because they wanted it. In 1901, however, he frequently recorded the date of his pictures in his own files, perhaps because he felt that they marked some special achievement or benchmark.

Pl. 6. *Versailles, escalier de l'Orangerie, 103 degrés, 20 mètres*
de largeur. Juillet 1901. E:6125. MoMA 1.69.989

The Hundred Steps frame the Orangerie, and mount to the main terraces and parterres of the château's garden front. It is a much photographed motif, but perhaps no other picture of it emanates the hallucinatory force of this one. The great staircase seems here—with its high, slightly canted horizon and long, barren foreground—to suggest not so much the power and grandeur of an absolute monarch as the punishment of Sisyphus.

Pl. 7. *Versailles.* (1905.) E:6580. MoMA 1.69.89

See note for plate 1.

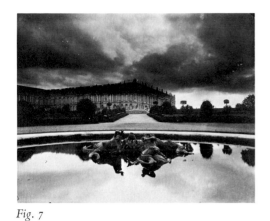

Fig. 7

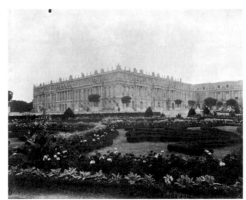

Fig. 8

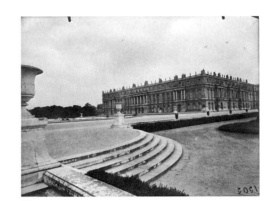

Fig. 9

Pl. 8. *Versailles, vase.* (1905.) E:6579. MoMA 1.69.187
Fig. 10. *Versailles, vase.* (1906.) E:6650. MoMA 1.69.182

It will be useful for the serious student to compare this picture
with figure 1, plate 1, figure 10, and plate 16—the five pictures
providing a brief summary of Atget's approach to the vases of
Versailles over a period of more than two decades. This family
of subjects was clearly a pleasure for Atget. The vases also pro-
vided a superb pedagogical lesson; the problem was always new
but never wholly new, and Atget could approach each new
example with a clear recollection of previous successes and fail-
ures. Considered as a series, these pictures change in three ways:
they move toward a concern for the sculptural content of the
subject, toward a greater economy in their definition of what
information is necessary, and toward a progressively sophisti-
cated grasp of photographic indication: the ways in which pho-
tographs convey information. Plate 8 demonstrates that the de-
scription of a simple form can be greatly abbreviated and still
perceived as whole, if adequate clues are provided. In this case
the light on the lip of the vase is essential; by describing the top
of the form it assures us that the right edge of the vase is, by
analogy, much like the left.

Pl. 9. *Versailles, Cyparisse par Flamen.* (1902.) E:6363.
 MoMA 1.69.4345

The statue represents Cyparisse, with his pet deer that he acci-
dentally killed while hunting. His despair was so great that he
wanted to kill himself, but Apollo, who liked the young man,
intervened and turned him into a cypress. See the note for
plate 14.

Pl. 10. *Trianon.* 1901. E:6157. MoMA 1.69.3211

Structurally, this picture is another interesting variant on the
compositional scheme discussed in the note for the frontispiece.
In the early Versailles pictures of this family, Atget seems con-
sistently to have chosen an hour when the trees were in shadow,
so that the foliage reads as a simple dark form.

Pl. 11. *Versailles.* (1901.) E:6075. MoMA 1.69.1946
Pl. 12. *Grand Trianon.* (1923–24.) V:1240. MoMA 1.69.1968
Pl. 13. *Trianon.* (1923–24.) V:1238. MoMA 1.69.2791

In 1921 Atget returned to his Versailles series after a hiatus of
fourteen years. The change in his vision is remarkable: his ear-
lier affection for rushing Baroque space and high drama has
been replaced by a taste for the serene and pellucid. His best
new pictures are now flatter and quieter in their construction,
but are no less vital. Atget's sense of the artistic possibilities of
the contingent and the conditional has grown stronger; the later
pictures are not composed out of knowledge, but discovered
out of a great and generous openness to the possibilities of sight.

Pl. 14. *Versailles, parc.* (1902.) E:6364. MoMA 1.69.88
Fig. 11. *Versailles, coin de parc.* (1902.) E:6361. MoMA 1.69.2774
Fig. 12. *Versailles, Vénus sortant du bain par Legros.* (1902.)
 E:6351. MoMA Study Collection, same as MoMA 1.69.1008

Plates 14 and 9 and figures 11 and 12 are based on the schematic
pattern discussed in the note for the frontispiece, with the dif-
ference that these four pictures introduce a nearer plane—half of
a proscenium arch—by including a close tree bole on one side
of the picture. The four pictures listed above were all made in
1902; the frontispiece, plate 11, and plate 22 were made in the
previous year. This could be explained as random coincidence,
but working photographers would have a different and (I think)
more persuasive explanation. In the first of the pictures (fig. 12)
the inclusion of the tree might have been dictated by another
unrelated consideration, formal or technical: by a wished-for
relationship between the sculpture and the tree mass, or by the
simple need to find a vantage point where a shadow shielded
the lens from the sun. If the first picture works, what started as
an expedient experiment becomes part of the photographer's
knowledge of formal possibilities (or bag of tricks).

The statue in figure 12 is the same one that appears in plate
21, made twenty-four years later. The years and their vandals
have taken their toll of Venus, and Atget's style has been
radically simplified.

Fig. 10

Fig. 11

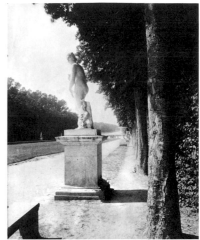

Fig. 12

According to Atget's inscription, the sculpture is by Legros, presumably Pierre Legros the Elder (1666–1719).

Pl. 15. *Grand Trianon.* (1923–24.) v:1210. MoMA 1.69.1940
Pl. 16. *Versailles.* (1922–23.) v:1176. MoMA 1.69.67

See note for plate 8. Plate 16 represents one of Atget's last vases at Versailles, and perhaps his best. Place your hand over the upper-left corner of the picture, and consider how the sculptural form of the vase disappears.

Pl. 17. *Grand Trianon, Pavillon de Musique.* (1923–24.)
v:1213. MoMA 1.69.2821

Atget's best attention seems to have been devoted to the periphery of great subjects. At Versailles his success cannot be measured by his photographs of the château, or the major fountains and parterres, which issues he seems scarcely to have confronted. In terms of the park itself, one could not on the basis of his pictures reconstruct a reasonable guess as to its form or extent. He photographed not the topography of the place, but what he understood to be its essence. To this end, he paid special attention to the subsidiary objects and structures of the place, perhaps for no better reason than that they lent themselves better to the needs of his art. For Atget the tiny Pavillon de Musique could be seen, as the great palace could not, as a demonstration of the claims of human intelligence and humane order within the larger authority of nature.

Pl. 18. *Grand Trianon, Le Temple de l'Amour à travers les arbres.* (1923–24.) v:1211. MoMA 1.69.214
Fig. 13. Neurdein Frères (X. Phot.). *Trianon, Le Temple de l'Amour.* (No date.) No. 268

The Temple of Love, the Pavilion of Music (pl. 17), and the Farm (pl. 30), all designed for Marie Antoinette toward the end of the regime, express the profound shift in the sense of Versailles's function that had occurred during the century separating the first designs of Le Vau and Le Nôtre from the accession of Louis XVI. Early Versailles was a statement of the power and

glory of the state; late Versailles celebrated the private pleasures of aristocratic privilege and the exquisite arts of amusement. To a modern viewer—like Atget—the gay Rococo conceits of late Versailles seem a little like beautiful broken toys. In Atget's late work in the parks of the great châteaux his subject seems consistently to touch the idea of loss, and a sense of interruption, similar to that felt by the traveler seeing the remains of Ozymandias's statue.

Pl. 19. *Trianon.* (1926.) v:1256. MoMA 1.69.1941

Of the plates in this volume, this picture is the last among those he made at Versailles. He would expose only five more plates there.

Pl. 20. *Versailles, Poème Satirique.* (1923–24.) v:1219.
MoMA 1.69.1958
Pl. 21. *Versailles, Vénus par Legros.* (1923–24.) v:1245.
MoMA 1.69.3210
Fig. 14. *Versailles, Vénus sortant du bain par Legros.* (1923–24.)
v:1244. MoMA 1.69.2801

The sculpture shown in plate 21 and figure 14 had been photographed by Atget over twenty years earlier (see fig. 12). The simplification of the subject in the later versions is characteristic. The difference between plate 21 and figure 14, which bear adjacent negative numbers, may suggest at least part of the motive that led to this need for simplifying the problem. The two pictures are very similar, much closer in their distinction than was normal for Atget, who generally seems to have known precisely where he wished to stand. The writer assumes that negative 1244 was made before 1245, not because it has a smaller number but because 1245 is a refinement, an improvement, of its antecedent. By moving a little to his right Atget has freed the hands and their gesture from the torso, and has accentuated the potential for movement—knee and shoulders forward—that the work proposes. He can move no further to the right (in this light) without losing the black line that separates the knees, which is essential. When such issues become important, they are enough,

166

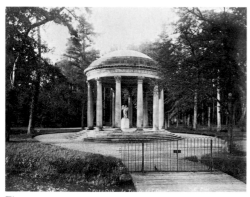

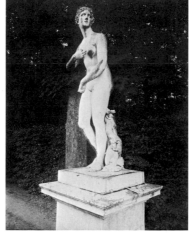

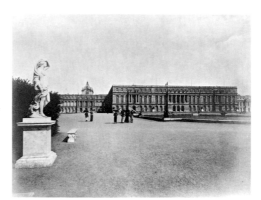

Fig. 13 Fig. 14 Fig. 15

and will not be compromised by more obvious artistic ambitions.

Pl. 22. *Versailles, parc.* (1901.) E:6074. MoMA 1.69.207
Fig. 15. L.P. Phot. *Versailles, le château et
le parterre d'eau.* (No date.) No. 234

A rough notion of how radically Atget simplified and clarified visual possibilities can sometimes be grasped by comparing his pictures with those made on the same sites by his contemporaries and competitors. Figure 15, by the firm known as "L.P.," is approximately contemporary with plate 22 by Atget. It seems likely that it corresponds more closely than the Atget to what we would have seen had we been there.

Pl. 23. [*Petit*] *Trianon* [*Pavillon Français*]. (1923–24.) V:1225.
MoMA 1.69.1955
Fig. 16. [*Petit*] *Trianon* [*Pavillon Français*]. (1903.) E:6283.
MoMA 1.69.987
Fig. 17. [*Petit*] *Trianon* [*Pavillon Français*]. (1902.) E:6238.
MoMA 1.69.2794

Atget photographed the Pavillon Français on at least two occasions prior to the picture of 1923–24 reproduced as plate 23. Typically, his last picture of the subject is the most serenely composed. During the preceding three years Atget had made most of his pictures of the reflecting pools at Saint-Cloud (pls. 84–95), where he had been fascinated with the shapes of the dark trees mirrored in the water and the corresponding negative shapes of the sky and water. In plate 23 the similarity of the framing trees provides a comparable symmetry to the sky and water shapes, and the pattern forms a vaguely ominous Rorschach background for J.-A. Gabriel's elegant garden house. Figure 16 shows a different face of the building, ninety degrees removed from the viewpoint of the other two pictures.

Pl. 24. *Trianon.* (1923–24.) V:1234. MoMA 1.69.51

Atget's late work is very bold in its acceptance of extreme lighting conditions. The light that falls on the two busts here is, from the point of view of sculptural documentation, impossible. The strong sunlight strikes the white stone almost from the axis of vision, erasing all modulation and detail, and subsuming the sculptures into a violent pattern of brilliant highlights and dark shadows. Atget, in his later sixties, was surely not surprised by the character of his negative. The question remains, what did he think he was photographing?

Pl. 25. *Grand Trianon.* (1924–25.) V:1254. MoMA 1.69.2818

The mature Atget would also often photograph directly into the light—a practice now made familiar by coated lenses and anti-halation films, but habitually avoided by sober-minded professionals of Atget's day, since it resulted in a serious loss of detail in both highlights and shadows and a vaporous flare (halation) where the two met. Atget learned to use the limitations of his lens and plates to his advantage, by anticipating the result and using it to produce the illusion of brilliant, radiant skies and a palpable sense of the physical atmosphere. The illusion is created not by the highlights (which are at best not so white as paper), but by the dissolution of the black foliage, which seems burned away by the brilliance of the light. (See also Vol. I, pls. 61 and 97.)

Pl. 26. *Versailles, vase.* (1905.) E:6576. MoMA 1.69.124
Pl. 27. *Versailles, vase (détail).* (1906.) E:6645. MoMA
1.69.1960
Pl. 28. *Versailles, vase (détail).* (1906.) E:6646. MoMA
1.69.186
Pl. 29. *Versailles, vase (détail).* (1906.) E:6647. MoMA
1.69.184

Plate 26 bears a marked graphic resemblance to plate 1, from which it is separated by only three negative numbers. In the following year Atget made three additional photographs of the same vase, reproduced here. These were among the last photographs that Atget would make for his Versailles file until he returned there fifteen years later. The last pictures of this first period at Versailles were all of vases, including plates 32 and 33 and figure 10.

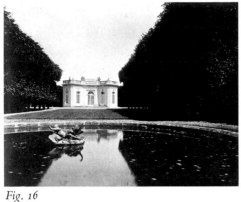

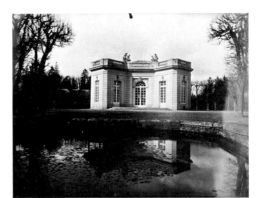

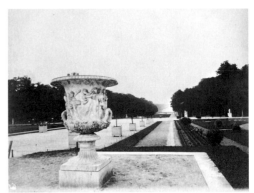

Fig. 16 *Fig. 17* *Fig. 18*

By 1906 Atget generally sacrifices the profile of the vase in order to accentuate its sculptural content, and often works with his lens so close to his subject that it might seem to passersby that he is studying the various species of lichen that grow there. This violates the standards normally agreed on in the photographing of objects of art, which prescribe a lens of relatively long focal length and as great a viewing distance as can be practically managed. The reasons for this standard are easily understood if we consider portraits of people we know taken from close up. As the camera comes closer the nose becomes increasingly long in relationship to the ear; the chin and forehead slide swiftly away toward infinity, and the remembered, characteristic shape of the head disappears. Just as one cannot see the shape of the earth from an airplane, one cannot see the shape of a head, or a vase, if one approaches close enough to study its sculptural geography. In his later photographs of Versailles vases, Atget consistently elides or ignores the shape of the vase for the sake of sculptural and spatial drama.

Pl. 30. *Petit Trianon [Hameau].* (1923–24.) V:1232. MoMA 1.69.26

The Hameau was not of course a single building, but a little village, such as one might find, Ian Dunlop said, in the background of a painting by Greuze. Real cattle grazed its meadows, real peasants worked its gardens, and the Queen presided with apparent pleasure and affection.

Pl. 31. *Versailles, parc.* (1906.) E:6622. MoMA 1.69.1950

The first series of photographs that Atget made at Versailles ended in 1906. Most of the best pictures in this six-year series are a young man's pictures: confident and expansive and fundamentally simple. By 1906, however, he has begun to make photographs that are more complex and introspective in aspect and in meaning, and that suggest those he will make when he returns fifteen years later. In this picture, why does the faun shiver in a winter chill, tangled in the black, leafless branches of

a northern country, and who is the lonely poet who reworks his manuscripts in the deserted park?

Pl. 32. *Versailles, vase (détail).* (1906.) E:6652. MoMA 1.69.221
Pl. 33. *Versailles, vase (détail).* (1906.) E:6654. MoMA 1.69.178
Fig. 18. *Versailles, parc.* (1901.) E:6101. MoMA 1.69.38
Fig. 19. *Versailles, vase.* (1906.) E:6656. MoMA 1.69.993

François Souchal (*French Sculptors of the Seventeenth and Eighteenth Centuries: The Reign of Louis XIV*, Oxford, 1981, vol. 2, p. 151) has attributed the vase shown in figure 18 to Simon Hurtrelle (1648–1724) and says that it was one of six vases copied by Hurtrelle and others from Medici and Borghese originals. The narrative frieze of the vase shown in plates 32 and 33 is virtually identical with that shown in figure 18, but the ornamental belly of the vase is different.

Today a photographer specializing in the documentation of works of art would not make the picture until the conservator had come and gently washed away the unauthorized recent inscriptions: "Gaston aime Héloïse 1981," etc. This is surely the right course; the Attic passion of the ancients, to the degree that it may have survived in a neoclassical vase, should not be confused with the unstructured passion of modern vandals. Nevertheless, from our perspective, two generations later, we are secretly grateful that Atget photographed the modern inscriptions too. For us they are not merely graffiti but history, and oddly comforting.

Pl. 34. *Trianon.* (1910–14.) LD:741. MoMA 1.69.17
Pl. 35. *Arbre, Trianon.* (1919–21.) LD:939. MoMA 1.69.77
Fig. 20. *Trianon, sapin.* (1910–14.) LD:740. MoMA 1.69.2776
Fig. 21. *Trianon.* (1910–14.) LD:742. MoMA 1.69.3623
Fig. 22. *Trianon, sapin.* (1919–21.) LD:938. MoMA 1.69.63
Fig. 23. *Trianon.* (1922–23.) V:1162. MoMA 1.69.69

Although Atget added no pictures to his Versailles series be-

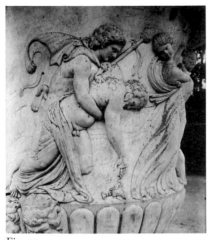
Fig. 19

Fig. 20

Fig. 21

tween 1906 and 1921, he did return several times during this period to photograph trees, for his Landscape-Documents series. He photographed the pine shown here on at least three separate occasions, spanning about a decade. Between the exposure of plates 34 and 35 two sizable branches have been removed, and the wounds of these amputations have healed. Plate 35 and figure 22 show (more or less) the Petit Trianon in the background. Figure 20 is notable, even in Atget's work, for the bravery, if not the success, with which it attacks visual chaos.

Pl. 36. *Juvisy, Pont des Belles Fontaines.* (1902.) E:6250. MoMA 1.69.1080

Fig. 24. *Juvisy, Belles Fontaines.* (1902.) E:6259. MoMA 1.69.1189

Fig. 25. *Juvisy, Belles Fontaines, mascaron.* (1921.) E:6919. MoMA 1.69.1073

Figure 24 shows the monument that stands atop the bridge in plate 36. The bridge spans the Orge River and was part of the road between Fontainebleau and Paris. The bridge was built in 1728, after the design of J.-A. Gabriel. The plaque on the obelisk reads: "Louis XV, Most Christian King, by having broken the rocks, smoothed the hills, and having made a bridge and roadways, has transformed this difficult route, steep and almost unpassable, into an equable, carriage-worthy, and agreeable highway."

Pl. 37. *Meudon, ancien château.* (1902.) E:6265. MoMA 1.69.1803

Pl. 38. *Meudon, ancien château.* (1902.) E:6266. MoMA 1.69.1802

The Ancien Château de Meudon had two centuries earlier been the seat of Monseigneur, the Grand Dauphin, son of Louis XIV, and it had been one of France's great palaces since the Cardinal of Lorraine built it in the sixteenth century. The writer does not know whether one might have found its grounds behind the rather anonymous wall described here, and there is no evidence to suggest that Atget ever got inside the gate. It is possible that

he was merely passing by; on the same trip he photographed the house of Armande Béjart, the wife of Molière, and the tomb of the actor Molé. For an old actor, these subjects might well have taken priority.

Pl. 39. *Crépy-en-Valois, vieille demeure XVIᵉ siècle.* (August 1921.) E:6963. MoMA 1.69.209

The house of Valois had held the throne of France for two and a half centuries, until the late sixteenth century, when their losses in the endless wars with the Hapsburgs had ruined them, while strengthening the Bourbons. By Atget's time Crépy-en-Valois, their ancient capital, was not even an important tourist site. The 1904 Baedeker says that a few traces remain of the Château des Valois, and mentions the old church dedicated to Thomas à Becket, who had studied in Paris and who sought refuge on the Continent in 1164, when his misunderstanding with his monarch, Henry II, became critical. He returned to England in time for his martyrdom in 1170. The church in Crépy-en-Valois was begun ten years later. The unknown building photographed by Atget would seem to date from some six centuries later, but it is probably a remodeling, perhaps a collage spanning most of a millennium. It seems unlikely that one architect designed both the doorway and the corner into which it has been shoved.

Pl. 40. *Châtillon, porte ancien château, rue des Pierrettes.* Mai 1916. E:6836. MoMA 1.69.2993

Châtillon was a favorite subject of Atget, particularly from the war years until about 1922. (In Volume I, see plates 17, 29, 36, 52, 69, 92, 93, 96, and 97, plus figures 45, 53, and 63.) Astonishingly, the village was only five miles by tram from Montparnasse; according to the Baedeker of 1904 the trip took about an hour, and cost twenty-five centimes, second class.

Pl. 41. *Bois de Boulogne.* (March 1923.) pp:13. MoMA 1.69.2530

The Bois de Boulogne did not become a park proper until the

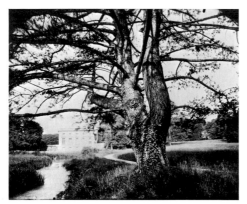

Fig. 22 Fig. 23 Fig. 24

1850s, when Napoleon III gave it to the City of Paris, with the understanding that it would be improved and made a place for the pleasure of the public. Before that it had for at least five centuries been crown property, bounded to the west by great châteaux and the Abbey of Longchamp, and a favored territory for hunting and (later) picnicking. Atget's photographs in the Bois avoid the obvious improvements, and show us something that might resemble the place in its earlier state.

Pl. 42. *Château de Sardou, Marly-le-Roi.* (1905.) E:6556. MoMA 1.69.1781

Marly is still known chiefly for the château that Louis XIV built there beginning in 1679. The place was conceived as a modest retreat where the Sun King could play the part of a common monarch, in the company of a few score of favored courtiers, but in the end it cost over half a million louis d'or, or something well in excess of fifty million current dollars. Louis XV used the place little, and Louis XVI not at all, and it had in effect been abandoned long before being demolished after the Revolution.

The great château had been designed by J.-H. Mansart, and the relatively modest house in Atget's photograph does have features that recall the work of that master—which is perhaps why Atget wrote "par Mansard" (sic) on the back of one print, under the title. However, the standard catalog of Mansart's work, by Pierre Bourget and Georges Cattaui, lists no house by him that this might be. It is clear that Atget was a careless art historian; in addition, this was the house of Victorien Sardou, one of the famous French playwrights of his day, an influential figure in the French cultural community, and apparently a useful acquaintance of Atget's. Surely it could not hurt to give the house of such a man the benefit of the doubt. (See also Vol. I, pl. 78 and fig. 55.)

Pl. 43. *Château. La Malmaison.* (1919–21.) LD:1000. MoMA 1.69.1620

Pl. 44. *Parc, La Malmaison.* (1919–21.) LD:1001. MoMA 1.69.4343

Fig. 26. *Cèdre, La Malmaison.* (1919–21.) LD:999. MoMA 1.69.1622

It has often been said that Atget rose in the small hours to work, perhaps because the streets were empty, or perhaps to serve more convincingly his assigned role of simple, naive workman, up and working while successful artists and bourgeois were still in bed.

It now seems clear that Atget, in the earlier years of his career, did most of his work during the standard working day, and that the habit of working early (and sometimes late) grew more pronounced as he grew older. The older Atget exhibits a deep interest in the rich variability of weather, and it seems most likely that he came to rise early because the light was better.

The broad simple massing of these two pictures at Malmaison is typical of Atget's landscapes after the war. The division of the picture space in plate 44 is especially interesting, and recalls the similar but even more radical solution of *Etang du Plessis-Piquet* (Vol. I, pl. 100), made a few months earlier.

The large cedar reflected in the water in plate 44, and shown again in figure 26, was planted by the Empress Josephine in 1800 to mark and honor her husband's great victory at Marengo.

Pl. 45. *Bois de Boulogne.* (March 1923.) PP:12. MoMA 1.69.1357

Pl. 46. *Roses du Nil.* (1910 or earlier.) LD:701. MoMA 1.69.705

Although unidentified by place, this is probably Bagatelle, which possessed a famous botanical collection, and where Atget did much work.

Pl. 47. *Nymphéa.* (1910 or earlier.) LD:697. MoMA 1.69.823
Pl. 48. *Nymphéa.* (1910 or earlier.) LD:698. MoMA 1.69.824

Probably at Bagatelle. The two pictures together comprise a precious first lesson for aspiring photographers, and an essential last lesson for photographers who have learned everything else. The maple leaf that floats in the lower right corner of plate 47 is the same one that appears in the lower left corner of plate 48.

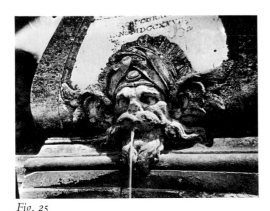

Fig. 25

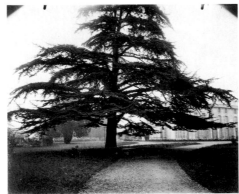

Fig. 26

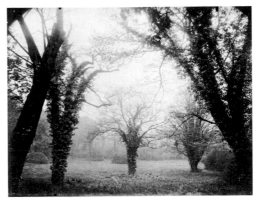

Fig. 27

By moving a meter to his right, the photographer has turned the light sky dark, and the dark lilies white. Either picture might with equal justice be called "documentary" by one who finds a comforting security in the term.

Pl. 49. *Antony, château.* (1923.) E:7018. MoMA 1.69.1526

The child standing by the big tree is asking what the old man with the odd apparatus and the black cloth over his head is doing. Unless he adopts her and makes her his apprentice, he cannot explain. He says, "Never mind, n'importe, I am only making documents. But please don't move." He was in fact wondering whether he should be closer to or farther from the house, that is, whether the bright white house was in proper balance with the shadow that surrounded it. Nevertheless he was doubtless grateful for the figure of the child, almost hidden in shadow.

Pl. 50. *Bagatelle, roseraie.* (1921.) LD:1055. MoMA 1.69.552
Pl. 51. *Bagatelle, géranium.* (1922–23.) LD:1171. MoMA 1.69.734

It is characteristic of Atget that he would focus on certain problems at certain places at particular times and ignore other potentially rich opportunities. At Bagatelle he concentrated on botany —especially the water lilies, but also the rose bowers, the potted geraniums, etc.—and paid little attention to the park as landscape, or to the architecture of the place.

Pl. 52. *Saint-Ouen, ancien château Rohan Soubise, 1735.* (1901.) E:6192. MoMA 1.69.1484

In spite of Atget's title, this house seems both too modest and too modern to have been the seat of any of the Rohan-Soubise family, who played fairly conspicuous, if not very important, roles during the century before the Revolution. The design of the picture is very interesting: the high horizon allows inclusion of the long diagonal of the road; the full silhouette of the tree establishes a plane behind the house. In principle the composi-

tion relates closely to the pictures that Atget was making at Versailles during the same period (see pl. 9).

Pl. 53. *Parc Delessert.* (1914.) T:1570. MoMA 1.69.1515
Pl. 54. *Parc Delessert.* (1914.) T:1542. MoMA 1.69.1505
Fig. 27. *Parc Delessert. 32 Quai de Passy.* (1914.) T:1550. MoMA 1.69.4346

The Parc Delessert is included in this volume because it seems more at home here than elsewhere; it is in fact a nineteenth-century park, named for its benefactor, the banker, politician, and amateur botanist Benjamin Delessert. For comment on the rendition of trees and sky, see the note for plate 25.

Pl. 55. *Bagatelle.* (1910 or earlier.) LD:713. MoMA 1.69.531
Pl. 56. *Bagatelle.* (1910 or earlier.) LD:714. MoMA 1.69.524
Fig. 28. *Bagatelle, chêne.* (1910 or earlier.) LD:712. MoMA Study Collection

After exposing a half-dozen plates (more or less) on a given outing, Atget would return home, develop his negatives, and assign them the next available numbers in the appropriate indexing category. This is what one would expect from an orderly and systematic worker. It appears that Atget may have gone further and numbered the plates in the order in which they were exposed. When more than one picture of a given motif was made on the same day, the numbers seem generally to correspond to the natural sequence of further investigation.

It is worth noting that plate 56, dealing with the subject matter more as sculpture and less as pattern, is more fully exposed; the texture of the central tree is more fully described, and its tonal value is more clearly contrasted to the darker trunks to the right and left. Note also that at the closer vantage point the two trees on the left are separated by a sliver of air. Such are the options that photographers wrestle with.

Pl. 57. *Saint-Cloud.* (1924.) SC:1243. MoMA 1.69.285

Saint-Cloud—two miles west of the old fortifications of Paris, and now surrounded by the city—was the seat of Philippe, Duc

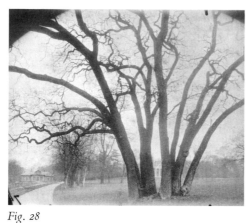

Fig. 28

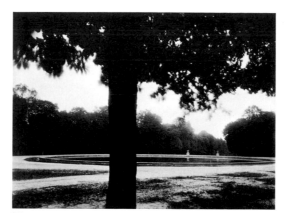

Fig. 29

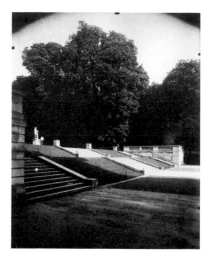

Fig. 30

d'Orléans, brother of Louis XIV, called Monsieur. The château was destroyed during the Franco-Prussian War, but the cascade that was the chief source of its fame survived. The gardens were designed by Le Nôtre. In 1784 Marie Antoinette purchased the place, thinking its climate more salubrious than that of Versailles, but she neglected, alas, to remain there.

In all of Atget's work, perhaps no single motif was so richly rewarding over so long a span of time as Saint-Cloud. He first photographed there in 1904, a master of his craft, and full of the confidence and optimism of robust middle age. He made his last pictures there during his last summer, when his strength was mostly gone and he could make only a few photographs of the most important things.

Pl. 58. *Saint-Cloud.* (1904.) E:6453. MoMA 1.69.395

Plate 58 represents one of the earliest—perhaps *the* earliest—of Atget's pictures at Saint-Cloud. Its character is typical of the best work that he did before the war: the composition is broadly and vigorously massed, the lighting dramatic (at least ninety degrees from the vantage point), and the space is described in graphic rather than atmospheric terms. Compare with plates 60 and 62.

Pl. 59. *Saint-Cloud.* (1906.) E:6609. MoMA 1.69.383

This writer, if asked to guess the date of plate 59 on the basis of the image alone, without reference to the machinery of scholarship, would say that it was made some fifteen years later than it was in fact. The picture's economy, its flatness, its quietude, its subject—a space filled with radiant light and the smell of melancholy—suggest Atget's work of the early twenties (see pls. 66, 67). This is also one of the earliest pictures in which Atget makes such extreme and apparently intentional use of halation. See the note for plate 25.

Pl. 60. *Saint-Cloud.* (1904.) E:6504. MoMA 1.69.2994

See note for plate 58.

Pl. 61. *Saint-Cloud.* Juin 1926. SC:1272. MoMA 1.69.403
Fig. 29. *Saint-Cloud.* Juin 1926. SC:1273. MoMA 1.69.404

Much of the force of plate 61 is generated by the closed white shape created by the silhouettes of the near and far trees and compressed between them. This compression, and the coherent linear character of the white form, makes it operate as a shape (as opposed to a space)—which in turn tends to pull the near and far foliage toward the same plane. Compare with figure 29, which in the absence of odious comparison would seem superb.

Pl. 62. *Saint-Cloud.* (1904.) E:6500. MoMA 1.69.392
Pl. 63. *Saint-Cloud.* Fin août, 6½ h., 1924. SC:1252. MoMA 1.69.399
Fig. 30. *Saint-Cloud.* (1924.) SC:1250. MoMA 1.69.364
Fig. 31. *Saint-Cloud.* (1924.) SC:1251. MoMA 1.69.410
Fig. 32. *Saint-Cloud.* Fin août, 6½ h. (1924.) SC:1253. MoMA 1.69.3008

The four consecutive pictures beginning with SC:1250 (fig. 30) show Atget at work as a designer, shuffling and rearranging the elements of his material to achieve the most effective and elegant solution, without radically changing the definition of the problem: a description of the character of the architectural recession. The elements that he works with are the grand stairway, the long *allée* (expressed or implied), the backdrop of trees, and a figure (statue) or two. These pictures recall those that he had made twenty-odd years earlier (frontispiece, pls. 9, 11), with the difference that he has slowed and de-emphasized the thrust into deep space in two ways: by placing himself farther from the sculptures that are the obvious focal points of his compositions (and thus placing them closer to their visual backgrounds), and by rendering in graduated, spatial terms the receding foliage, and the atmosphere that it now defines. Plate 62 illustrates the simpler, more purely graphic solution that was characteristic of his earlier work.

Pl. 64. *Saint-Cloud.* (1924.) SC:1244. MoMA 1.69.358
Pl. 65. *Saint-Cloud.* (1923.) SC:1208. MoMA 115.50

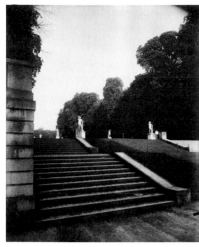
Fig. 31

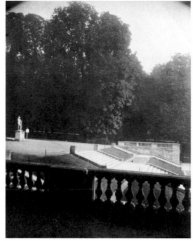
Fig. 32

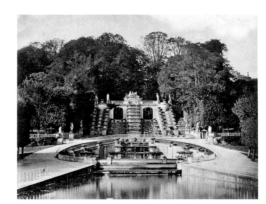
Fig. 33

Pl. 66. *Saint-Cloud.* (1924.) sc:1240. MoMA 1.69.355

Pl. 67. *Saint-Cloud.* Fin août, 6½ h., 1924. sc:1255.
MoMA 1.69.412

Fig. 33. Achille Quinet. *Cascades de Saint-Cloud.* (c. 1875.)
MoMA 194.83, Benjamin Zeller Memorial Fund

Fig. 34. Neurdein Frères (X. Phot.). *Parc de Saint-Cloud,
La Grande Cascade.* (c. 1900.) No. 247

Fig. 35. *Saint-Cloud.* (1923.) sc:1179. MoMA 1.69.310

For most visitors of earlier periods, Saint-Cloud's Grande Cascade was the chief focus of admiration. Unlike Versailles, Saint-Cloud had a generous water supply, and when the cascade performed it suggested a robust natural force that had accepted a degree of classical discipline sufficient to make it decent. Atget made many pictures of the cascade, but few that attempted to explain it in a single view; for the architectural historian the long location shots of Atget's contemporary Neurdein Frères (X. Phot.), or the earlier ones of Achille Quinet, are probably more useful than figure 35 of Atget, who was, typically, anxious to come closer, to see the other side, to find the photographs that were hidden within the nominal subject.

At the top of the cascade is a sculpture symbolizing the gods of the rivers. This sculpture appears repeatedly in Atget's pictures of the cascade, often from vantage points so close, or so far, or so misted over by Atget's feeling for the encompassing ambiance of the place, that it easily escapes identification. Plate 65 shows a detail from behind the figure representing the Marne (or Seine?) River; in plate 66 the sculpture is seen just to the left of the largest tree; in plate 67 it appears within the light oval patch in the center, almost obscured by brilliance.

The point of this apparent indirection was neither obfuscation nor subtlety. It was Atget's goal to produce neither a map of the park nor a catalog of its more or less admirable artifacts, but a description of the quality of the place.

Pl. 68. *Saint-Cloud.* Mars 1926, 9 h. matin. sc:1261.
MoMA 1.69.417

Fig. 36. *Saint-Cloud.* 150 s. vers 9 h. matin, mars 1926.
sc:1260. MoMA 1.69.400

Fig. 37. *Saint-Cloud.* 9 h. matin, mars 1926. sc:1263.
MoMA 1.69.401

This picture recalls plate 31, a picture made twenty years earlier at Versailles. Both the scheme and the feeling are much the same, but the faun has been replaced by a vase, and the anonymous poet by a bicycle. This was one of Atget's very best days; within a stone's throw of the spot from which he made this picture he had three other superb successes—see plate 83 and figures 36 and 37. In figure 36 one can see in the middle distance the vase of plate 68, and beyond it Poseidon holding the trident, the statue in figure 37. The foreground figure in figure 36 reappears in plate 83.

The relevant page of Atget's reference album in which figure 36 was filed bears the notation "150 s[econds] vers 9. h. matin, mars 1926." The existing albums contain almost no technical records. These homemade paper books were fragile, and were remade periodically. If the early albums had originally contained technical notations they were not transcribed when the albums were replaced, since their lessons had presumably been absorbed. The appearance of an exposure record at this late date in Atget's career might suggest that he was experimenting, and 150 seconds does seem a massive exposure, even for a dark morning in March. The handbook of Lumière et Jougla for 1927 indicates that twenty seconds should have been enough (at f:64 and with the Lumière *bleue* plate that Atget used). Greater exposure and reduced development would produce the softer, more smoothly modulated gray scale that characterizes so much of Atget's very late work. See plates 76 and 77.

Pl. 69. *Saint-Cloud.* 1926. sc:1256. MoMA 1.69.413

From the early years of his career, Atget was attracted to trees that had been scarred and bent by the struggle for survival. (See Vol. I, pls. 30, 48, 49, 99.) The tradition of drawing and painting distressed trees was very old by Atget's time. In the Renais-

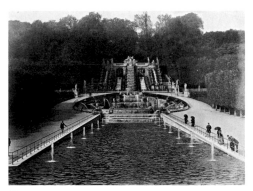

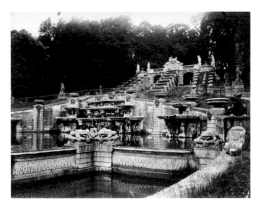

Fig. 34 Fig. 35 Fig. 36

sance such pictures often symbolized the dark and threatening forces that were inherent in the idea of wilderness; by the time of Théodore Rousseau they could stand as a metaphor for the lives of men; Alfred Stieglitz could believe that he found in a dying poplar the material for autobiography. We do not know where on this scale Atget's ideas might lie, but this viewer would guess that he found the terrific animistic power of the tree in plate 69 to be first of all not a symbol but a fact of nature, as immediate as a tiger.

Pl. 70. *Parc de Saint-Cloud, arbre.* (1919–21.) LD:964.
 MoMA 1.69.492
Pl. 71. *Saint-Cloud.* (1924.) sc:1226. MoMA 1.69.372
Fig. 38. *Saint-Cloud, hêtre.* (1919–21.) LD:1012. MoMA 1.69.235

Atget photographed this beech tree on at least three occasions, first (about 1920) in the summer and twice subsequently during the winter, making a total of at least seven negatives. The vantage point of plate 71 is very similar to that of figure 38, and the position of the sun is virtually identical; this writer had originally supposed that the two negatives were made within minutes of each other, and that the very different character of the tonal rendition in the two pictures was due to the fact that Atget exposed and processed them differently—aiming in the first case for a spatial and sculptural description and in the second for a graphic one. The supposition was abandoned when it became clear that plate 71 was made three or four years later than figure 38. Under these circumstances the next plausible explanation might be that Atget decided he was not satisfied with the rendering of the earlier picture and returned later, in the same season and at the same hour, to do it better.

Pl. 72. *Saint-Cloud, hêtre.* (1919–21.) LD:1008. MoMA 1.69.231
Pl. 73. *Saint-Cloud, hêtre.* (1921.) LD:1026. MoMA 1.69.243

After the war Atget worked at Saint-Cloud with increasing frequency; in 1922 he established a separate series for his subsequent work there, as well as one for Versailles, and adopted separate and parallel numbering sequences for these projects.

(See the essay by Maria Morris Hambourg in this volume.)

Atget's earlier work at Saint-Cloud had emphasized what one might call landscape architecture, and is relatively more art-historical in viewpoint than the postwar pictures. Beginning about 1920 a remarkably large proportion of the Saint-Cloud pictures are in effect portraits of individual trees, either whole or in detail. These pictures were made both in the designed and maintained areas of the park and in its natural woods. (See Vol. I, pls. 116–20.)

Pl. 74. *Saint-Cloud.* Fin mai, 7 h. soir. (1922.) LD:1104.
 MoMA 1.69.2998
Pl. 75. *Saint-Cloud.* (1922.) LD:1103. MoMA 1.69.256

Photographs of trees were among Atget's earliest subjects, when he worked in unexplained circumstances in the north of France. Those pictures showed single, whole trees, pinned like the perfect drawings of happy children against a paper sky. The Saint-Cloud tree pictures are complex and austere. They are not seductive; they do not conjure up images of the elegant and frivolous entertainments that the court enjoyed there. There is in them no more happiness or sadness than there is in nature. They describe the ways that trees grow—the ways in which they occupy their space—and the ways that such matters can be described in a photograph.

Atget's tree photographs at Saint-Cloud were for the most part made in winter, when the leafless branches reveal the structure and articulation of the tree. On sunny days (pl. 74) the shadows overlaid a second pattern on that created by the trees themselves, producing an apparent flatness similar to that produced by double exposure. From mid-career, as Atget became consciously interested in the transforming effect of light, he accepted this difficult problem with some regularity. (See Vol. I, pls. 40, 41, 120.)

Pl. 76. *Saint-Cloud.* (1922.) LD:1112. MoMA 1.69.265
Pl. 77. *Saint-Cloud, étang.* 9 h. matin, avril 1926. sc:1264.
 MoMA 1.69.402

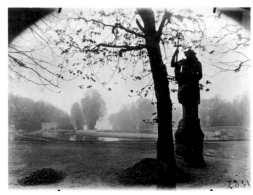
Fig. 37

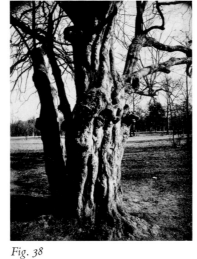
Fig. 38

Fig. 39

Plate 77 was made from a vantage point some distance to the right of that chosen four years earlier for plate 76. The softer, more atmospheric character of the light in plate 77 recalls the difference between plate 71 and figure 38 (discussed above) and is characteristic of the tendency of Atget's work during the 1920s. Compare also plates 116 and 117, Volume I, made in the same years as the two pictures discussed here.

Pl. 78. *Saint-Cloud.* (1921–22.) LD:1082. MoMA 1.69.137
Pl. 79. *Saint-Cloud.* (1919–21.) LD:977. MoMA 1.69.498
Pl. 80. *Saint-Cloud.* (1919–21.) LD:974. MoMA 1.69.495
Pl. 81. *Saint-Cloud.* (1922.) SC:1160. MoMA 1.69.253
Fig. 39. Joseph Stella. *First Light* [*Crépuscule premier*]. (c. 1928.)
 Oil on canvas. MoMA 203.66, Elizabeth Bliss Parkinson Fund

Most artists of stature are tenacious; barring exceptions like Leonardo and Picasso, they will pursue a useful idea until it or the artist is exhausted. The part of Atget's work represented in this volume is especially rich in evidence of this aspect of his artistic character. Plates 78 to 81 reproduce four of eleven pictures in the Abbott-Levy Collection in which the same tree, of a singularly beautiful profile, defines the end of the pictorial space. After making the picture reproduced as plate 81 Atget ended the series, perhaps feeling it unlikely that he would ever serve that tree any better.

There is no evidence to suggest that Joseph Stella was simultaneously painting the opposite side of the same tree. The consonance of sensibility, during the same years, is nevertheless interesting.

Pl. 82. *Saint-Cloud.* Juin 1926. SC:1276. MoMA 1.69.407
Pl. 83. *Saint-Cloud.* 9 h. matin, mars 1926. SC:1262.
 MoMA 1.69.418
See note for plate 68.

Pl. 84. *Saint-Cloud.* (1922.) SC:1149. MoMA 1.69.270

Pl. 85. *Saint-Cloud.* Matin 7 h., juillet. (1921.) LD:1066.
 MoMA 1.69.248
Pl. 86. *Saint-Cloud.* Le soir, 7 h. (1921.) LD:1071. MoMA
 1.69.3001
Pl. 87. *Saint-Cloud.* Le soir, 7 h. (1921.) LD:1070. MoMA
 1.69.275
Pl. 88. *Saint-Cloud.* (1915–19.) LD:780. MoMA 1.69.487

Pl. 89. *Saint-Cloud.* Juin 1926. SC:1274. MoMA 1.69.405
Fig. 40. *Saint-Cloud.* (1904.) E:6502. MoMA 139.50

Most of Atget's pictures of the pools at Saint-Cloud were made after the war, but at least one—figure 40—was made as early as 1904. After this attempt he apparently abandoned the motif for more than a decade, and then made the picture reproduced as plate 88. The difference between the two pictures is instructive. In the latter picture he has moved away from the central axis of the alley perhaps thirty degrees, placing both statues on one side of the composition, and finding a profile of the trees that is both simpler and more dynamic. It would seem that he is working here, as in the later pool pictures, either early or late in the day, and the still water provides the sharpness of line in the reflection that is necessary if the large dark masses are to read as coherent, flat shapes. The quality of light and weather might on this occasion have been fortuitous; it is interesting that after about 1920 Atget began—not inevitably, but frequently—to note the hour of exposure in the titles of his Saint-Cloud pictures. Often he would note the hour and the month, but not the year. Plate 89, the simplest of this long series of the reflecting pools, was also the last.

Pl. 90. *Saint-Cloud.* 6 h. matin. (1921.) LD:1064. MoMA
 1.69.247
Pl. 91. *Saint-Cloud.* Matin 6½ h., juillet. (1921.) LD:1065.
 MoMA 1.69.3033
Fig. 41. *Saint-Cloud.* (1921.) LD:1065. MoMA 1.69.3032
Fig. 42. *Saint-Cloud.* (1921.) LD:1065. MoMA 1.69.3031

For plates 90 and 91 Atget has given us the hour and the month

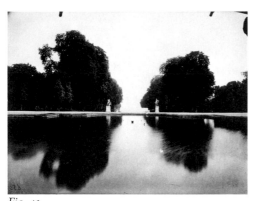

Fig. 40

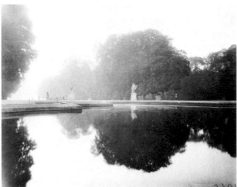

Fig. 41

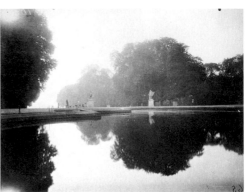

Fig. 42

of exposure, but not the day or the year. It is therefore possible, but not credible, that they were made on different days. Surely Plate 91 was made a half-hour after plate 90.

It has been pointed out here more than once that Atget, throughout his mature life as a photographer, was fascinated by the competing beauties of flat pattern and the illusion of deep space. As the years passed his mastery of pictorial construction became more confident and more flexible, and he often seemed to find a perfect tension—an equilibrium—that satisfied both goals. Yet he never found a simple programmatic answer to end the wonderful competition. Plates 90 and 91 provide a perfect concrete example of the abstract problem and the decisions that it requires. Plate 90 is one of the flattest of the pond pictures. No significant illusion of space is admitted; the symmetrical dark shape, reaching from edge to edge, is read as a pattern, which in turn pushes back the water to the same plane as the sky. In plate 91, by moving a few steps to his right and rotating his camera to the left, Atget includes an exit into the distance; the far trees are now lightened and recessed by fog, and the dark trees on the left stand in a closer plane.

The problem is not yet fully resolved, for the plate must still be printed. Atget was not one to agonize over the problem of printing; in general he knew what he wanted, and got it—or something close enough to serve—without undue trouble. But on this occasion it would seem that he was uncertain as to what it was that he had seen on that July morning. The Abbott-Levy Collection contains three prints of negative 1065, all carefully made and finished, printed dark, lighter, and lightest. Each is beautiful and persuasive in its own way; the lightest describes atmosphere, and the darkest pattern. None of the three versions could be called more objective than the others.

Pl. 92. *Saint-Cloud.* (1921–22.) LD:1085. MoMA 1.69.279

Pl. 93. *Saint-Cloud.* Fin août, 6½ h., 1924. SC:1254.
MoMA 1.69.3028

Pl. 94. *Saint-Cloud.* (August 1922.) SC:1156. MoMA 1.69.252

Pl. 95. *Saint-Cloud.* (August 1922.) SC:1157. MoMA 1.69.254

Fig. 43. *Saint-Cloud.* (1922.) SC:1155. MoMA 1.69.286

Fig. 44. *Saint-Cloud.* (1904.) E:6505. MoMA 1.69.389

These pictures were made from the terrace shown in the preceding two plates. Comparison of plate 94 and figure 43 reveals much about Atget's concerns during this period. The specific data included in the two pictures are much the same. If we assume that the lower-numbered picture was made first, Atget then moved to his right, spreading horizontally the elements of his composition and allowing the central dark form (of the lower foliage and its reflection) to be fully articulated. It is interesting that the dark form on the right is terminated at the same point in both photographs. The division of the picture space in the second version is more surprising, and its pattern more secure.

Plate 95 seems to this viewer one of the most wonderful of Atget's pictures, recapitulating with breathtaking ease, and an economy that is almost ostentatious, the motifs and ideas that had occupied him at Saint-Cloud for almost two decades.

The pool had originally been called the Bassin des Cygnes, and was later renamed the Bassin du Fer à Cheval (Horseshoe Pool), presumably after the swans had flown.

Figure 44 shows the use that Atget had made of the same materials eighteen years earlier.

Fig. 45. *Saint-Cloud.* Mai 1927. SC:1284. MoMA Study
Collection, print 1978

This is the last picture that Atget made at Saint-Cloud. The negative has suffered considerable deterioration.

Pl. 96. *Bourg-la-Reine, entrée du château.* (1924.) E:7060.
MoMA 1.69.1145

The Château de Sceaux and its gardens were built by Jean-Baptiste Colbert, the man who served Louis XIV as controller general of finance; superintendent of buildings, royal manufactures, commerce, and fine arts; secretary of the navy; and secre-

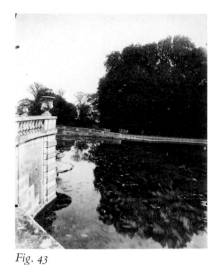
Fig. 43

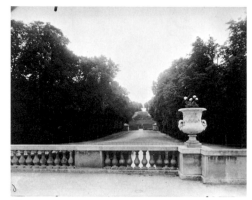
Fig. 44

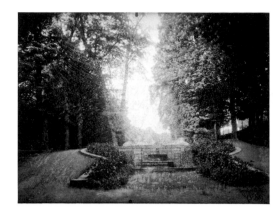
Fig. 45

tary of state for the King's household—finally holding all of these posts simultaneously. When Mazarin, his predecessor as indispensable man, lay dying, he told the King, "Sire, I owe everything to you, but I repay my debt . . . by giving you Colbert."

Among his lesser accomplishments, Colbert prepared the case that destroyed Nicolas Fouquet for embezzlement, thus bringing his undiplomatically extravagant château at Vaux-le-Vicomte into the King's hands. More important, the court inherited Le Vau, Le Brun, and Le Nôtre, who among them would direct much of the artistic achievement of the King's early and best years.

Colbert's original château at Sceaux was designed in 1673 or '74 by Claude Perrault, a doctor and amateur architect who also collaborated with Le Vau on the design of the Louvre. It was destroyed at the time of the Directory, at the end of the eighteenth century.

In 1924 Atget visited and photographed at least seven villages near Paris, describing their squares, churches, historic houses, and picturesque roads for his Environs series. While photographing near the village of Sceaux he made this photograph of the gateway of the château; perhaps he did not know precisely what he was photographing, since he titled the picture with the name of the adjacent town, Bourg-la-Reine. It is possible that he reconnoitered the park, for although he made no photographs of it on this occasion, he returned early in the spring to produce what was perhaps the most concentrated and consistently remarkable series of his entire career.

Pl. 97. *Parc de Sceaux*. Juin, 7 h. matin. (1925.) s:72.
 MoMA 1.69.2709
Pl. 98. *Entrée du parc de Sceaux*. Mai, 8 h. matin. (1925.)
 s:56. MoMA 1.69.2718

Atget worked at Sceaux from March through June of 1925, making sixty-six photographs (s:10–75) in an undetermined number of visits. The sequence in which he made his pictures

suggests that he proceeded intuitively, without a program, other than the wish to photograph the quality of the place and moment. The two photographs of the small gatehouse shown here were separated by a month, and fifteen intervening photographs.

Pl. 99. *Parc de Sceaux* [*Escalier, Pavillon de l'Aurore*].
 Mai, 8 h. matin. (1925.) s:53. MoMA 1.69.2769
Pl. 100. *Parc de Sceaux*. (June 1925.) s:75. MoMA 1.69.1512

This building, an independent garden house for small entertainments, survives from the time of Colbert. The two pictures are separated by a month; in the interval the restoration of Sceaux—in preparation for its conversion to a public park—had begun. In plate 100 the moss and lichen have been scraped from the ancient stone steps. Atget, perhaps recognizing the familiar symptoms of progress, made this one last picture and left, not to return.

Pl. 101. *Sceaux*. Juin, 7 h. matin. (1925.) s:64. MoMA
 487.80. Print by CAW, 1978
Pl. 102. *Parc de Sceaux*. Avril, 7 h. matin. (1925.) s:40.
 MoMA 1.69.2707

The taste for ruins was not strong in the court of Louis XIV; that romantic penchant was prepared for by the ideas of Rousseau and his followers. By the early nineteenth century it was universally understood that failure was a more poetic subject than success. In front of the Théâtre Français stands a statue of the poet Alfred de Musset (who died in the year of Atget's birth) which bears these lines by him: "The most beautiful songs are the most despairing; / I know immortal ones that are but sobs." (Les plus désespérés sont les chants les plus beaux, / Et j'en sais d'immortels qui sont de purs sanglots.) Irving Babbitt pointed out that the thought is scarcely distinguishable from Shelley: "Our sweetest songs are those that tell of saddest thought." In either language, the sentiment is presumably one that Colbert would not have understood.

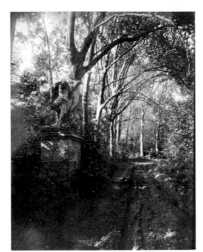

Fig. 46 *Fig. 47*

Pl. 103. *Parc de Sceaux*. Avril, 7 h. matin. (1925.) s:32.
 MoMA 1.69.2771

The statue is of Pluto and Persephone. It is there because similar sculptures with similar Roman names had stood placed in much the same way in earlier French gardens at least since Vaux-le-Vicomte. Earlier still their antecedents stood with rows of cypress in Italy. If Atget knew their names he did not record them.

Pl. 104. *Parc de Sceaux*. Mars, 8 h. matin. (1925.) s:25.
 MoMA 1.69.2672
Fig. 46. *Parc de Sceaux*. Juin, 7 h. matin. (1925.) s:63.
 MoMA Study Collection

This appears to be the same road described in plate 101, which was made two months later, and from the opposite direction. The vantage point of plate 104 is virtually the same as that of figure 46, but the lens has been pointed farther to the left and the plate is used horizontally rather than vertically, probably because Atget found the leafless, unmodulated March sky an unsatisfactory way to end the left corner of his picture.

Pl. 105. *Parc de Sceaux*. Mai, 7 h. matin. (1925.) s:55.
 MoMA 1.69.2686
Pl. 106. *Parc de Sceaux*. Juin, 7 h. matin. (1925.) s:65.
 MoMA 1.69.2678
Fig. 47. *Saint-Cloud*. (1923.) sc:1223. MoMA 1.69.3205

The ingredients of these pictures are much the same as those in the photographs that Atget had made a quarter-century earlier at Versailles, typified by the frontispiece of this volume—a sculptured figure, trees, and space. The earlier pictures are clearly informative, precisely articulated in their drawing, rational in their description of space, expansive in mood. The Sceaux pictures are subtly obscure in description, mysterious in design, spatially ambiguous, and elegiac. At Versailles Atget showed the statues' faces and silhouetted their figures clearly against a flat backdrop; now he is just as likely to show them from the back, tangled in a dominating pattern of sky and vegetation:

they are anonymous figures in a landscape, or stones in the act of reclaiming their past.

In 1923 Atget's last picture of the season at Saint-Cloud was the one reproduced as figure 47, of a sculpture on the periphery of the cascade. It is a new picture for Atget: two figures from the back, obscured by real and sculpted foliage. A year later he would discover Sceaux.

Pl. 107. *Parc de Sceaux*. Avril 1925, 7 h. matin. s:37.
 MoMA 1.69.2712
Pl. 108. *Parc de Sceaux*. Avril, 7 h. matin. (1925.) s:38.
 MoMA 1.69.1511

There is a moment during the year—perhaps ten days if the spring comes slowly—highly prized by landscape photographers, when one can see both the structure of a tree and the beginning of its efflorescence. Before the leaves themselves are visible, a light green watercolor wash appears across the framework of the tree, and every excited warbler is a visible ornament in its branches. The photographs of Parc Delessert (pls. 53, 54) were made a few days later, in an earlier year.

Pl. 109. *Parc de Sceaux*. Juin, 7 h. matin. (1925.) s:69.
 MoMA 111.50

Howard Adams (*Atget's Gardens*, p. 118, n. 51) identifies this as the Allée de la Duchesse, a part of Le Nôtre's original park plan. The figure in the distance is the same sculpture that appears in plates 117 and 118.

Pl. 110. *Parc de Sceaux*. Juin, 7 h. matin. (1925.) s:67.
 MoMA 1.69.2675

The design of a photograph is determined essentially by the vantage point and the fix of the camera's lens, matters that are controlled, within limits, by the photographer. In the case of plate 110 Atget, by moving two paces forward, could have eliminated the dark foreground and made a picture more ethereal in mood, similar to the pictures of the Saint-Cloud ponds.

Throughout the Sceaux series there is a strong sense of the weight of the earth.

Pl. 111. *Parc de Sceaux*. Avril, 7 h. matin. (1925.) s:33.
MoMA 1.69.2770

The lichen-camouflaged sculpture need not have been further obscured by placing it against the net of leafless branches. By moving to his right, the photographer could have clarified the outline of the figure against the plain background of the sky. The still solid base (on which the statue slowly dissolves) is described with clarity and weight. Its importance could have been minimized by a closer vantage point (see pls. 20, 21) or by a tilted camera, although the latter device might have run counter to the photographer's principles; he seems never to have tilted his camera.

Pl. 112. *Parc de Sceaux*. Mars, 7 h. matin. (1925.) s:20.
MoMA 1.69.2677

Pl. 113. *Parc de Sceaux*. Mars, 7 h. matin. (1925.) s:21.
MoMA 1.69.2696

Pl. 114. *Parc de Sceaux*. Mars, 7½ h. matin. (1925.) s:23.
MoMA 1.69.3208

The dark tree on the left is surely closer to the camera than the sculpture's pedestal, but cropped by the bottom edge of the picture, both the tree and the pedestal are allowed to stand in an unspecified plane. (Compare with pls. 9 and 14.) The flatness of the light, the allover pattern of the branches, and the alignment of the figure's feet with the far edge of the pond all increase the effect of spatial disorientation.

Pl. 115. *Parc de Sceaux*. Mars, 7 h. matin. (1925.) s:18.
MoMA 1.69.2694

The figure is Vertumnus, Roman god of the changing seasons. The mask in his hand symbolizes his ability to assume any guise he chose, a useful advantage in his seduction of Pomona, the goddess of gardens and fruit. See also plate 105.

Pl. 116. *Parc de Sceaux, vase*. Avril, 7 h. matin. (1925.)
s:28. MoMA 1.69.1519

Of all of Atget's vases, this one—perhaps the last—seems least like a photograph of an object of art, and most like an unexplained relic that has somehow survived an ancient war.

Pl. 117. *Parc de Sceaux*. (June 1925.) s:71. MoMA 1.69.1513
Pl. 118. *Parc de Sceaux*. Mars, 8 h. matin. (1925.) s:26.
MoMA 1.69.1514
Pl. 119. *Parc de Sceaux*. Mars, 7 h. matin. (1925.) s:17.
MoMA 1.69.1510

Atget was blessed among photographers in becoming better and better as he grew older. It seems to this writer that in his first thirty-odd years he never made a picture quite so perfectly just and unfamiliar as this one. Perhaps he would not quite match it again, although he would several times come very close with the two hundred plates, plus or minus, that he had remaining to him.

Appendix

Since Atget's work progressed along multiple fronts according to a distinctive logic of its own, the order of his numbering sequences developed complex patterns. With this in mind, and with a little forbearance for the charting of such idiosyncrasies, one may date almost any photograph in the oeuvre if two coordinates, subject and negative number, are known. To proceed, first consult the descriptions of the series to determine the category in which Atget filed the picture. If more than one series accommodates the subject, the right series can usually be identified through the compatibility of its number sequence; for example, a picture of a Parisian courtyard with the number 1675 would belong in Topography (numbered from 10 to 1695), not Art in Old Paris (3500 to 6721).* Once its series has been established, the picture may be dated by consultation of the chart, where, beneath each heading, two columns of negative numbers appear. Listed by year, each pair of numbers represents the span of pictures datable with certainty to that year. If there is but a single number, it happens to be the only photograph in the series that could be positively dated to that year. An asterisk indicates that no pictures now exist—perhaps none ever existed—with numbers between those listed. Blank spaces within sequences (without the asterisk) denote either a period of temporary dormancy or a total lack of datable pictures. Bracketed numbers indicate pictures that are not firmly dated, but could not have been made later than the year assigned. The sign < before a date stands for "earlier than." A list of known exceptions follows the chart.

<div style="text-align: right">M.M.H.</div>

* There are cases, especially with photographs of boutiques numbered between 200 and 514, where the correct series cannot be determined on the basis of these charts alone. For instance, such a picture numbered 496 could belong either to Topography or to the second part of Picturesque Paris, and thus would be dated either 1909 or 1914.

THE SERIES

LANDSCAPE-DOCUMENTS (LD:10–1290). Landscapes, seascapes, botanical subjects, parks and gardens; animals, peasant scenes, and rural subjects; a few houses, churches, and monuments; also the houses and streets of Old Rouen.

VIEILLE FRANCE (VF:1100–61). Public architecture and decoration in Amiens, La Rochelle, and other provincial cities.

COSTUMES–RELIGIOUS ART (CO:10–56). Copy photographs of paintings, prints, and reproductions of works by Giotto, Abraham Bosse, Daumier, etc.

PICTURESQUE PARIS, PART I (PP:2997–3281). Activity in Parisian streets, gardens, and along the Seine; "portraits" of the small tradesmen of Paris.

PICTURESQUE PARIS, PART II
(VE:1–73). Vehicles: modes of transport and machines on wheels.
(Z:100–59). Zone: gypsies and ragpickers, their huts and wagons, and the landscape at the edge of the city.
(PP:200–533). Installations for commerce and entertainment: kiosks, shops, markets, displays, street fairs; also gardens, quais, and the fortified "zone."

PICTURESQUE PARIS, PART III (PP:10–159). Prostitutes, small tradesmen, storefronts, displays, mannequins, circuses, and various forms of popular amusement.

ART IN OLD PARIS (AP:3500–6721). Architecture and decoration (interior and exterior); also Parisian streets, quais, courtyards, gardens, and public sculpture.

ENVIRONS (E:6000–7157). Same motifs as in Art in Old Paris but taken in the environs. Includes the architecture and gardens at Versailles (1901–06), Saint-Cloud (1904–07), and other suburban châteaux.

TOPOGRAPHY OF OLD PARIS (T:10–1695). Old streets, facades, courtyards, and demolition sites.

INTERIORS (I:722–74). Domestic interiors of Parisian apartments.

TUILERIES (T:100–348). Statues, vases, and views of the park.

SAINT-CLOUD (SC:1145–1284). Landscaped gardens and wooded parklands. (See also Environs and Landscape-Documents.)

VERSAILLES (V:1148–1261). Same motifs as in Saint-Cloud with the addition of the château and pavilions. (See also Environs and Landscape-Documents.)

PARIS PARKS (PP:10–76). Same motifs as in Saint-Cloud but taken in the Bois de Boulogne, Luxembourg, and other Parisian parks.

SCEAUX (S:10–75). Abandoned garden with statuary and pavilions.

Note: Although structurally part of the second phase of Picturesque Paris, Vehicles and Zone have been given separate headings and prefixes to avoid confusion with the third phase of the series.

				LANDSCAPE-DOCUMENTS		
	(Views, Plants) LD	(Work Animals) LD	(Rouen) LD	(Farm Animals) LD	(Mixed Documents) LD	(Views, Plants) LD
<1900	12–21	208–280		400–417	600–646	800–883
<1899	22–26					884–887
<1900	27–120					888–896
1896?	121–135					
<1900	136–161					897–899
undated						
1898						
1899						
1900						
1901						
1902						
1903						
1904						
1905						
1906						
1907			300–355			
1908					690–720 1910 OR EARLIER	
1909					721 1910 OR LATER	
1910						
1911						
1912						
1913						
1914					754–755	
1915					756–758	
1916						
1917						
1918						
1919					[800] *900	
1920						
1921					1017–1076	
1922					1102–1141	
1923					1203	
1924						
1925					1232–1262	
1926						
1927					[1290]	

LANDSCAPE-DOCUMENTS

314, 352–54. Copy photographs of photographs and engravings of Old Rouen. No dates

764–67, 775. Photographs of northern France on small (13 × 18 cm) plates. Probably before 1898

782. A wagon. Formerly 768. 1910 or before

800. Banana trees. Before 1900

800. Saint-Cloud. 1915–19

958. Copy photograph of wood engraving "Etampes, ruines." No date

1000. Amiens. No date; probably before 1898

1000. Malmaison. 1919–21

1138–40, 1143–44, 1147–49, 1153–62, 1188. Plants and landscapes in Cannes, Menton, Nice, and Ile Saint-Honorat, of which many are copy photographs. No dates

1142. Formerly E:6485. 1904

1164. Copy photograph of photograph by Neurdein Frères ("X. Phot."). No date

1181. La Bièvre, Paris. Inscribed by Atget "disparu en 1891"; before 1902

1213. Formerly 736. 1910–14 ?

1214. Formerly 739. 1910–14 ?

1225–27. Copy photographs of photographs by Neurdein Frères ("X. Phot." and "ND. Phot.") of the Forest of Fontainebleau. No dates

1231. Harvester in the Somme. No date; probably before 1898

PICTURESQUE PARIS, PART I

2997–99. At the Musée Carnavalet, Paris, dated 1899; at the Bibliothèque Historique de la Ville de Paris, dated 1898

PICTURESQUE PARIS, PART II
Vehicles

9. Formerly PP:3063. 1898

59. Formerly PP:3067. 1898

60. Formerly PP:3218. 1899–1900

61. Formerly PP:3071. 1898

62. Formerly PP:3186. 1899–1900

63. Formerly PP:3260. 1899–1900

64. Formerly PP:3169. 1899

65. Formerly PP:3170. 1899

66. Formerly PP:3006. 1898 or earlier

67. Formerly PP:3127. 1898–99

68. Formerly PP:3229. 1899–1900

69. Formerly PP:3233. 1899–1900

70. Formerly PP:3234. 1899–1900

71. Formerly PP:3240. 1899–1900

72. Formerly PP:3066. 1898

73. Formerly PP:3062. 1898

PICTURESQUE PARIS, PART II
continued

200. Formerly AP:493_. 1904–05

201. Formerly AP:4085. 1900

202. Formerly AP:4087. 1900

203. Formerly T:665 and AP:5730. 1909

336. Formerly Z:100. 1910

337. Formerly Z:101. 1910

338. Formerly Z:102. 1910

339. Formerly Z:103. 1910

340. Formerly Z:104. 1910

341. Formerly Z:108. 1910

342. Formerly Z:109. 1910

343. Formerly Z:111. 1910

344. Formerly Z:112. 1910

345. Formerly Z:120. 1910

348. Formerly Z:12_. 1910

354. Formerly PP:3000. 1898 or earlier

355. Formerly PP:3250. 1899–1900

356. Formerly PP:2997. 1899?

357. Formerly PP:3270. 1899–1900

358. Formerly PP:3198. 1899–1900

359. Formerly PP:3075. 1898

360. Formerly PP:3124. 1898–99

361. Formerly PP:3168. 1899

362. Formerly PP:3137. 1898–99

363. Formerly PP:3276. 1899–1900

364. Formerly PP:3211. 1899–1900

515–28. Probably 1914–21; not later than 1925

529–33. Probably 1914–21; not later than 1927

PICTURESQUE PARIS, PART III

13, 16. Copy photographs of undated photographs of nudes

25. Marly-le-Roi. 1922?

26. Femme de Verrières. 1922?

49, 51–53. Copy photographs of undated photographs of nudes

132–35, 137–39. Copy photographs of undated photographs of nudes

ART IN OLD PARIS

4104 bis–22 bis. Switzerland. 1901?

4178–82. La Bièvre. Inscribed by Atget "disparu en 1895"

5492. Copy photograph of 5426. 1907

5493. Copy photograph of 5163. 1905–06

5494. Copy photograph of 3659. 1899

5495. Copy photograph of ?. No date

5496. Copy photograph of 3725. 1899–1900

5498. Copy photograph of ?. No date

5499. Copy photograph of 3619. 1899

5500. Copy photograph of ?. No date

5501. Copy photograph of 3969. 1900

5502. Copy photograph of 4079. 1900

5503. Copy photograph of 3941. 1900

5504. Copy photograph of 4219. 1901

5505. Copy photograph of 4296. 1901

5506. Copy photograph of 4341. 1901

5507. Copy photograph of 4402. 1901

5513. Copy photograph of ?. No date

5515. Copy photograph of 4449. 1901–02

5523. Copy photograph of 4696. 1903

5524. Copy photograph of 4716. 1903

5525. Copy photograph of ?. No date

5527. Copy photograph of 5002. 1905

5529. Copy photograph of ?. No date

5531. Copy photograph of 5007. 1905

5533. Copy photograph of 5281. 1905–06

5535. Copy photograph of ?. No date

5607. Copy photographs of 3528. 1898

5608. Copy photographs of 3625. 1899

5610. Copy photograph of 4076. 1900

5611. Copy photograph of 4080. 1900

5612. Copy photograph of ?. No date

5614. Copy photograph of 4498. 1902

5615. Copy photograph of 4571. 1902–03

5616–18. Copy photographs of ?. No dates

5620–21. Copy photographs of ?. No dates

5622. Copy photograph of 4883. 1903–04

5624. Copy photograph of 5220.

1905–06
5625. Copy photograph of 5219.
 1905–06
5626. Copy photograph of 5229.
 1905–06
5627–28. Copy photographs of ?.
 No dates
5630. Copy photograph of ?. No date
5631. Copy photograph of 3912. 1900
5632. Copy photograph of 5248.
 1905–06
5634. Copy photograph of ?. No date
5635. Copy photograph of 3895. 1900
5636. Copy photograph of 4081. 1900
5637. Copy photograph of 4254. 1901
5638. Copy photograph of 444_.
 1901–02
5639. Copy photograph of 4544.
 1902–03
5640. Formerly T:308. 1908
5641. Formerly T:310. 1908
5642. Formerly T:357. 1908
5644. Copy photograph of 4711. 1903
5645. Copy photographs of 5093.
 1904–05
5646. Copy photograph of 5547. 1908

5647. Copy photograph of 5604.
 1908–09
5722 bis–5730 bis. Not later than 1910
5726. Formerly T:312. 1908
5727. Formerly T:314. 1908
5729. Formerly T:653. 1909
5730. Formerly T:665. 1909
5739. Formerly T:876. 1910
5740. Formerly T:873. 1910
5742. Formerly T:889?. 1910
5743. Formerly T:898. 1910
5744. Formerly T:902. 1910
5745. Formerly T:968. 1910
5846. Formerly T:820. 1910
5878. Formerly T:1097. 1911
5939. Formerly T:197. 1907
6224. Copy photograph of 4113. 1900
6291. Copy photograph of 5268.
 1905–06
6301. Copy photograph of ?. No date
6309. Copy photograph of 3592?.
 1898–99
6310. Copy photograph of 3602?.
 1899
6328. Copy photograph of 3703.
 1899–1900

6329. Copy photograph of ?. No date
6338. Copy photograph of 5364.
 1906–07
6369. Copy photograph of ?. No date
6385. Copy photograph of 5767. 1911
6386. Copy photograph of T:1476.
 1913
6392. Copy photograph of 5756. 1911
6442. Copy photograph of ?. No date
6452. Copy photograph of 3596.
 1898–99

TOPOGRAPHY
10–54. At the Bibliothèque Nationale,
 Paris, dated 1906; purchased July
 1907. In the Abbott-Levy albums
 and at the Bibliothèque Historique
 de la Ville de Paris, dated 1907

Note: Some other exceptions exist, to
wit: several unnumbered photographs
(no dates), two photographs of en-
gravings of birds numbered 10 and 11
(no dates), and three photographs of
houses of famous Parisians numbered
10, 11, 12 and dated 1915.

The text for
THE WORK OF ATGET: THE ANCIEN RÉGIME
is set in Bembo monotype.
Type composition by The Stinehour Press
Design by Christopher Holme
Halftone negatives by Richard Benson
Printing by The Meriden Gravure Company
Binding by Sendor Bindery, Inc.